MODERN MASTER DRAWINGS

MODERN MASTER
drawings

Forty Years of Collecting at The University of Michigan Museum of Art

Catalogue of the exhibition by Hilarie Faberman

With contributions by Lauren Arnold, Carole McNamara, Evan M. Maurer, Charles H. Sawyer, and others

The University of Michigan Museum of Art · Ann Arbor 1986

MODERN MASTER DRAWINGS:
Forty Years of Collecting at
The University of Michigan Museum of Art

The Arts Club of Chicago
 31 March – 26 April 1986
Grand Rapids Art Museum
 20 September – 2 November 1986
The University of Michigan Museum of Art
 24 February – 5 April 1987

Cover: catalogue number 57
Pablo Picasso, *White Horse*, 1919

© The University of Michigan Museum of Art 1986
ISBN 0-912303-33-6

Support for the exhibition and catalogue was provided
by a grant from the Campaign for Michigan and
by the Charles Ulrick and Josephine Bay Foundation,
New York

CONTENTS

FOREWORD

The University of Michigan Museum of Art is pleased to present this survey of our collection of nineteenth- and twentieth-century drawings and watercolors. The history of the collection has been eloquently told by our director emeritus, Charles Sawyer who, along with our first director, Jean Paul Slusser, must be given the major credit for assembling the fine selection of works that we present in this catalogue. The nineteenth- and twentieth-century European and American drawings are part of a larger collection which now numbers close to 1,000 examples – a large group considering the limited resources available to the Museum for acquisition.

Because we are a Museum existing within an academic community we have always tried to use our valuable art resources as an integral element within the teaching and research functions of the University. This has included the various exhibitions and publications that are enumerated in the text of this catalogue as well as other didactic opportunities that have been enriched by our ability to have our professors and students interact directly with original works of art. During our recent reorganization of museum exhibition spaces a special area was created so that for the first time we could exhibit selections from our graphic arts collection on a regular basis. The exhibition function of our drawings has been reinforced by another new area specifically designed to house works requested by professors as an integral part of their class assignments. These works are changed on a very frequent basis maximizing our ability to show as many objects as possible. Our drawings and watercolors are also available for use by faculty and students in controlled study environments. In this way individual members of the University community have the opportunity of study and research with a growing collection of original works of art.

This exhibition presents a full range of the many types and functions of modern master drawings. There are drawings of preliminary ideas, such as the double-sided sheet by Delacroix (8), preparatory studies by Gericault (5), and drawings that are highly finished art works in their own right, such as the Doré landscape (24), the Decamps *Samson* (10), and the great Nolde landscape (40). There are drawings for decorative projects by Delacroix (9), Lord Leighton (22), Burne-Jones (26), and Albert Moore (34); drawings related to paintings by Sutherland (85); and drawings for sculpture, including works by Lipchitz (69), Flannagan (74), Roszak (89), and Meadows (92). The objects in the exhibition cut across national boundaries and styles; it is thus instructive to compare the portraits by Devéria (11) and Kaulbach (12) – executed only two years apart – for their respective characteristics. There are drawings by artists known primarily as printmakers, such as Brockhurst (65), Hayter (82), and Wujcik (95), and drawings by the architects Viollet-le-Duc (17), Sullivan (36), and Le Corbusier (64). There are caricatures by Isaac Cruikshank (1) and Sir Max Beerbohm (45), and preparatory drawings for book and periodical illustrations by Martin (4), Pennell (37), Sloan (43, 44), and Steinberg (91). Drawings of the nude by Stevens (21), Matisse (42), Léger (55), Gill (58), Lachaise (59), Archipenko (63), Miró (72, 73), Noguchi (87), and Grausman (95), perhaps best demonstrate the quality and breadth of the collection.

I would like to thank my predecessors for the extraordinary legacy of fine drawings they have left for us, and especially Hilarie Faberman, curator of the exhibition, and our colleagues on the Museum staff, whose talent and hard work have resulted in this beautiful and scholarly publication.

Evan M. Maurer
Director

ACKNOWLEDGMENTS

When this exhibition of the collection's finest nineteenth- and twentieth-century drawings and watercolors was proposed, it provided the timely opportunity to bring to light, on the eve of the Museum's fortieth anniversary, the extraordinary connoisseurship and scholarship exercised over four decades by the institution's various directors and curators. The introductory essay by Charles Sawyer, director emeritus, recounts the debt owed to the Museum of Art's first director, Jean Paul Slusser, and its subsequent directors, Bret Waller and Evan Maurer, and to two of its former curators, Helen B. Hall and Nesta Spink. In many ways, this catalogue is their publication. On behalf of the contributors, I would like to thank Charles Sawyer for writing his forty-year "secret history," and for his continuing role as guiding spirit and inspiration of the Museum of Art. Evan Maurer, our present director and drawings' devotee, has recognized their value by assiduously pursuing their acquisition in the manner of his predecessors, and by his contributions to the conception and realization of this exhibition and catalogue.

No collection is built without the care of its patrons: to the Friends of the Museum and to its many generous donors, we extend our appreciation. For assistance in the publication of the catalogue, we wish to thank the Campaign for Michigan, for recognizing that the Museum of Art is indeed a jewel in the University's crown.

The entire staff of The University of Michigan Museum of Art participated in organizing this exhibition and catalogue, but the following individuals have been particularly helpful. Lauren Arnold, assistant to the director and editor of this publication, and Carole McNamara, registrar, deserve special citation for their dual roles; each has written more than a dozen entries for this catalogue. I would also especially like to thank them for sharing their ideas and for their constant and enthusiastic support, making *Modern Master Drawings* a true team effort. Patrick Young, photographer, and Jane Clink, assistant registrar, expertly handled the assembly and production of visual materials from the Museum of Art's collection. Mary Kujawski, curator of education, provided invaluable advice during the final stages of the catalogue. Martha Mehta, development officer, coordinated the University's administrative and alumni offices with the Museum of Art, and thereby facilitated the exhibition's progress. To Samuel Ferraro and Richard Plewa, Museum security officers, we extend our gratitude for their deft translations. Steve Williams, Museum technician, with the skill of a surgeon and the eye of an aesthete, prepared the works for exhibition.

The exhibition also allowed the Museum to continue its primary university function as an institution of research. Graduate students in the History of Art department and the Museum Practice Program cheerfully and intelligently assisted in writing catalogue entries and in various editorial and administrative tasks. We especially thank Victoria Julius (*VJ*), Terry Mackin, Suzanne Ramljak (*SR*), and Karen Wight (*KW*) for their help. We have also been fortunate to receive "extra-mural" help from the Charles Ulrick and Josephine Bay Foundation of New York, in the form of a grant for drawings conservation. The significance of this assistance cannot be overestimated. Valerie Baas, paper conservator at The Detroit Institute of Arts, carried out the treatments with her typical care and concern, with the able assistance of Elizabeth Buschor.

Jennifer Spoon, graphic artist, and Suzanne Williams, editor, of the Office of Development and Marketing Communication, receive our gratitude for their considerable roles in the design and production of this handsome catalogue.

In the course of our research, we have contacted many artists and their descendants. For their helpful replies, we wish to thank Miss Sara Jane Roszak, Saul Steinberg, Theo Wujcik, and the Adolph Gottlieb Foundation. Philippe Brame, Graham Galleries, the Lefevre Gallery, the Donald Morris Gallery, Shepherd Gallery Associates, E. Weyhe, and Wildenstein and Co. provided documentation that has enriched our records. For their expertise we would like to acknowledge the following individuals: Brian Allen, Ronald Alley, Martha Asher, Ursel Berger, Susan Ferleger Brades, Duncan Bull, Andreas Franzke, David Fraser-Jenkins, Ann Garrould, Jürgen Glaesemer, Stephen Goddard, Philippe Grunchec, Elizabeth Hawkes, Robert Herbert, the Interlibrary Loan staff at Hatcher Library, Stephen Jones, Elise Kenney, Dewey Mosby, Roy Muir, Jane Munro, Evelyn Newby, Barbara Peacock and the staff of the Fine Arts Library, Kenneth Pokorny, Douglas Smith, Peter Tunnard, Martin Urban, Alan Wilkinson, and Wim de Wit.

Over these forty years, the Museum of Art has been gifted with an extraordinarily hard-working staff, with wise directors and curators, and with extremely generous patrons. It has been a privilege to work on this collection, and to bring to bear the research of my predecessors. It has also been enormously gratifying personally to discover the aesthetic and scholarly value of these drawings, to present much new information about them, and to organize the material for this publication. I hope *Modern Master Drawings* will serve as the foundation for further research that will continue to be shared with the Museum's visitors and scholars.

Hilarie Faberman
Curator of Western Art

FORTY YEARS OF COLLECTING DRAWINGS AT THE MUSEUM OF ART

The drawings and watercolors in this exhibition reflect the taste and interests of four generations of curators and directors of the Museum and of a number of private collectors who have given or bequeathed major works to the University at intervals over four decades. Each has brought a somewhat different perspective and point of view, in terms of particular interests, vision, and experience. Dealers in this country and abroad have also played an important role: first, in bringing important examples to the attention of the Museum and its patrons, and then, with the realization that this was really a "teaching collection" used in the training of future curators, teachers, and collectors, in making significant examples available at comparatively modest prices.

In addition to members of the Museum staff, faculty colleagues on the Executive Committee and in the related departments of instruction have also initiated acquisitions and participated in their selection. Over the past twenty-five years, graduate students in the History of Art and the Museum Practice Program have benefitted from the opportunity to observe and study these drawings at first hand. Among their number are many museum professionals, including directors and curators of prints and drawings in museums in different sections of the country, as well as numerous assistants and interns preparing for continuing careers in collections of graphic art.

The drawings in this exhibition represent only a fraction of the European and American drawings of the period in the Museum's collection. Quite appropriately, they are the individual choice of the present generation of Museum of Art professionals. In reflection, I see as a unifying factor spanning the generations, a common respect and enthusiasm for drawings as a medium of expression, for the insight they give to the artist's intention, and for the intrinsic qualities of the individual drawings as illustrated in an infinite variety of media, subject matter, and modes of expression.

Professor Jean Paul Slusser, the first director of the Museum of Art, was responsible for the acquisition of a substantial portion of the drawings in this exhibition. Although his term as director was only ten years (from the founding of the Museum in 1946 to 1956), he brought to the Museum a lifetime of experience as an artist, a critic, and an avid collector of works of art. Born in Chicago of German ancestry, he had a particular affinity for the work of the German Expressionists, and, following World War II, with the active collaboration of Helen B. Hall, curator of the collection for twenty-five years, Slusser acquired one of the most representative collections of German Expressionist works to be assembled by an American university museum. Examples included in this exhibition are by Emil Nolde (40), Georg Kolbe (47), Paul Klee (51), Ludwig Kirchner (53), and Max Beckmann (61). Professor Slusser and Miss Hall also acquired a number of notable drawings by English artists, including *Seated Figures*, an early drawing by Henry Moore (78), and the watercolor *South Polar Quadrille*, by John Tunnard (79). Acquisitions in the French tradition of the twentieth century included the works by Jean Dubuffet (80) and the Swiss-born Alberto Giacometti (81).

The most adventurous and far-sighted purchase of Professor Slusser's administration was the acquisition of over one hundred drawings in 1948 from John Becker, a pioneer collector and dealer in modern art in New York and Los Angeles. Presumably, Paul Slusser had been acquainted with Becker and his collection in New York during Slusser's years as an art critic for *The New York Sun*, and on learning that the collection was to be dispersed, recognized its importance and the opportunity for the Museum. Included in the purchase were several of the major drawings in this exhibition, such as the Matisse *Seated Nude* (42), the Picasso *White Horse* (57), examples by Léger (55, 56), Pascin (62), Le Corbusier (64), Gaudier-Brezska (68), and the very interesting drawings by Alexander Calder (77), and Isamu Noguchi (87). The entire collection was acquired for an investment of less than three thousand dollars, an extraordinary and unrepeatable accomplishment in light of today's prices.

Toward the end of Professor Slusser's administration, The University of Michigan received a magnificent bequest of works of art from the estates of Dr. Walter R. Parker and Margaret Watson Parker of Grosse Pointe. Mrs. Parker was a notable collector of art throughout her life. Upon her death in 1936 she left several hundred objects to the Regents of the University, giving her husband life interest. Works began to be officially transferred to the Museum of Art in 1953; the entire bequest entered the collection by 1955. While the Parker collection is especially notable for its Oriental art, there are also outstanding examples of the work of James McNeill Whistler. In addition to a comprehensive collection of his prints are several exceptionally fine drawings and watercolors, a number of which are included in this exhibition: the chalk drawing, *Lady with a Fan* (27), and the watercolors *Street Scene, Paris [Rue Laffitte (?)]* (28) and *Blue and Silver: Morning, Ajaccio* (29). Also from the Parker collection are two fine charcoal drawings by Jean-François Millet, *The Mendicant* (15), and *The Shepherdess* (16). Two drawings by Augustus John (48, 49), and drawings by Albert Moore (34) and Gerald Leslie Brockhurst (65), added further di-

mensions to the growing representations of drawings by English artists which Professor Slusser had initiated.

I became director of the Museum of Art in 1957 with a mandate from the University administration to broaden the base of the collections and to enhance its usefulness to the entire University and Ann Arbor communities. There was also an expressed desire on the part of the constituent Art and History of Art faculties that both the collections and exhibitions should be oriented more specifically to instructional purposes. The scope of the collection was enlarged to include Western art from the fifth through the twentieth centuries, and, with the Parker Collection as a core, to expand the collections of Oriental art, gradually incorporating the arts of the Near East, as well as the Far East. While substantial additional funds for this purpose were provided by the University, they were still modest by the standards of larger museums. To supplement the small nucleus of affordable major paintings and sculpture, it was essential to provide other examples of good quality, but of a smaller scale and price. Following the precedent already well-established by Professor Slusser and Miss Hall, the collection of graphic art in general, and of historic and contemporary drawings in particular, were expanded materially during the next decade and a half. Miss Hall continued to play an active role in these acquisitions, in their documentation and in assisting students in their research. With degrees from The University of Michigan and many years of curatorial and editorial experience, she was meticulous in her own research and in establishing procedures and standards for her colleagues and successors to follow.

My initial interest in master drawings was inspired by Professor Paul J. Sachs and his colleague Professor Jakob Rosenberg. In their museum course at the Fogg Museum at Harvard University in the early 1930s, they gave particular emphasis to the graphic arts. A continual exposure to Professor Sachs's collection of drawings, (which became the basis of the great collection of master drawings at Harvard), and to the related collections in the Museum of Fine Arts, Boston, were an inspiration to a generation of future museum directors and curators. Both Sachs and Rosenberg gave particular emphasis to the development of connoisseurship and to the collecting of drawings of the highest quality. Three decades later, following his retirement from Harvard, Professor Rosenberg taught for a semester at Michigan and shared his great expertise on Rembrandt and the artist's generation, with faculty, staff, and graduate students.
In subsequent years, while serving as director of the Addison Gallery of American Art at Andover and subse-

quently of the Worcester Art Museum, I was also influenced by the somewhat different interests and perspectives of William M. Ivins, Jr., curator of prints and drawings, and of A. Hyatt Mayor, his associate and successor at the Metropolitan Museum of Art. They were less concerned with the quality of the individual drawing or print, and gave greater emphasis to the impression or drawing as a document and symbol of the culture which produced it. Both Sachs's and Ivins's influence are apparent in the examples acquired during my sixteen years as director. Hyatt Mayor was especially helpful and supportive in the formation of the Museum's considerable collection of architectural drawings acquired during my administration. Of the works in this exhibition, two by John Sloan (43, 44) reflect a documentary perspective. They were bought from the Kraushaar Gallery in New York, an important source for me over many years, with the cooperation of Mrs. Sloan. Along with several others, they were chosen to represent the artist's early career as illustrator and social commentator. A similar documentary perspective is suggested in *River Junkmen* (38) by George Luks, acquired at the auctions of the Cranbrook Collections in 1972.

Most of the drawings acquired during my tenure were purchased for their intrinsic quality, as well as to represent the work of the artist and his tradition. Among the first drawings purchased were Delacroix's *Lion Attacking a Horse* (8), and *"Sara la Baigneuse"* (30) by Henri Fantin-Latour, both from Wildenstein, one of several dealers to whom Professor Sachs had introduced me. The early Corot *Landscape Study* (7) came from the Charles E. Slatkin Galleries, New York, the source of a considerable number of drawings we acquired at that time; Mrs. Slatkin had also been a student of Professor Sachs at the Fogg. Other works which I would regard as in "the classical Sachs tradition" include *Studies of a Peasant Digging* (23) by Pissarro, bought through Colnaghi's in London, and the Harpignies watercolor (19), also purchased there.

Professor Sachs had provided me with a letter of introduction to Gus Meyer, then the senior partner at Colnaghi's when I was in London in 1936, and I visited with him occasionally when I was in London in 1944-45 during World War II. When I came to Michigan in 1957, I renewed my contacts with Colnaghi and James Byam Shaw, specialist in drawings, and the firm was uniformly supportive in our search for drawings. In addition to those we found through the firm, Shaw also bid for us on drawings auctioned by Sotheby's, and acquired several more for us from other dealers. Another important con-

tact with a major London house which resulted from the Sachs connection was with the firm of Thomas Agnew & Sons, Ltd. Sir Geoffrey Agnew, until recently the senior partner, was a good friend over many years and participated in many of our major acquisitions during the 1960s.

During the 1960s the Museum collected drawings by artists little recognized at the time, who came to be appreciated in the following years. These include the watercolor by Gustave Doré (24) and a watercolor sketch by Tissot (32), whose work became increasingly important a decade later. For inspiring the search for the work of relatively unknown artists of high quality, I owe a particular debt to Charles Chetham, director of the Smith College Museum of Art, who, as assistant director of our Museum in 1961-62, organized an exhibition of French artists of the nineteenth century, entitled "Great Draughtsmen," which opened our eyes to the excellence of many artists who had fallen into obscurity. Another drawing of good quality by a comparatively minor French master, and acquired from a purchase consideration exhibition at the conclusion of my administration, is the *Portrait of a Lady ...* (6) by Julien-Léopold Boilly, son of the painter.

In retrospect, exhibitions, small and large, played an important role in the development of the collection of drawings. In contrast to the essentially classical nature of Professor Chetham's earlier show, "Great Draughtsmen," was an exhibition organized in 1965 by guest curator Professor Al Mullen of the School of Art, entitled "One Hundred Contemporary American Drawings." This exhibition included the work of a number of artists shown in this region for the first time, who in the following decades attained national recognition. Several drawings were acquired from this exhibition for the permanent collection.

The collection of contemporary American prints and drawings was notably enriched by the gifts and then the bequest in 1968 of Mrs. Florence L. Stol, of New York and Vernon, Vermont, several of which are included in this exhibition: Adolph Gottlieb's *Beasts at Night* (84), Arshile Gorky's *Study for "Image in Xhorkom"* (86), and two pencil drawings (72, 73) by the Spanish artist Joan Miró, who in the 1940s became closely associated with, and influential for the American tradition. Mrs. Stol had worked as a consultant for John Becker, and personally knew many important twentieth-century artists, from whom she directly acquired works of art. She generously gave many fine works to the Museum in 1964, and at her death in 1967, bequeathed further examples of contemporary sculpture, prints, and drawings. Her legacy to the Museum greatly enhanced its collection of modern art.

Apart from the French and American drawings, a number of drawings by British artists of the late-nineteenth and early-twentieth centuries came into the collection during this period. Most of them were purchased from London dealers, chosen quite deliberately to supplement those Professor Slusser had previously acquired. From this group are the decorative *Design for a Fan* (41) by Charles Conder; *The Destruction of Sodom* (4) by John Martin; *Homage to Augustus John* (45) by Max Beerbohm; and the very romantic *Dorigen of Bretaigne Longing for the Safe Return of Her Husband* (25) by Sir Edward Burne-Jones. Among the considerable group of drawings by British sculptors which Professor Slusser and I acquired, the drawing by Bernard Meadows (92) was purchased from the Gimpel Gallery in London, to accompany a sculpture by Meadows acquired by the Museum at approximately the same time.

While the acquisitions of drawings by German artists were comparatively few during my tenure, I took particular pleasure in *Family Portrait* (12) by Wilhelm von Kaulbach, bought from a dealer in Zurich, along with several earlier drawings. It appealed to me both as an arresting work of fine quality, and as an interesting Teutonic variant on the classical tradition of Ingres and his followers. Of the twentieth century, we also found the gouache *Artillery Duel* (67) by Otto Dix at the Alan Frumkin Gallery, New York, and the pen, ink, and wash drawing *A Dream* (71) by George Grosz. Both were chosen to supplement the distinguished group Professor Slusser had previously assembled. The collection of French drawings of the nineteenth century, along with many other aspects of the Museum collection, were notably enriched by objects from the private collection of Professor Paul Grigaut, as part of a memorial collection formed following his sudden and tragic death in 1969. Among these, five are included in the current exhibition: the pencil drawing *Study for "Cicero Accusing Verres"* (9) by Eugène Delacroix; the portrait in watercolor (11) by Eugène Devéria, an artist active in the first half of the nineteenth century; two splendid landscape drawings (13, 14) by Théodore Rousseau; and the much admired *Street in a Village* (18) by Charles Daubigny. A man of modest means who possessed impeccable taste, Professor Grigaut was an inveterate collector, and the size, variety, and quality of his collection was a pleasant surprise even to his closest associates and friends. Born in France and steeped in the tradition of French culture and humanistic studies, Paul Grigaut, in his earlier years in this country, was professor of Romance Languages at the University of New Hampshire. By way of transition to a subsequent career as chief curator of The Detroit Institute of Arts from 1945 to 1963, he had studied

briefly with Professors Sachs and Rosenberg at Harvard. Following a short tenure as vice-director of the Virginia Museum of Fine Arts, he came to The University of Michigan in 1965 as professor of the History of Art and associate director of the Museum of Art. In the short period of four years, he influenced and inspired a generation of graduate students in art history and in other disciplines with a sense of connoisseurship and a concern for works of art, with particular emphasis on European decorative arts and the graphic arts.

During the mid-1970s, major alterations in space in the museum galleries, shifting priorities, limited funds, and an astronomical increase in the price of master drawings all combined to curtail acquisitions. Drawings which had been available in previous decades for modest amounts now commanded prices well into the thousands. Bret Waller, director of the Museum from 1973 until 1980, gave particular emphasis to purchasing prints and photographs. He had the continued aid and active participation of the Friends of the Museum, established in 1967 at the time of the sesquicentennial observance of the founding of The University of Michigan. Following earlier precedent, a few fine drawings by artists of lesser reputation were acquired. Notable among these are *Violetta* (31) by Jules Lefebvre, and the chalk drawing *Study of Maple Trees* (33) by Gustave Guillaumet. Nesta Spink, who joined the Museum staff in 1967 and later succeeded Helen Hall as curator, and John Holmes were active participants in these acquisitions, instrumental in securing gifts and in purchasing contemporary art during this period. Especially notable among twentieth-century examples acquired were the india ink on paper drawing (52) by Hans Hofmann, and the drawing by Saul Steinberg, *The Highway at Night* (91). Nesta Spink, who in her previous professional career had been associated with the Fogg Museum at Harvard and with the American Federation of Arts, joined the Robert Light Galleries, specialists in prints and drawings, in 1979.

An especially interesting and stimulating exhibition of Professor Waller's administration was the "Collection of Dorothy and Herbert Vogel," a showing of works acquired by these indefatigable observers, students, and collectors of the contemporary New York art scene. Although the Vogels were largely self-taught, and possessed limited resources, they demonstrated a discerning eye and a continuing dedication to acquiring new art works of considerable significance by artists who would become well recognized a decade later. Among the objects brought to the Museum's attention by the Vogel

exhibition and its accompanying symposium were Brice Marden's *Hydra Study* (97) and Edda Renouf's *Sounds of Dawn* (99). Other significant contemporary drawings that entered the collection at this time included *Nude* (95) by Philip Grausman, *Tribute to the Graphicstudio: Portrait of Philip Pearlstein* (96) by Theo Wujcik, and *Male Venus* (98), a watercolor by the Chicago "Hairy Who" artist, Gladys Nilsson.

Despite soaring prices, it is especially gratifying to note that the Museum's present director, Evan Maurer, has followed the lead established by Jean Paul Slusser four decades ago for sagacious acquisitions. One such example is the *Study for "The Dance"* (22) by Frederic, Lord Leighton. Generous gifts also continue to augment the collection: these include objects presented by individuals and Friends of the Museum, such as the drawings by Gericault (5) and Decamps (10). Finally, Professor John Rewald, the pioneer scholar of Impressionism and modern art, has presented several fine drawings to enrich our resources. Among those in the exhibition are works by the Dutch artist Jongkind (20), Renoir (35), and Manzù (90). The importance of gifts and purchases cannot be overstated, for they – and those that preceded them – constitute the legacy and commitment to the appreciation and understanding of the history of art integral to humanistic studies at The University of Michigan.

Charles H. Sawyer
Director Emeritus

15

EDITOR'S NOTES

A catalogue of drawings presents a unique challenge to an editor, since works on paper are highly varied, both in artistic intention and medium. Given the wide scope of this catalogue, including works by over eighty artists, and the plethora of visual and written information we discovered during its research, Hilarie Faberman and I have tried to order the catalogue into a coherent, easily accessible body of information. In every case, it has been our intention to appeal to two overlapping audiences – drawings' enthusiasts and serious scholars. To those who will primarily delight in the images, we have tried to make this catalogue as visually appealing as possible (and thanks to Jennifer Spoon, its designer, this need has been successfully met). For scholars, we have attempted to order the material into consistent categories, making information retrievable as easily and as completely as possible. The following notes explain the methods we have employed in giving this catalogue its brevity and clarity.

General notes to the catalogue: Entries are chronologically listed by date of birth of the artist. An alphabetical Index of Artists, at the back of the book, gives page references. Photography Credits, also at the back, gives complete information and sources for the comparative illustrations.

Title: When a work has more than one title, the secondary or foreign title is given in parentheses. If the paper has images on both recto and verso, and only one title is given, the words "Double-sided drawing" are indicated in parentheses, to show that another work exists on the verso of the sheet. Not all versos are illustrated.

Watermarks and Inscriptions: We have tried to faithfully transcribe all written or stamped inscriptions found on the drawings. The only exception has been watermarks, which regardless of their appearance on the paper have been set in small capitals, to distinguish them from other marks. Although it has not been possible to reproduce inscriptions photographically, we have indicated them as closely as possible in italics, with grammatical or other marks included. Unless otherwise noted, all inscriptions are assumed to be in the same medium as the drawing, and all marks are assumed to be on the recto. Signature and date always precede other inscriptions. Collectors' and estate stamps are assumed to be in black ink, unless another color is given. If the stamp is listed in Lugt, then the Lugt number follows in parentheses.

Placement of inscriptions on the sheet is indicated by the following abbreviations: upper and lower by "u." and "l." ; and right, center, and left by "r." and "c." and "l." Missing or illegible information is indicated by [...], and slashes indicate that the following words fall on another line.

Exhibitions and References: Many of the drawings have been in the same exhibitions, or published in the same literature, so frequently repeated references have been listed in abbreviated form, a full list of which follows these notes. In both the *Exhibitions* and *References* sections, pages are indicated without the usual "pp." References within the text that are listed in a shortened form show that a full reference exists above; otherwise, a full citation is given in the text following the quoted material.

Provenance and Credit Line: The direct line of descent of an object from one collection to another is indicated by a series of commas. When there is a break in information, or we could not verify that an object passed directly from one collection to another, we have indicated this break with a semi-colon. If the object was a gift to the Museum of Art, then a credit line is given before the accession number; in which case, the benefactor received or purchased the object from the last person or institution listed in the provenance. If the accession number appears alone, it may be assumed that the Museum of Art purchased the object from the last person or institution listed in the provenance.

Lauren Arnold
Assistant to the Director
Editor of Publications

ABBREVIATIONS: EXHIBITIONS

Chicago 1952
The Art Institute of Chicago, "Contemporary Drawings from Twelve Countries 1945-1952" (traveled to: The Toledo Museum of Art; Hartford, Wadsworth Atheneum; San Francisco Museum of Art; Los Angeles County Museum of Art; Colorado Springs Fine Art Center; Louisville, The J. B. Speed Museum), 1952

Saginaw 1954
Saginaw Museum of Art, "Drawings Old and Modern from The University of Michigan Museum of Art Collection," 1954

Oberlin 1956
Oberlin College, The Dudley Peter Allen Memorial Art Museum, "Twenty-Three Contemporary Paintings and Drawings from the Collection of The University of Michigan Museum of Art," 1956

Lincoln 1957
Lincoln, The University of Nebraska Art Galleries, "Sixty-Seventh Annual Exhibition of Contemporary Art, Nebraska Art Association," 1957

AFA 1957-58
American Federation of Arts, "A University Collects – Michigan" (traveled to: Minneapolis, University of Minnesota; Saratoga Springs, Skidmore College; Oswego, State University Teacher's College; Roanoke Fine Arts Center; Bowling Green State University; Denton, Texas Women's College; Charleston, Eastern Illinois University; Dallas, Southern Methodist University; Montevallo, Alabama College; Atlanta Public Library), 1957-58

East Lansing 1959-60
East Lansing, Michigan State University, "Fifty Modern Drawings – Exhibition Circulated by the University of Michigan Museum of Art" (traveled to: Albion College), 1959-60

Flint 1961
Flint College, "Drawings by Twentieth-Century Sculptors," 1961

Flint 1962
Flint Institute of Arts, "Watercolor Panorama," 1962

East Lansing 1963
East Lansing, Michigan State University, Department of Art, "Contemporary Sculpture and Sculptor's Drawings," 1963

Flint 1963
Flint College, "Contemporary Figure Drawings," 1963

Iowa City 1964
Iowa City, State University of Iowa, Art Department, "Drawing and the Human Figure," 1964

Ann Arbor 1965-66
The University of Michigan Museum of Art, "Reflections: The Image of Man," 1965-66

Ann Arbor 1966
Rackham Galleries, The University of Michigan, The University of Michigan Museum of Art, "Twentieth-Century American and European Drawings," 1966

MSCA 1967-68
Michigan State Council for the Arts, "Thirty Contemporary Drawings" (traveled to: Roseville Museum; Bay City, Delta College; Holland, Hope College; South Haven Community Arts Council; Kalamazoo Institute of Arts; Olivet College; Warren, Macomb Community College; Adrian College; Petoskey High School; Traverse City, Mark Osterlin College; Grosse Pointe Public Library; Fenton Community Center), 1967-68

Ann Arbor 1968
The University of Michigan Museum of Art, "Selections from the Florence L. Stol Collection Recently Bequeathed to the Museum of Art," 1968

Maryland 1977-78
College Park, The University of Maryland Art Gallery, "From Delacroix to Cézanne: French Watercolor Landscapes of the Nineteenth Century" (traveled to: Louisville, The J. B. Speed Museum; Ann Arbor, The University of Michigan Museum of Art), 1977-78

Ann Arbor 1982-83
The University of Michigan Museum of Art, "The Nude," 1982-83

Ann Arbor 1984
The University of Michigan Museum of Art, "Images of the Performing Arts: Music, Dance, and Theater," 1984

ABBREVIATIONS: REFERENCES

Handbook **1962**	*A Handbook of the Collections of The University of Michigan Museum of Art,* Ann Arbor, 1962
Eighty Works... *A Handbook* **1979**	*Eighty Works in the Collection of The University of Michigan Museum of Art: A Handbook,* Ann Arbor, 1979
UMMA Bulletin	*Bulletin, Museums of Art and Archaeology,* the University of Michigan. The *Bulletin* is a scholarly journal published yearly or bi-yearly from 1950 until the present, with articles on works in the collections of the Kelsey Museum of Archaeology and the Museum of Art

N.B. Over the years the *Bulletin* has changed the title of its list of objects acquired by the Museum of Art. This title has been standardized in this catalogue to "Acquisitions ..."

COLOR PLATES

Plate numbers in the color section correspond to entry numbers in the catalogue.

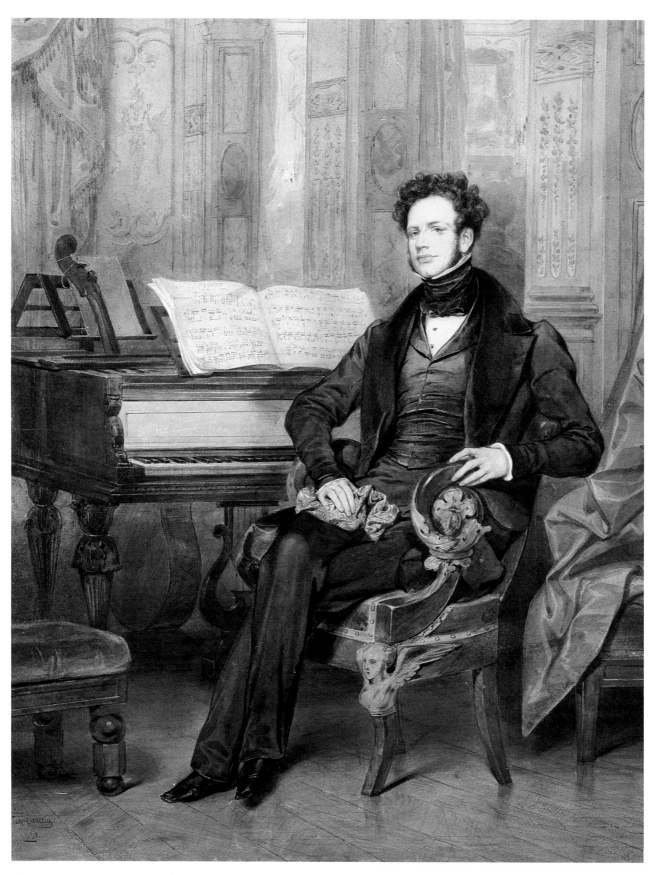

Plate 11 Eugène Devéria, *Portrait of Henri Herz*, 1832

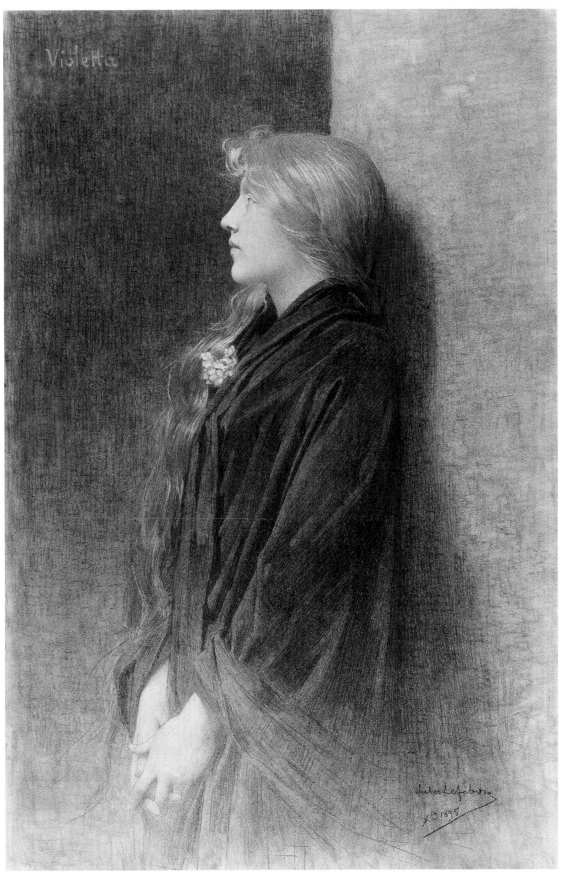

Plate 31 Jules-Joseph Lefebvre, *Violetta*, 1895

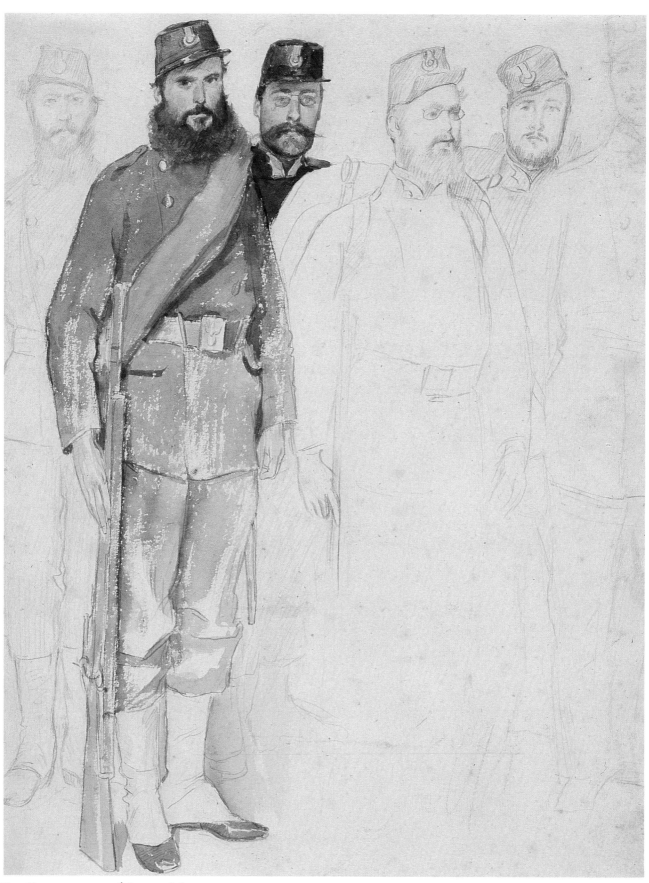

Plate 32 James Tissot, *Les Éclaireurs de la Seine*, ca. 1870-71

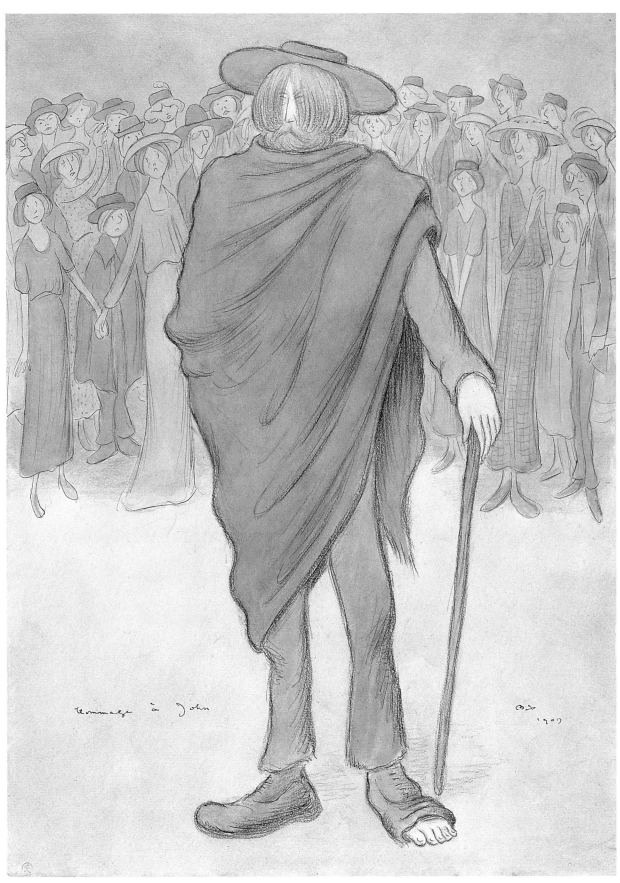

Plate 45 Sir Max Beerbohm, *Homage to Augustus John*, 1907

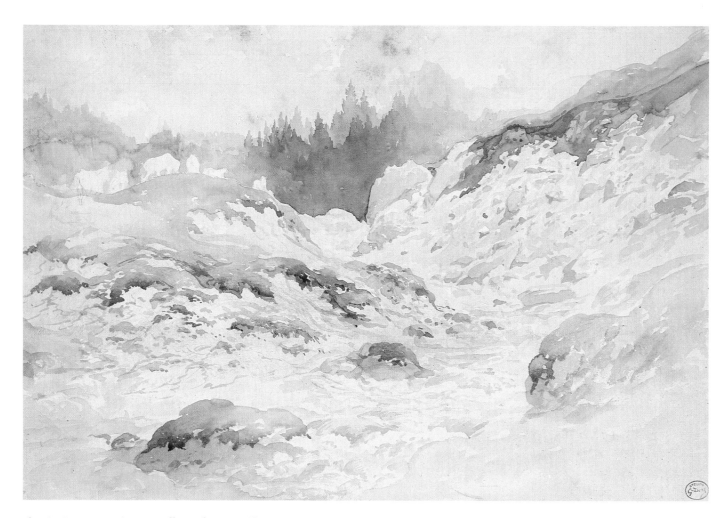

Plate 24 Gustave Doré, *River Valley in the Vosges(?)*

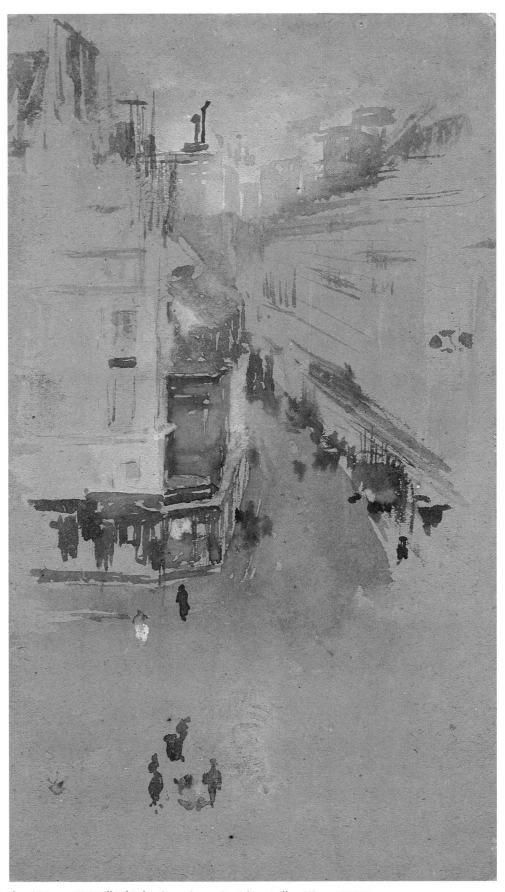

Plate 28 James McNeill Whistler, *Street Scene, Paris [Rue Laffitte(?)]*, ca. 1883-85

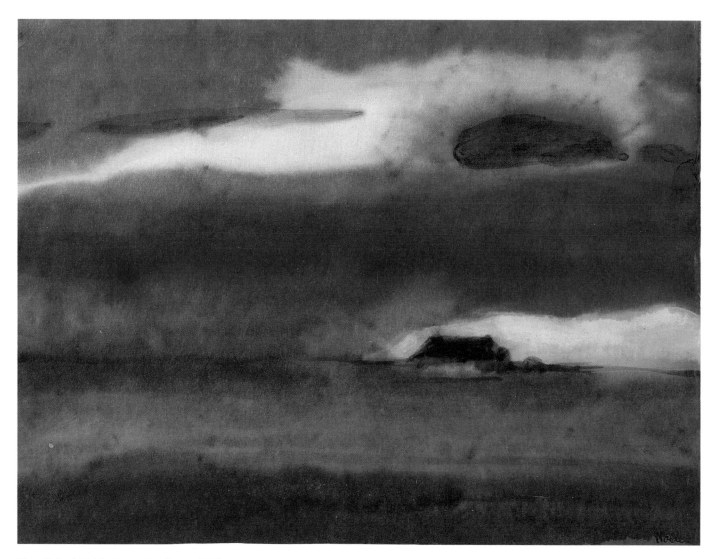

Plate 40 Emil Nolde, *Frisian Landscape*, 1930s

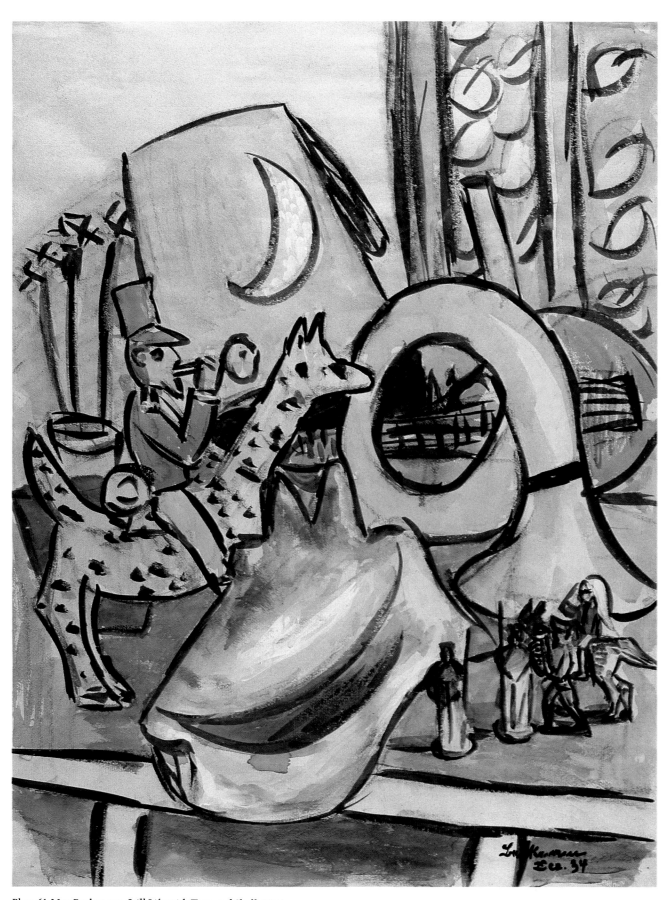

Plate 61 Max Beckmann, *Still Life with Toys and Shell*, 1934

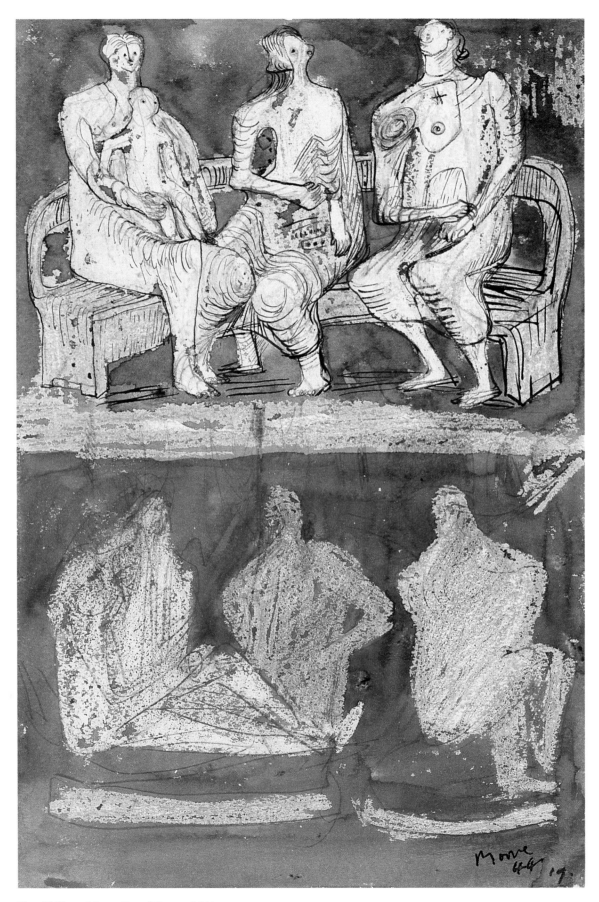

Plate 78 Henry Moore, *Seated Figures*, 1944

Plate 84 Adolph Gottlieb, *Beasts at Night*, 1949

Plate 91 Saul Steinberg, *The Highway at Night*, 1954

Plate 80 Jean Dubuffet, *Night Landscape*, 1952

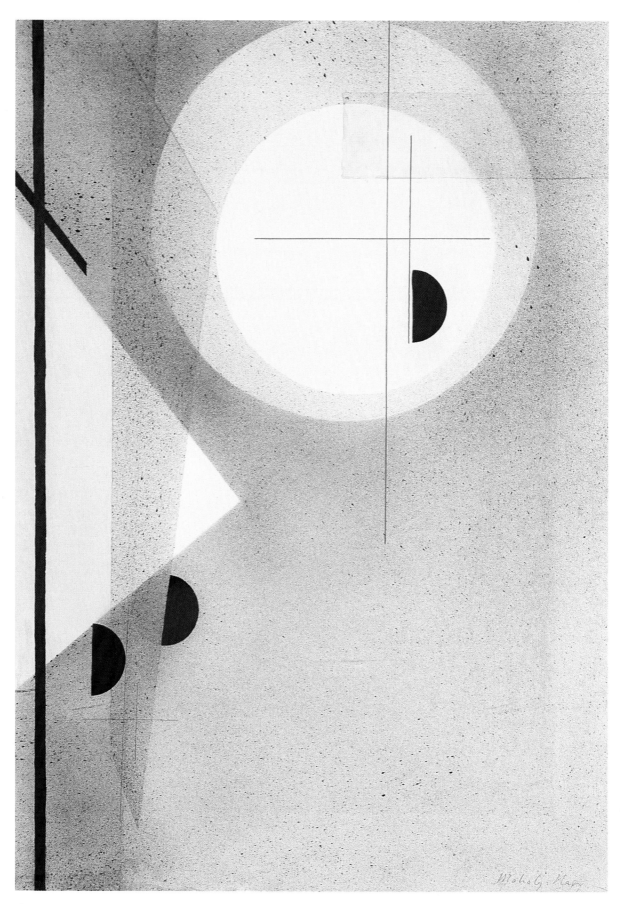

Plate 75 Laszlo Moholy-Nagy, *Abstract Composition*

Plate 79 John Tunnard, *South Polar Quadrille*, 1947

Plate 98 Gladys Nilsson, *Male Venus*, 1974

CATALOGUE OF THE EXHIBITION

1

ISAAC CRUIKSHANK

English
1756-1810/11

DANCERS
 FIVE COUPLES (Recto);
 THREE COUPLES (Verso)

Pencil and watercolor on white paper

9¼ x 20⅞ in. (235 x 531 mm) irregular

Signed recto and verso, in pencil, l.r.: I.C.

Exhibitions: Ann Arbor 1984

References: "Acquisitions July 1, 1968–June 30, 1970," *UMMA Bulletin*, 1970-71, 69

Provenance: collection of William H. Woodin (?), New York; collection of Paul Leroy Grigaut

The Paul Leroy Grigaut Memorial Collection

1969/2.97

*I*saac Cruikshank is best known for his biting and frequently crude satirical engravings, filled with caricatures and commentary on the great social and political upheavals of his age. In this wonderful drawing, however, Cruikshank focuses on a lively subject dear to every eighteenth-century heart – men and women dancing together. Cruikshank's powers of observation and his ability to capture the humorous essence of a social situation make this drawing as fresh today as when he sketched it. Two phases of the dance are depicted in this double-sided sheet. The recto concentrates on the physical interactions of the dance and the five couples participating; the verso draws our attention to the courtship aspects of this social ritual.

In the recto, Cruikshank alternates stout and slim pairs in a mock minuet. Beginning at the right, a portly man dances with some apparent effort with his sedate, equally stout partner. They are contrasted to an elegantly dressed couple, she with her arm swept outward, calculating the effect, very self-assured. The central pair is the most comically engaging, however, because the male partner's distress is highly visible: his wig flaps are high in the air from the leaping nature of the dance and his expression, with eyebrows raised alarmingly and mouth in a terrible grimace, signals his possible pain or embarrassment. Cruikshank finishes this drawing by contrasting another set of couples enjoying the physical activity of the dance; he juxtaposes an attractive, youthful pair with a the older woman bowing with a big grin, while her mate finesses a particularly lively turn. The gamut of expression of those taking part in the social ritual – from pained looks to pleasurable excitement – is superbly conveyed by Cruikshank.

The verso study of three couples is more intimate and speaks to the nature of courtship and attraction. Although Cruikshank portrays six people here, he is actually contrasting two couples who are obviously more interested in each other than in the dance. From right to left, an obese gentleman, his face bulging above his ruffled shirt and distended waistcoat, spreads his arms in a sweeping gesture, as if preparing for a ponderous twirl above his elegantly pointed toes. This posture draws our attention to the fact that he is standing with both feet on his partner's train, a fact that she does not appear to notice, however. Her bulging eyes and horsey face are coyly directed at her partner – a picture of arch flirtation, bold assessment, and crude expectation, like a hawk poised to strike a particularly plump and juicy mouse.

Cruikshank repeats the woman's bold look in the face of the young, slender man in the center dancing with the lovely young woman in a yellow gown. He is only visible from the back and in profile, but the predatory look on his face, his wide smirk, and proud, calculating stare are all directed at his mild-faced young companion. The spectacles pushed back on his pig-tailed head suggest that he is a clerk – perhaps trying to woo his superior's daughter? Whatever his status, it is obvious that he is not an appropriate match for his partner. Watching the young man's advances but powerless to stop them, is a worried-looking older woman to the left, perhaps the young woman's mother or chaperone. Cruikshank, with devastating wit, has added the final touch here, capturing the essence of a common social situation. The duenna is so caught up in watching the young couple's interactions (and in her own distress over them) that she completely ignores the crude-looking man talking to her; while he, absorbed in his own conversation, is entirely oblivious of her lack of attention.

Other works by Isaac Cruikshank in Michigan's collection include *The New Wig* (1969/2.98) and *Musical Interior* (1948/2.18).
LA

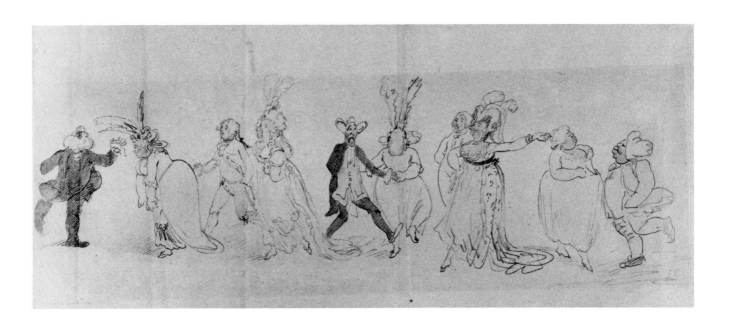

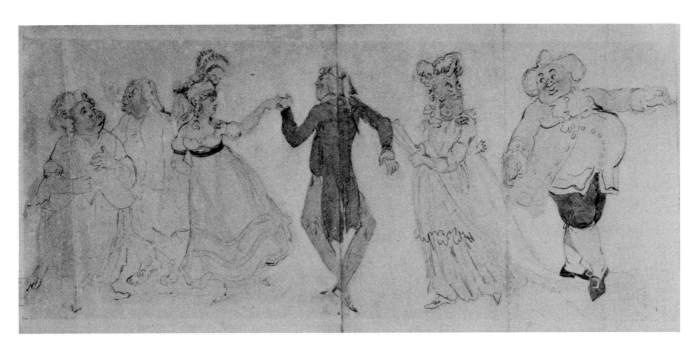

2

JOHN VARLEY

English
1778-1842

BAMBURGH CASTLE, NORTHUMBERLAND

Ca. 1830

Watercolor with scraping-out on white wove paper, mounted on heavier paper

7⅛ x 10⅝ in. (181 x 270 mm)

Signed l.r.: *J. Varley.*

Exhibitions: Saginaw 1954

References: Helen B. Hall, "Several English Water Colors and Drawings," *UMMA Bulletin*, 1952, 10-11

Provenance: F.R. Meatyard, London, purchased from him in 1951 by P. & D. Colnaghi & Co., Ltd., London

1951/2.36

John Varley, a founding member of the Society of Painters in Water-Colours, was also one of its most faithful and prolific participants. Between 1805 and 1842 he exhibited more than 700 works, a score of which represented Bamburgh Castle and its environs. Today, about a dozen of Varley's watercolors of this subject are known, examples of which are in the National Gallery of Scotland, the Victoria and Albert Museum [see C. M. Kauffmann, *John Varley (1778-1842)*, London, 1984, p. 118, no. 25; pp. 155-56, no. 52], in the Whitworth Art Gallery and the City Art Gallery in Manchester.

Varley visited Bamburgh (also spelled Bamborough) in 1808 and filled a sketchbook with drawings of the coastal castles of Northumberland. Some of these pencil studies were worked up into large, finished exhibition watercolors, while other sketches served as *aides mémoires* for Varley's freer, more imaginative landscapes of the following decades. *Bamburgh Castle* is most likely from the latter period of Varley's career. The somewhat contrived design of Michigan's watercolor is nonetheless evocative; between the dark, solid, menacing rock in the foreground, and the bobbing, wind-tossed sailboat at the left, stands the prominence on which sits the Norman fortress of Bamburgh Castle, weathered by the ages, bathed in a vaporous and luminescent glow.

The artist realized the texture of the pounding surf in *Bamburgh Castle* by scraping out the darker tints of the water, baring the white paper of the support. A.T. Story, one of Varley's earliest biographers, noted that the artist would "moisten and rub the paper clean away" to obtain these effects. Typical too of Varley's practice is the support of wove paper, laminated onto other stronger sheets (*ibid.*, p. 31).

With Girtin and Turner, Varley was one of the most influential painters in the history of watercolor. His *Treatise on the Principles of Landscape Design*, 1816, emphasized the special characteristics of watercolor – its transparency and luminescence, its ability to convey the mutability of light, its white paper, which enhanced the natural brightness of the medium – and codified the principles that earned him the dual reputations of successful artist and teacher. Varley's depiction of the antiquarian pile of Bamburgh Castle achieves the naturalism and picturesque effects sought after by many of the *plein-air* watercolorists and painters of the early decades of the nineteenth century.

HF

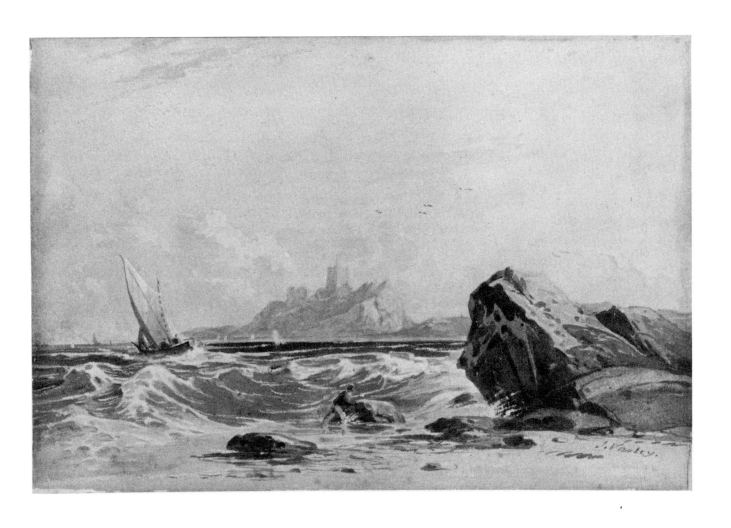

3

JOHN SELL COTMAN

English
1782-1842

THE HOUSE OF THE THREE STONES, LLANBERIS (?)

Ca. 1803

Pencil and wash on off-white wove paper

7½ x 11⁹⁄₁₆ in. (190 x 293 mm)

Signed l.l.: *JS. Cotman.*

Provenance: collection of Percy Moore Turner before 1950; Mr. G. Dixon, Ruislip, purchased from him in 1953 by P. & D. Colnaghi & Co., Ltd., London

1954/2.33

Although this watercolor traditionally has been identified as *The House of the Three Stones, Llanberis,* there is no evidence to prove that Cotman ever visited such a site. He did, however, make at least one trip to Wales in 1800, and Cotman's biographer, Sydney Kitson, maintained that a second trip to North Wales, in 1802, was taken in the company of fellow Sketching Society member Paul Sandby Munn. Kitson recorded that on 29 July 1802, Cotman and Munn traveled through the Pass of Llanberis on their way down to Caernarvon and the sea, and *en route,* both made drawings of the House of Nine Sisters (*The Life of John Sell Cotman,* London, 1892, reprint 1907, pp. 43-44).

Richard Wilson and Paul Sandby first visited Wales in the 1770s. With the publication of the Reverend William Gilpin's treatises on the picturesque in the next decade, Wales became an even more popular touring ground for artists.

Indeed, Turner, Girtin and Varley (2), three of the generative forces in the development of English watercolor painting, visited Wales at the turn of the nineteenth century in their search for the picturesque and sublime.

The subject of Cotman's Welsh figure, dwarfed by the massive cromlechs in the stormy landscape, is both scenic and awesome. Furthermore, Cotman's firm draughtsmanship, and his flat, tonal, transparent washes, which are suggestive of light and shadow, and which are undifferentiated by pencil outlines, demonstrate that the artist was one of the most advanced and gifted painters of the early nineteenth century.

HF

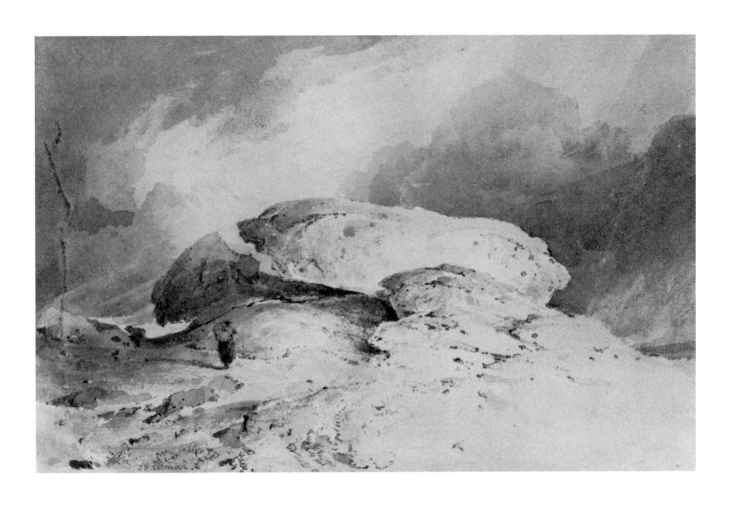

JOHN MARTIN

**English
1789-1854**

THE DESTRUCTION OF SODOM

1833

Sepia wash over pencil on cream wove paper, mounted on paper

3⅜ x 5⁷⁄₁₆ in. (86 x 138 mm)

Signed and dated, l.r.: *J•M•1833*

Exhibitions: New York, The Alan Gallery, "Sculpture, Drawings, Watercolors, Prints of Three Centuries," 1962, no. 20 repr.

References: "Acquisitions July 1, 1961–June 30, 1964," *UMMA Bulletin*, 1966-67, 47

Provenance: The Alan Gallery, New York

Gift of the estate of Marion Lehr Simpson 1962/1.117

John Martin was involved in a number of projects for Bible illustrations in the 1830s. The first, an independent venture (1831 to 1835) for which Martin himself served as printer and publisher, was not a success. More favorably received was his *Illustrations of the Bible*, to which he and Richard Westall (1765-1836) jointly provided ninety-six designs (1834-35). *The Destruction of Sodom* was the thirteenth illustration in the book, which in fact only contained Old Testament scenes. Both Westall and Martin received ten guineas per design. William Bagg, who drew Westall's and Martin's compositions onto the woodblock, earned five guineas per illustration, and the engravers – W.H. Powis, John Jackson, Mosses and others – averaged twelve guineas

per design. The outlay of over £2700, before the publisher, Edward Churton, met the costs of such items as paper and printing, made the project an expensive undertaking (Thomas Balston, *John Martin 1789-1854: His Life and Works*, London, 1947, pp. 151-52; 287, 289-90).

To prepare for the publication of Churton's book, Martin made seventy-two sepia drawings, many of which are extant (William Feaver, *The Art of John Martin*, Oxford, 1975, p. 137). The ink studies were then redrawn onto smaller blocks (Fig. 4a) by John Bagg (Balston, *op. cit.*, p. 152). It is a tribute to Martin's artistic genius that the spatial depth, atmospheric clarity and compositional complexity of *The Destruction of Sodom* lost none of its theatricality on this minute scale.

Martin, who was famous for his spectacular scenes of tragedy and cataclysm, depicted Lot, Lot's wife and his daughters in *The Destruction of Sodom*. The Lord, angered by the corruption of the denizens of Sodom and Gomorrah, rains hellfire and brimstone on Sodom, but allows Lot's family to escape His wrath. Lot's wife, against Divine interdiction, looks backwards towards the doomed city, and is turned into a pillar of salt (Genesis 19: 15-26).

Illustrations of the Bible maintained its popularity into the Victorian era. The book was a particular favorite with the Rossettis, who admired Martin's powerful invention (*ibid.*, p. 153).

Michigan's collection also includes a watercolor by John Martin, *Cephalus and Procris*, 1821 (1962/1.118).

HF

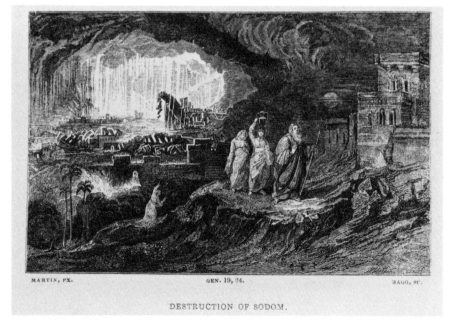

MARTIN, PX. GEN. 19, 24. BAGG, SC.

DESTRUCTION OF SODOM.

Fig. 4a William Bagg after J. Martin, *The Destruction of Sodom*, ca. 1833-35, wood engraving (63 x 98 mm). From *Illustrations of the Bible*, by Westall and Martin, with descriptions by the Rev. Hobart Caunter, London, 1835.

5

THÉODORE GERICAULT

French
1791-1824

STUDIES OF GROOMS
RESTRAINING HORSES

PALEFRENIER ROMAIN
ARRÊTANT UN CHEVAL
(Recto);
JEUNE HOMME AU TORSE
NU RETENANT UN
CHEVAL (Verso)

Ca. 1817

Pencil on off-white wove paper

6⅜ x 8¼ in. (163 x 211 mm)

Exhibitions: London, Hazlitt,
Gooden & Fox Ltd., "Nineteenth-
Century French Drawings," 1980,
7, no. 14, pls. 14, 15

References: New York, Pierpont
Morgan Library, "Master Draw-
ings by Gericault," 1985-86, no.
29a repr. (not in exhibition)

Provenance: purchased from
Hazlitt, Gooden & Fox Ltd.,
London

Gift of Mary and Millard Pryor

1984/1.286

This double-sided sheet depicts two scenes from the Barberi horse race that Gericault attended during his trip to Rome in 1816-17. The celebrated spectacle of riderless horses, held during the last days before Lent each year, took place along the Corso, between the Piazza del Popolo and the Piazza del Palazzo de Venezia. It was one of the chief events of the Carnival, and Gericault was fascinated by the fiery-tempered horses and the efforts of their grooms to restrain them. Gericault had been uncertain as to which aspect of the event to portray: the start with its spirited, lunging horses; the race itself; or the finish. Paintings in the Louvre, the Walters Art Gallery, and elsewhere represent the climax of the struggle between man and beast (see Paris, Grand Palais, "French Painting 1774-1830: The Age of Revolution," 1975, pp. 449-50, no. 76). Scores of preparatory drawings, depicting both the start and conclusion of the race, exist in a variety of media. The Museum of Art's drawing is an outstanding example of Gericault's reductive process: recto and verso are monumental compositions rendered with bold, sweeping strokes, distilling the energy of the struggle to a play between force and counterforce. Costumes are simplified, figures are minimized, backgrounds are omitted. The recto is controlled and taut in its balanced composition, while the verso (also depicting the race's finish) is more explosive and baroque in form.

Gericault's skill at capturing the most fleeting and transitory of poses is clearly evident in the recto drawing of a groom endeavoring to restrain a horse by its bridle in order to arrest its forward momentum at the end of the race. Philippe Grunchec relates the recto to a work in ink in a private collection (Fig. 5a), in which the central motif of the groom and horse is reversed and incorporated into a larger composition of men catching their steeds (see above, Pierpont Morgan Library, "Master Drawings by Gericault,"). A similar compositional drawing features the group on the verso, again in reverse (see C. Clément, *Gericault*, intro. by L. Eitner, Paris, 1973, reprint of 1879, pl. VIII) which is often the case in Gericault's drawings. Another study of two grooms trying to restrain a horse, a reversed design of the recto of the Museum of Art's drawing, is closest to it in composition (Fig. 5b; see Musée des Beaux-Arts et d'Archéologie de Besançon, "Autour de David et Delacroix: Dessins français du dix-neuvième siècle," 1982-83, no. 86 repr.). In the Michigan sheet Gericault has isolated one element, creating an image of such sculptural strength and heroic proportions that the drawing takes on some of the characteristics of antique bas-relief.

The hind quarters and legs of the horse on the recto are lightly indicated while sharp, sure contours delineate the horse's neck and head. The man, drawn with fluid lines, his costume only barely indicated, braces himself with his right leg against the surging movement of the horse. Here the similarities to the larger grouping end. In the ink drawing the groom stretches upward to catch the bridle while the startled horse throws its head backward in protest. While both drawings are pyramidal in design, their effect is quite different. Instead of dissipating the force of the horse and groom upward, the energy of the Museum's drawing is concentrated, like a coiled spring. The horse's arched neck, with its streaming mane, is perfectly counterbalanced by the bowed back of the groom. Connected to one another by the figure's left arm, all other elements of the drawing are subordinated to this match of forces, including the horse's ears and the man's soft cap.

Gericault's love of horses, a legacy which he left to his student, Delacroix, first attracted him to the Barberi race. This exquisite study from the series of works reveals, in its balance and grandeur, his sympathy with the art of antique.
CM

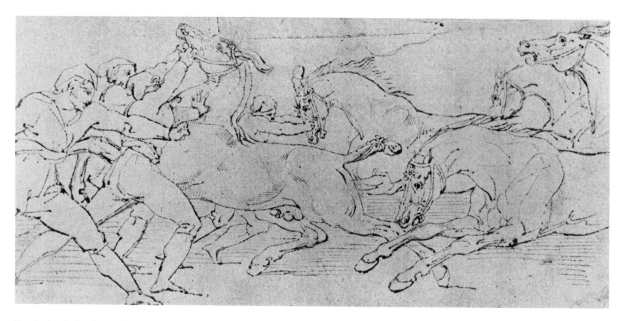

Fig. 5a *Study for the Barberi Race*, pen and brown ink (150 x 320 mm), private collection, Paris.

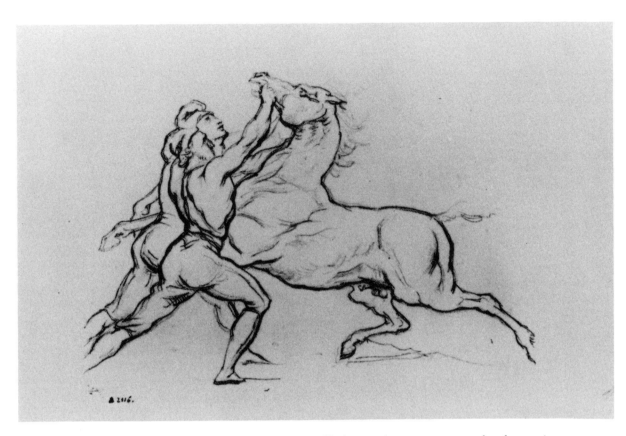

Fig. 5b *Barberi Horse Held by Two Grooms before the Race (Cheval barbe avant la course retenu par deux hommes)*, crayon on transparent paper (170 x 240 mm), Besançon, Musée des Beaux-Arts et d'Archéologie (Inv. D 2116).

6

JULIEN-LÉOPOLD BOILLY

French
1796-1874

PORTRAIT OF A LADY, POSSIBLY MADAME BOILLY (NÉE ADÉLAÏDE LEDUC)

1814

Black chalk, heightened with white and red chalk, on brown wove paper

8½ x 7⅛ in. (216 x 188 mm)

Signed and dated l.l.: *J. Boilly fils / 1814*

Exhibitions: Ann Arbor, The University of Michigan Museum of Art, "The Museum Collects," 1972

References: "Acquisitions July 1, 1971–June 30, 1976," *UMMA Bulletin*, 1976-77, 32, 29 repr.

Provenance: Mrs. Reba H. Rubin, New York; purchased from the Schaeffer Galleries, Inc., New York

1972/2.375

Julien-Léopold (Jules) Boilly was the eldest of the three artistic sons of the portrait and genre painter Louis-Léopold Boilly (1761-1845) and his second wife Adélaïde-Françoise-Julie Leduc (1778-1819). Although he was not as gifted as his father, Julien-Léopold gained considerable success during his long career as a painter, lithographer, and engraver, most particularly for his prints after the oils of Pierre-Paul Prud'hon. J.-L. Boilly studied under his father and the Baron Gros, entered the École des Beaux-Arts in 1814 (the year of the Michigan drawing), and earned acclaim at the Paris Salons where he exhibited well into the nineteenth century.

The Museum of Art's drawing traditionally has been identified as Adélaïde Leduc, J.-L. Boilly's mother, whom L.-L. Boilly married in 1795. She was the daughter of Pierre-François Leduc and Françoise-Joséphe-Julie Carton, who had wed in Paris in 1771. The identification of the Michigan portrait is reasonable, for the sitter's age corresponds roughly to that of the thirty-six-year-old Mme Boilly in 1814. Furthermore, there is some similarity between this representation and other portraits of Adélaïde Boilly, including an oil by her husband in the Musée Municipal des Beaux-Arts, Quimper and a drawing in the Musée des Beaux-Arts, Orléans [on L.-L. Boilly's marriage see Henry Harrisse, *Louis-Léopold Boilly: Sa vie et son oeuvre*, Paris, 1898, p. 17 and Paul Marmottan *Le Peintre Louis Boilly (1761-1845)*, Paris, 1913, p. 261].

J.-L. Boilly's signature is curious, as it is unusual to find an artist with a different Christian name than his father using the term *"fils."* One might surmise that the eighteen-year-old Julien-Léopold Boilly, ready to enter the École des Beaux-Arts, was deliberately asserting his independence from his well-known father, yet maintaining his associations with his gifted and successful family. The drawing is remarkable as an early work, especially in its treatment of light and in the rendering of textures.
HF

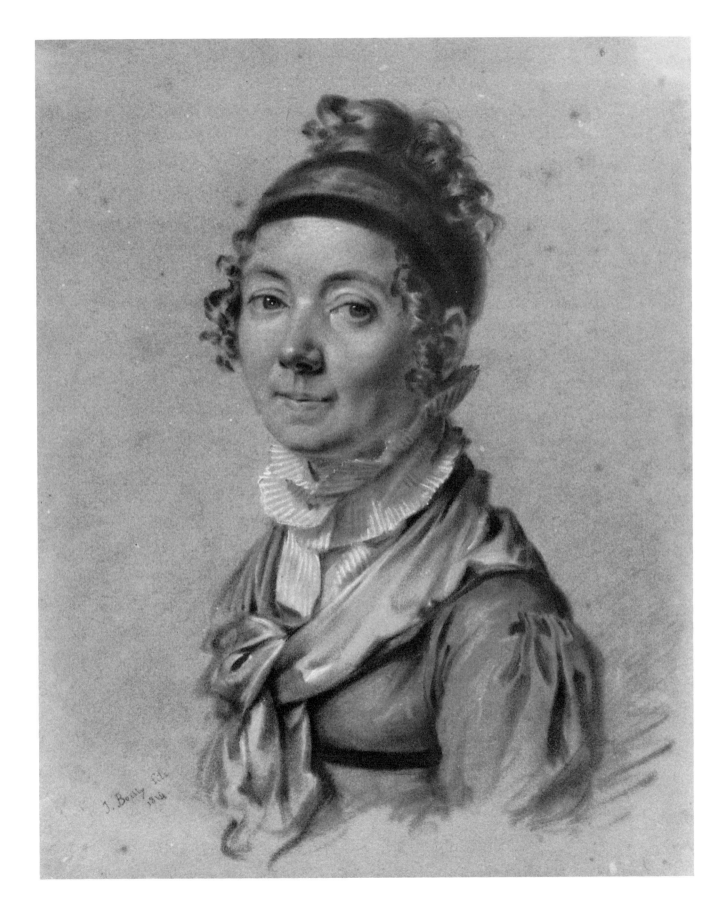

JEAN-BAPTISTE CAMILLE COROT

French
1796-1875

LANDSCAPE STUDIES, ITALY (ÉTUDE DE TERRAINS, ITALIE) (Double-sided drawing)

1826-28

Pencil on white wove paper

8¼ x 12⅞ in. (211 x 232 mm)

Stamped in brownish-red (Lugt 460a), l.l.: *VENTE / COROT*

Exhibitions: Utica, Munson-Williams-Proctor Institute, "Masters of Landscape: East and West," (traveled to: The Memorial Art Gallery of the University of Rochester), 1963, no. 45, 50 repr.

References: Alfred Robaut, *L'Oeuvre de Corot: Catalogue raisonné et illustré*, IV, Paris, 1905, 12, no. 2500; *Handbook* 1962, no. 30 repr.; "Acquisitions July 1, 1961–June 30, 1964," *UMMA Bulletin*, 1965-66, 40; *Eighty Works ... A Handbook* 1979, no. 55 repr.

Provenance: collection of the artist (Lugt 460a); collection of A. Robaut (?); purchased ca. 1956 from the Thiollier Collection, St. Etienne, by Bernard Lorenceau, Paris, purchased from him by Charles E. Slatkin Galleries, New York

1959/1.162

*I*n 1825 Corot made the first of three trips to Italy, sojourns that provided him with inspiration and a poetic vocabulary that lasted the rest of his life. This fresh sketch dates from his first trip. Struck by the clarity of Italian light, Corot painted some of the famous monuments of Rome, such as the Colosseum, but preferred to sketch the sun-drenched environs of the Roman Campagna. Jacquelynn Baas Slee (see above, *Eighty Works ... A Handbook* 1979), mentions Corot's relationship in these early landscapes to the architectonic styles of Poussin and Cézanne.

This sketch of the Italian countryside exemplifies Corot's early classicizing style. Observed from a high vantage point, the landscape is modelled by light. Volumes are created by long, cast shadows on the rocky terrain, indicated by parallel diagonal and vertical hatchings. Areas of darkness and light are sensitively balanced, giving the drawing a faceted, almost cubist structure, yet this study is pervaded by the evocative lyricism that became a hallmark of Corot's oeuvre.
CM

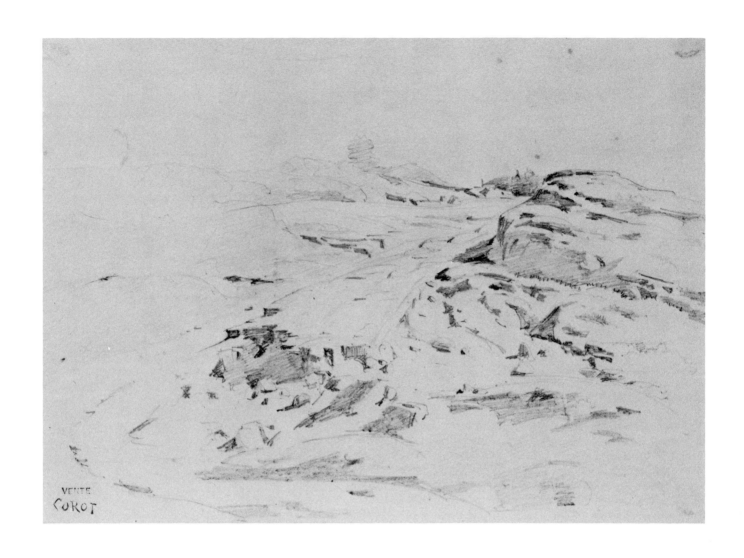

8

EUGÈNE DELACROIX

French
1798-1863

LION ATTACKING A HORSE
(Recto);
STUDY OF A SEATED
WOMAN IN A LANDSCAPE
(Verso)

Ca. 1830

**Recto: pen and brown ink, gray
wash on off-white wove paper**

Verso: pen and wash

Watermark: C WISE / 1829

6⅜ x 5⅝ in. (161 x 144 mm)

Printed verso, at right: *Paris, le 183*

Exhibitions: Fine Arts Gallery of
San Diego, "The Horse in Art,"
1963, no. 49, cover repr.; Iowa
City 1964, no. 97; Albuquerque,
University of New Mexico, Uni-
versity Art Museum, "The Animal
Kingdom: An Exhibition for Young
People," 1968, no. 15; Ann Arbor,
The University of Michigan
Museum of Art, "Homage to Arn-
heim: Principles of Art and Visual
Perception," 1985

References: *Handbook* 1962, nos.
3l, 3la reprs.; "Acquisitions Janu-
ary l, l957–June 30, 1961,"
UMMA Bulletin, 1965-66, 40

Provenance: collection of Paul
Gachet, Auvers-sur-Oise (?); Wil-
denstein & Co., Inc., New York

1958/2.71

One recurring theme in
the art of Eugène Dela-
croix is that of creatures
engaged in combat. Com-
ing to this motif from his study of
works by Rubens, much of Dela-
croix's imagery includes depictions
of lion hunts, and lions and other
large cats attacking men and
horses. Delacroix has long been
associated with images of felines,
and the Michigan sheet joins two
symbols of strength and grace in a
dramatic image of struggle.

The central grouping of the
horse with the lion astride his back
rises in a series of ascending curves
and countercurves. Rearing in an
effort to dislodge the lion, the
horse twists its neck and torso
away from the attacker. As with
many of Delacroix's images, preda-
tor and prey are inextricably woven
into a single mass of writhing
fury. To either side of the central
pair are additional figures of fallen
and struggling horses.

With its tight, spiraling compo-
sition, the Michigan drawing is
similar to a sheet in the Louvre
(Fig. 8a). More explosive in compo-
sition than the Louvre drawing, the
Museum's of Art's work has
greater emphasis on movement
and is more dramatic in concep-
tion. Delacroix uses gray wash to
indicate the streaming mane of the
lion and the arched tail of the
horse, as well as to make adjust-
ments in the positions of the fore-
legs and head of the horse, giving
the work a sense of energy.

The drawing on the verso, a
study of a woman in a landscape, is
possibly a preparatory sketch for a
larger composition. Delacroix con-
centrates on the bather, with par-
ticular focus on her bent head.
Placed in a shallow, undefined fore-
ground, the model is shown in a
simple shift removing her stock-
ings. A few brief lines at her feet
suggest the shore of a river or lake,
and the landscape opens at the left
into a deep space, with indications
of another figure among the rocks.

The verso of the Michigan draw-
ing has a printed heading with a
date, suggesting that the sheet may
have come from a diary or a jour-
nal. This, along with the date of
1829 in the paper's watermark,
would place the work around
1830. The Louvre sheet, similar in
technique and subject matter, is
presently dated 1826-30. Based on
the evidence of the Museum of
Art's drawing, it seems likely that
1830 is a *terminus post quem* for
both works.
CM

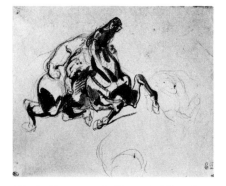

Fig. 8a *Horse Attacked by a Cat (Cheval
attaqué par un félin)*, ca. 1826-30, pen and
brown ink and pencil (162 x 205 mm),
Musée du Louvre, Cabinet des dessins (RF
9688).

EUGÈNE DELACROIX

STUDY FOR "CICERO ACCUSING VERRES"

1844-47

Pencil on off-white laid paper

Watermark: shield with illegible interlocking letters, surmounted by laurel wreath, surrounded by leaved branches

9⅝ x 14⅞ in. (246 x 379 mm)

Inscribed at top: *[...] loque brulee [...] par [...] rouge / un teinte loque brulée et blanc et tres peu rouge vandyk / clairs rehaussés rouge vandyk et très peu de vermillon*

Stamped in red (Lugt 838), l.l.: *E.D*

Exhibitions: Ann Arbor, The University of Michigan Museum of Art, "A Connoisseur's Choice: Selections from the Collection of Paul L. Grigaut," 1969, no. 82

References: "Acquisitions July 1, 1968–June 30, 1970," *UMMA Bulletin*, 1970-71, 69

Provenance: estate of the artist (Lugt 838); collection of Paul Leroy Grigaut

The Paul Leroy Grigaut Memorial Collection

1969/2.43

In addition to easel paintings, Delacroix received important commissions to decorate churches and government buildings throughout Paris. Between 1844 and 1847 he worked on the decorations for the Library of the Chambre des Députés in the Palais Bourbon, a project involving paintings for two hemicycles and five cupolas. The drawing in the Museum of Art is a study for the cupola representing Legislation, and in this scene, *Cicero Accusing Verres*, the famous Roman orator is shown publically exposing Verres's corruption and extortion.

The composition of the Michigan sheet remains essentially unchanged in the final painting, and in the margins of the drawing Delacroix worked out the details of the figures' poses and accessories, such as the stool. Related drawings for this pendentive are in the Louvre, and one design also includes in the right margin the depiction of a woman's head (Fig. 9a; see Louvre, Cabinet des Dessins, *Inventaire général des dessins école française, Dessins d'Eugène Delacroix 1798-1863*, I, Paris, 1984, p. 161, nos. 293-95). The man bearing the jar at the right of the pendentive is visible in two places in the Michigan drawing, and is also the subject, in reverse, of a drawing in the Louvre (Fig. 9b). The inscription at the top of the page, although only partly legible, indicates the artist's thoughts on the colors to be used in the final painting.

This drawing, a late working sketch for an important project, is quite different in subject and treatment than the freer and more intimate double-sided sheet in the collection (8). These two drawings, together with an oil sketch for *Lycurgus Consulting the Pythia* (1968/2.75), also for the cupola of legislation in the Library of the Chambre des Députés, constitute a small but interesting selection of Delacroix's works.

CM

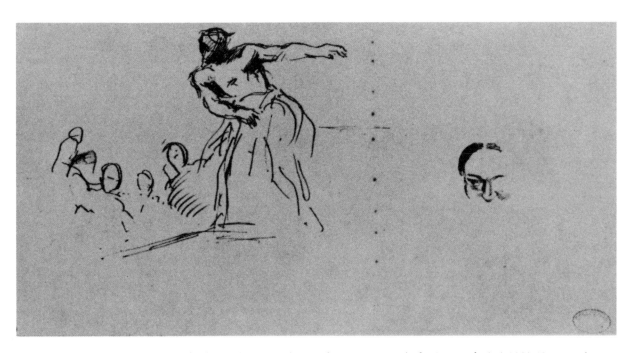

Fig. 9a *Man Addressing a Crowd; Study of a Head (Homme demi-nu haranguant une foule; Croquis de tête)*, 1838-40, pen and brown ink (147 x 282 mm), Musée du Louvre, Cabinet des dessins (RF 22965).

Fig. 9b *Study of a Man Carrying a Jar (Étude d'homme portant une jarre)*, pen and brown ink (79 x 36 mm), Musée du Louvre, Cabinet des dessins (RF 9940).

ALEXANDRE-GABRIEL DECAMPS

French
1803-1860

BATTLE OF SAMSON
AGAINST THE PHILISTINES

Ca. 1839

Black chalk and watercolor
heightened with white on tan wove
paper, mounted on cardboard

8 ¹³⁄₁₆ x 12 ⁹⁄₁₆ in. (223 x 318 mm)

Signed l.r.: *DC.*

Inscribed with stylus, l.r.: *camps*

References: "Acquisitions July
1981–December 1982," *UMMA
Bulletin*, 1983-84, 76, 75 repr.

Provenance: Hector Brame and
Jean Lorenceau, Paris

Gift of Mr. and Mrs. Charles H.
Sawyer through the Friends of
the Museum

1982/1.262

In 1839 Alexandre-Gabriel Decamps exhibited a painting entitled *Samson Combatting the Philistines* at the Paris Salon (see Dewey F. Mosby, *Alexandre-Gabriel Decamps 1803-1860*, New York and London, 1977, p. 645, no. 517). It depicted an episode from Judges 15:9-20, in which the Nazarene Samson, in self-exile after his betrayal by the Philistines, allows the men of Judah, who had been conquered by the Philistines, to return him to their mutual enemy. When the Philistines arrive to claim their prize prisoner, the bound and infuriated Samson breaks his restraints and slays the hordes with the jawbone of an ass, the only accessible weapon.

Because the Salon picture has been owned by private collectors since the nineteenth century, and has not been photographed, the work is better known through the numerous published drawings and prints of the composition. It is difficult to establish the exact chronology and interrelationship of the drawings and prints because Decamps often repeated his successful designs. The Michigan drawing is highly finished, however, and may have been executed after the Salon painting of 1839, and might possibly have been drawn preparatory to the print made by Desmadryl and Berthoud, which was published in *L'Artiste* in that year (Fig. 10a). The print features the same masses of light and dark as the drawing (particularly in the clouds, in the shadows in the fore- and middle-ground and in the

illuminated townscape in the background), and there are only small differences in their details (in the rocks in the left foreground and in the positions and costumes of the mounted horsemen). Among the other works related to the painting are the preparatory drawing in the Louvre for the work exhibited at the Salon (Fig. 10b; see Mosby, *ibid.*, p. 543, no. 299), and a lithograph of the picture by Pirodon (see Adolphe Moreau, *Decamps et son oeuvre*, Paris, 1869, p. 109, no. 71), which dates after 1863. A transfer drawing at the Spencer Museum of Art at the University of Kansas has been attributed to Decamps (Fig. 10c), and has been related to a lithograph by Challamel (Fig. 10d), but their actual image sizes differ and the lithograph reverses the original design (see Mosby, *ibid.*, pp. 298-99, no. 214; and Moreau, *ibid.*, pp. 108-109, no. 70).

Owing probably to the success of the *Samson* of 1839, Decamps drew a series of nine designs based on the legend, which he exhibited at the Salon of 1845 (see Mosby, *ibid.*, pp. 190ff; and Moreau, *ibid.*, p. 138). Lithographs of six of nine compositions were later produced by Eugene LeRoux.

A reduced study for Decamps's important battle scene *The Defeat of the Cimbri (La Défaite des Cimbres)*, 1833, shown at the Salon in 1834 and now in the Louvre (see Mosby, *ibid.*, pp. 529-30, no. 280), is also in the collection of The University of Michigan Museum of Art (1969/2.94).
HF

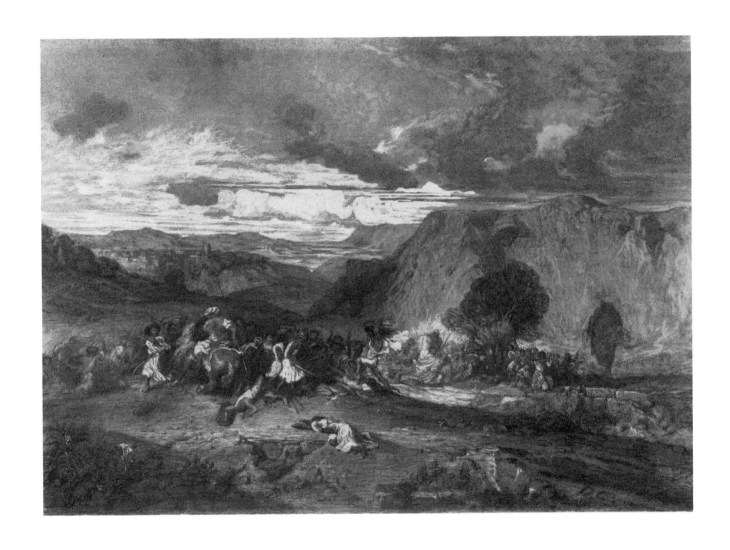

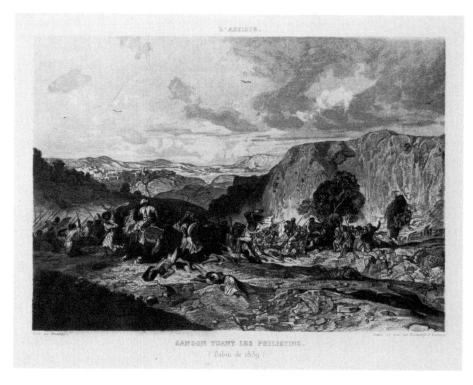

Fig. 10a Desmadryl and Berthoud after A.- G. Decamps, *Samson Slaying the Philistines (Samson tuant les Philistins)*, 1839, steel engraving (156 x 231 mm), from *L'Artiste*, 1839.

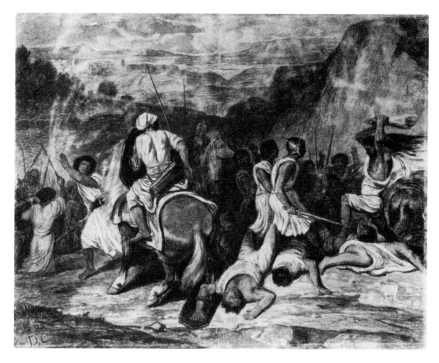

Fig. 10b *The Battle of Samson (La Bataille de Samson)*, black chalk and charcoal (500 x 652 mm), Musée du Louvre, Cabinet des dessins (RF 1683).

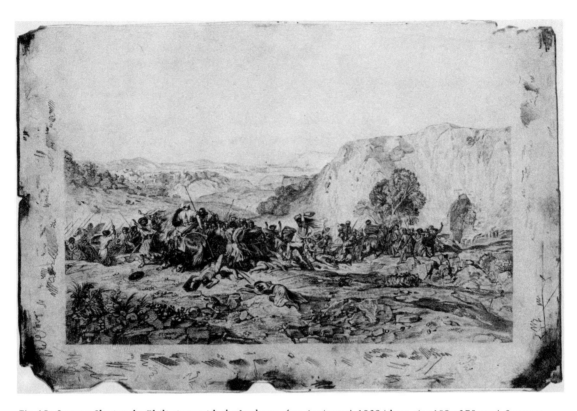

Fig. 10c *Samson Slaying the Philistines with the Jawbone of an Ass* (verso), 1839 (sheet size 180 x 275 mm), Spencer Museum of Art (68.17a).

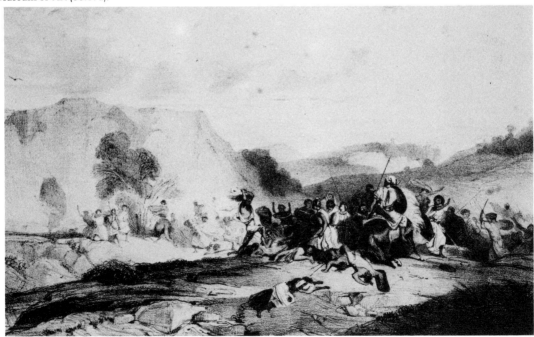

Fig. 10d Jules Robert Challamel after A.-G. Decamps, *Samson Slaying the Philistines (Samson tiré de la caverne du Rocher d'Etame)*, lithograph (sheet size 234 x 316 mm), Spencer Museum of Art (68.17b).

EUGÈNE DEVÉRIA

French
1805-1865

PORTRAIT OF HENRI HERZ

1832

Watercolor and ink over pencil on off-white wove paper

Watermark: J WHATMAN

19¹¹⁄₁₆ x 15½ in. (500 x 400 mm)

Signed and dated l.l.: *Eug. Devéria / 1832.*

Exhibitions: Ann Arbor, The University of Michigan Museum of Art, "French Watercolors 1760-1860," 1965, no. 45 front. repr.; Ann Arbor, The University of Michigan Museum of Art, "A Connoisseur's Choice: Selections from the Collection of Paul L. Grigaut," 1969, no. 50; Ann Arbor 1984

References: "Acquisitions July 1, 1968–June 30, 1970," *UMMA Bulletin*, 1970-71, 67, 51 repr.

Fig. 11a Achille Devéria, *Portrait of the Pianist, Henri Herz*, 1832, lithograph (383 x 293 mm), The University of Michigan Museum of Art (1956/1.55).

Provenance: collection of Paul Leroy Grigaut

The Paul Leroy Grigaut Memorial Collection

1969/2.81

Achille Devéria (1800-57) and his younger brother Eugène were the fourth and fifth children of a government official from Montpellier and his wife. Their sister Laure was also an artist. Although their reputations are overshadowed by that of the promethean Delacroix, both Achille and Eugène were important personalities in the Romantic Movement. Achille earned renown as a graphic artist for his book illustrations and lithographic portraits.

The brothers drew numerous portraits of important contemporary individuals in the world of arts and *belles lettres*. One prominent figure in musical circles was Henri Herz (1806-88), a Viennese-born pianist and composer, whose brother Jacques Simon Herz (1794-1880) was also a talented musician. The precocious younger Herz was admitted to the Paris Conservatory while still in his teens. He traveled throughout Europe giving concerts, with journeys to Germany in 1831 and England in 1833 and 1843, and he even toured North and South America for six years, from 1845 to 1851. In 1842 he was named professor of the pianoforte of the women's class at the Conservatory, and he taught there until he resigned over thirty years later.

Herz was famous as a virtuoso performer, and while his exercises and studies are still valued as instructional tools, his original compositions are now viewed as mediocre. (Herz, moreover, was also a maker of pianos, whose instruments stood comparison with those of Erard and Pleyel.)

Eugène Devéria has presented the composer Herz in 1832, at the height of his fame. A contemporary musicologist described the composer Herz as: "...of the Israelite type; a prominent forehead, aquiline nose; wide-eyed and alert, indicating lucidity and benevolence. His mouth is accentuated with full lips and a rounded chin...His height is above the average...." (A. Marmontel, *Les Pianistes célèbres*, second ed., Tours, 1887, p. 43). The richness of the room, the quality of the furniture, its upholstery, the wallpaper and wallhangings, carvings, the fine piano and the costume and demeanor of the sitter all attest to Herz's material success.

The Michigan watercolor was probably the source for Achille Devéria's lithograph of the sitter, which also dates from 1832 (Fig. 11a). In the print Herz is represented in three-quarter length, holding a handkerchief and wearing a cravat and suit nearly identical to that of the watercolor. Another print of Herz, designed by Devéria, and engraved by Fauchery, depicts Herz at the piano, surrounded by a group of women (H. Beraldi, *Les Graveurs du XIXᵉ siècle*, VI, Paris, 1887, p. 95, no. 4). *HF*

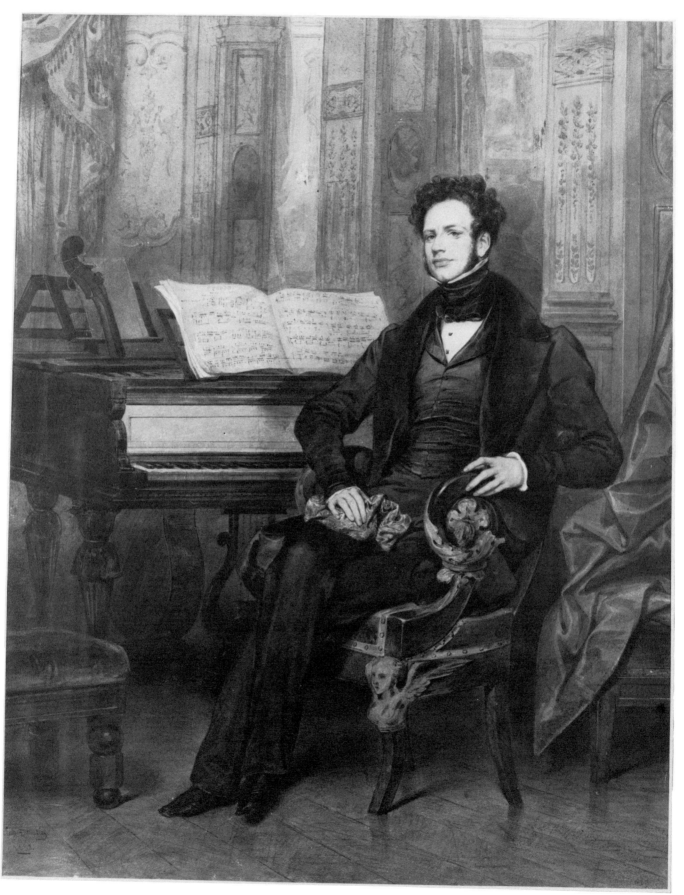

12

WILHELM VON KAULBACH

German
1805-1874

FAMILY PORTRAIT

1834

Pencil on off-white wove paper

25 x 19⅝ in. (637 x 500 mm)

Signed, dated, and inscribed, l.l.: *W. Kaulbach im July / 1834*

Exhibitions: Iowa City 1964, no. 101; South Hadley, Dwight Art Memorial (organized by The Mount Holyoke Friends of Art), "The Legacy of David and Ingres to Nineteenth-Century Art," 1966, no. 27 repr.

References: "College Museum Notes: Acquisitions, 1800 to Present," *Art Journal*, XX, 2, Winter 1960-61, 100; *Handbook* 1962, no. 32 repr.; "Acquisitions January 1, 1957–June 30, 1961," *UMMA Bulletin*, 1965-66, 42

Provenance: purchased on 16 June 1960 from L'Art Ancien, Zurich, through Klipstein & Kornfeld, Bern, lot 132 repr.

1960/2.82

Of all the pupils of the Nazarene artist Peter Cornelius, none was as famous or as facile as Wilhelm von Kaulbach. Kaulbach, a member of a prominent artistic family, received important commissions by the age of twenty-one, and throughout his successful career he was continually showered with royal patronage, receiving requests for decorations from the Duke Maximilian, Count Raczynski, Friedrich Wilhelm IV, and Ludwig I of Bavaria, whom he served as court painter. Kaulbach was equally adept at working on a small scale; he excelled not only in the illustration of literary works by Schiller, Goethe, and Shakespeare, but also in the more intimate genre of fairy tales and fables.

If the academically correct, dispassionate Kaulbach icily emerges in his large scale projects, then his more penetrating powers of observation are present in his domestic portraiture. The sitters in the Michigan sheet are not known (although the woman bears a resemblance to the artist's mother), but clearly a rapport exists among the individuals and the artist. The eldest child, an attractive adolescent girl bearing a flower, stands at the pinnacle of a compact triangle that includes the stern but protective mother, whose arm enfolds the youngest child (who also holds a blossom). At the left of this tightly-knit group, a rather independent-looking lad glances up from his book, his slight turn away from the other figures complementing his older sister's outstretched arm.

Drawn the year before Kaulbach traveled to Italy, the twenty-nine-year-old artist had already assimilated the style of Cornelius and the clarity of Nazarene art. In its way, *Family Portrait* is a fine example of the pervasive influence of the international linear classicism espoused not only by German artists active in Rome in the first quarter of the nineteenth century, but also by Ingres, the consummate master of the portrait in pencil.

HF

13

THÉODORE ROUSSEAU

**French
1812-1867**

**LANDSCAPE WITH FIGURES
(Recto);
STUDY OF TREES;
LANDSCAPE (Verso)**

1828-32

**Recto: brush and ink on beige
wove paper**

Verso: pencil

7 x 9⅛ in. (177 x 233 mm)

Estate stamp (Lugt 2436), l.r.c.:
TH•R

Collector's stamp (Lugt 1170), l.r.:
G.L.

Exhibitions: Maryland 1977-78,
no. 140, 55 repr.

References: "Acquisitions July 1,
1968–June 30, 1970," *UMMA
Bulletin*, 1970-71, 69

Provenance: estate of the artist
(Lugt 2436); collection of Dr. G.L.
Laporte, New York (Lugt 1170);
collection of Paul Leroy Grigaut

The Paul Leroy Grigaut Memorial
Collection

1969/2.100

*T*his dramatic wash drawing is an excellent example of Rousseau's early style. Dated circa 1828-32 by John Wisdom (letter in object file, 7 April 1977), this study, possibly influenced by Paul Huet, exhibits the passion and intensity of Rousseau's youthful work. The figures are placed in an exuberantly rendered landscape composed of rocky hillside, writhing foliage, dark shadows, and a leaden sky. Brushwork is widely varied and tonal contrasts are created by areas of untouched paper juxtaposed with passages of deep shadow. The scene verges on the theatrical, with the players (possibly in costume) striding across a stage with a well-lit foreground, before the windswept and stormy terrain. Rousseau's romantic, byronic *Landscape with Figures*, drawn while he was still in his late teens, is an energetic work exploding with youthful virtuosity. Its mood stands in marked contrast to the Museum of Art's more pastoral drawing by Rousseau, *In the Fields* (14).
CM

14

THÉODORE ROUSSEAU

IN THE FIELDS (LA HAYURE)

Mid-to late-1840s

Black and white chalk on brown wove paper

8½ x 14½ in. (217 x 368 mm)

Estate stamp (Lugt 2436), l.l.: *TH·R*

Collector's stamp (Lugt 1170), l.r.: *G.L.*

Exhibitions: Ann Arbor, The University of Michigan Museum of Art, "A Connoisseur's Choice: Selections from the Collection of Paul L. Grigaut," 1969, no. 78; Ann Arbor, The University of Michigan Museum of Art, "Drawings and Watercolors: English and French Landscapes," 1977

Reference: "Acquisitions July 1, 1968–June 30, 1970," *UMMA Bulletin*, 1970-71, 69

Provenance: estate of the artist (Lugt 2436); collection of Dr. G.L. Laporte, New York (Lugt 1170); collection of Paul Leroy Grigaut

Gift of Mr. and Mrs. William L. Hays for the Paul Leroy Grigaut Memorial Collection

1969/2.161

By the 1840s Rousseau's landscape drawings had shifted from the wildly romantic depictions of his youth (13), to scenes of a more gentle and humble type. In 1836 he established a studio in the village of Barbizon at the edge the Forest of Fontainebleau. Forsaking tempestuous views, he chose instead to concentrate his efforts on the flat country around Barbizon and the plain of Chailly, and on the Berri region and Bordeaux. Although far less dramatic in conception than his earlier work, this study displays a sense of loneliness, with its isolated figure set against a panoramic view of an agrarian landscape. The simple design, divided roughly into three horizontal bands – foreground, figure with hedges and fence, and sky – is typical of Rousseau's compositions of the 1840s. His light touch, full of subtle modulation, and his focus on a rustic subject, show Rousseau's affinity with artists such as Constable.

This work dates from the second half of the 1840s (letter from John Wisdom in object file, 7 April 1977), and is similar to a drawing entitled *Landscape Sketch* in the Snite Museum of Art at the University of Notre Dame.
CM

15

JEAN-FRANÇOIS MILLET

French
1814-1875

THE MENDICANT (LA CHARITÉ; LE VIEUX MENDICANT)

Ca. 1857-58

Black chalk on off-white paper

15⅛ x 17½ in. (385 x 444 mm)

Signed l.r.: *J.F. Millet*

Exhibitions: Paris, Galerie Martinet, 1862; London, Durand Ruel, "Ninth Exhibition of the Society of French Artists," 1874, no. 134; London, Leicester Galleries, "Staats Forbes Collection of 100 Drawings by Jean-François Millet," 1906, no. 70 or 93; Paris, Grand Palais, "Jean François Millet," 1975-76, 137-38, no. 95 repr.; Ann Arbor, The University of Michigan Museum of Art, 'Margaret Watson Parker: A Collector's Legacy," 1982, 21, no. 6 repr.

References: Charles Holme, *Corot and Millet, The Studio*, Special no., Winter 1902, M13 repr.; Julia Cartwright, "The Drawings of Jean-François Millet in the Collection of the late Mr. James Staats Forbes: Part III," *The Burlington Magazine*, VI, December 1904, 198, 203, 199 repr.; Léonce Bénédite, *Les Dessins de J.F. Millet*, Paris, 1906, pl. 45; Étienne Moreau-Nélaton, *Millet raconté par lui-même*, II, Paris, 1921, 46-48, 113-14, 121, fig. 126; Helen B. Hall,

"Two Millet Drawings," *UMMA Bulletin*, 1956, 37-39, fig. 27; Andre Fermigier, *Jean-François Millet*, Geneva, 1977, 66 repr.

Provenance: collection of James Staats Forbes, London, by 1904; purchased in December 1919 from Scott & Fowles, New York, by Margaret Watson Parker

Bequest of Margaret Watson Parker

1955/1.107

After spending a number of years in Paris, Jean-François Millet moved in 1849 to the village of Barbizon, where he devoted his energies to the depiction of country life. Springing from well-to-do peasant stock, Millet's images of rustic labor have the same timeless and unchanging qualities as the land itself. His two chalk drawings in the Museum of Art, *The Mendicant* and *The Shepherdess* (16), possess all of the stately simplicity characteristic of his greatest works. Set in a humble interior almost totally devoid of decoration, a woman instructs her daughter to share their meal with a beggar, just visible through the doorway at the left. Drawn with a lively and descriptive line, the female figures, framed by the window on the far wall, are enveloped in a spare but cozy atmosphere, the dim luminosity of the room standing in

marked contrast to the brilliance of the sunlight falling across the doorway. Millet's ability to infuse a simple gesture of humanity and sympathy with the dignity of a homily brings his art close to that of Rembrandt, an artist he greatly admired. Millet, however, rather than focusing on the impoverished wanderer, as Rembrandt did, chose to illustrate the virtue of charity in the naive figure of the child (see above, Grand Palais, "Jean-François Millet")

In her essay on the drawing, Helen B. Hall (see above, "Two Millet Drawings") mentioned the existence of a painting commissioned by Paul Tesse after this drawing. The painting is lost, as are several related drawings, but others in the Louvre and in private collections, catalogued by Robert Herbert, are extant (see above, Grand Palais, "Jean-François Millet").

CM with HF

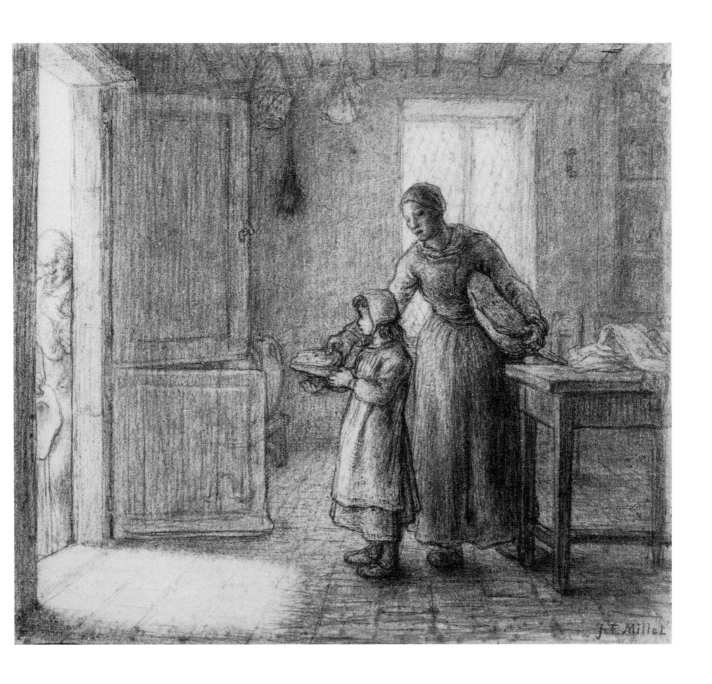

16

JEAN-FRANCOIS MILLET

THE SHEPHERDESS (LA BERGÈRE ET SES MOUTONS SUR LA LISIÈRE DANS LA FORÊT)

Ca.1857

Black chalk on off-white wove paper

12 x 15⅛ in. (307 x 384 mm)

Signed l.r.: *J.F. Millet*

Exhibitions: Flint Institute of Arts, "Masterpieces in the Midwest," 1961, no. 76; College Park, University of Maryland Art Gallery, "Hommage à Baudelaire," 1968, 35, 70 repr.; Tokyo, The Seibu Museum, "Millet, Corot and the School of Barbizon," (traveled to: Hyogo, The Museum of Modern Art; Sapporo, The Hokkaido Museum of Modern Art; Hiroshima, The Hiroshima Prefectural Museum; Kitakyushu, The Kitakyushu Municipal Museum), 1980, no. 7, 146 repr.

References: Julia Cartwright, "The Drawings of Jean-François Millet in the Collection of the late Mr. James Staats Forbes: Part II," *The Burlington Magazine*, V, May 1904, 142, 155 repr.; Léonce Bénédite, *Les Dessins de J.F. Millet*, Paris, 1906, pl. 24; Étienne Moreau-Nélaton, *Millet raconté par lui-même*, II, Paris, 1921, 37, fig. 111; Helen B. Hall, "Two Millet Drawings," *UMMA Bulletin*, 1956, 37-38, fig. 36; *Handbook 1962*, no. 36 repr.; *Eighty Works ... A Handbook* 1979, no. 58 repr.

Provenance: collection of James Staats Forbes by 1904; D. Croal Thomson (Barbizon House), London, Knoedler, London, in 1919, purchased in December 1919 from Scott & Fowles, New York, by Margaret Watson Parker

Bequest of Margaret Watson Parker

1955/1.106

*I*n February, 1862, Millet wrote to the critic Théophile Thoré that his motto was "rus" – the expression of rustic feeling in his art – and his aim was "to make things look not as though they were brought together at random...but as though they had an indispensable and necessary bond amongst themselves...." He added, "the beings I represent [should] look as though they are pledged to their positions, so that it would be impossible to imagine that they could be different; in short, that people and things must always be there for some purpose" (quoted in Linda Nochlin, ed., *Realism and Tradition in Art 1848-1900: Sources and Documents*, Englewood Cliffs, 1966, pp. 56-57).

As Joel Isaacson has pointed out, it is precisely this orderly view of man in harmony with nature that Millet presents in *The Shepherdess*:

Each figure has its role: the woman's job is to govern, the dog's to maintain order, the sheep's to freely conform. Each function is matched to appropriate form: the shepherdess straight and true, her white body placed against the aureole of the dark glade; the dog alert, nervously drawn, set dark against the light; the sheep, composed of broad, slow curves, share the contours of the terrain. Through the shadows they cast they help to model its form, and the undulating recession of the entire foreground is reiterated by the S-curve ... of the sheep, who browse on either side of the stream and meander up and back to the shepherdess. All is in sympathy (see above, *Eighty Works ... A Handbook* 1979).

Robert Herbert (letter in object file, 13 January 1986) has listed four drawings related to the design: two are in the Louvre (RF 11233 and RF 11234); a third is a study of the shepherdess with a reprise of her hand (ex-Sotheby Parke Bernet, New York, 25 June 1981, lot 175 repr.); and the last is presently on the art market.
CM with HF

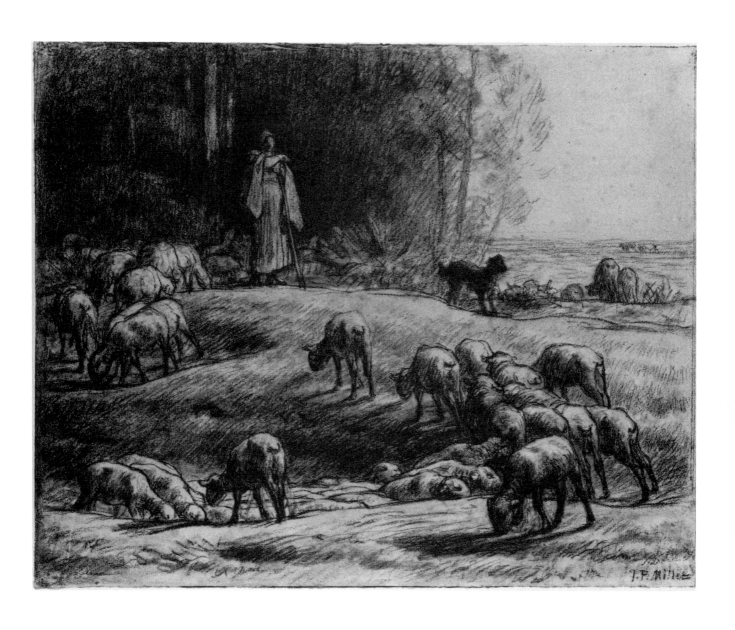

17

EUGÈNE-EMMANUEL VIOLLET-LE-DUC

**French
1814-1879**

INTERIOR OF A POMPEIIAN HOME WITH FIGURES (THE IMPLUVIUM)

1873

Grayish-brown ink and wash over pencil, with touches of red-brown wash, on off-white wove paper

8⅛ x 11⅝ in. (206 x 296 mm)

Dated, inscribed, and signed, l.r.: *1873. / Pompeii / E. Viollet le Duc.*

Inscribed on center of old mount (destroyed during restoration): *Pl. 168 [sic] / Pompei. Maison; regio VII. Insula XII. n°28 / Impluvium.*

Exhibitions: New York, Shepherd Gallery Associates, Inc., "The Non-Dissenters: Fifth Exhibition," 1976, no. 164 repr.; Ann Arbor, The University of Michigan

Museum of Art, "Pompeii as Source and Inspiration: Reflections in Eighteenth- and Nineteenth-Century Art," 1977, 22, no. 41 repr.; Ann Arbor, The University of Michigan, Harlan Hatcher Graduate Library, Rare Book Room, "Works of Viollet-le-Duc," 1979

References: Claude Sauvageot, *Viollet-le-Duc et son oeuvre illustré*, Paris, 1880, 86; "Acquisitions June 1976–July 1977," *UMMA Bulletin*, 1978, 79

Provenance: from the descendants of the artist (?), to Bruno de Bayser, Paris, to Frederick J. Cummings in the early 1970s, purchased from him in October 1975 by Shepherd Gallery Associates, Inc., New York

1976/2.20

Eugène-Emmanuel Viollet-le-Duc, whose name is synonymous with French architecture in the nineteenth century, designed modern structures and promoted the medieval and renaissance revivals that characterized the century's historical eclecticism.

Viollet visited Italy in 1836-37, 1861, 1864, 1871, and 1873. On this last journey he traveled to the southern part of the peninsula, staying in Naples and Pompeii from the fifteenth to the twenty-third of August, where he sketched furniture and domestic utensils in Neapolitan museums (see Grand Palais, "Viollet-le-Duc," 1980, p. 386; and Paris, Hôtel Sully, "Eugène Viollet-le-Duc 1814-1879," 1965, p. 239 and nos. 418, 419).

The drawing in the Museum of Art undoubtedly dates from that time and fancifully depicts the impluvium, the atrium or courtyard in a Roman home where rain water was collected. Many of Viollet's drawings were published during his lifetime, as was the Michigan sheet, illustrating his articles in the *Encyclopédie d'architecture* on the structure of Pompeiian homes (Fig. 17a; see II, 1873, pp. 129-31 and 152-55; III, 1874, pp. 33-35).

Viollet's romantic re-creation departs from archaeological exactness, and, like his architectural restoration, reflects the liberties taken by the nineteenth century in interpreting the past. Viollet's interest in domestic architecture in the mid-1870s is also seen in his book, *Histoire de l'habitation depuis les temps prehistoriques jusqu'à nos jours*, 1875 (*The Habitations of Man in All Ages*).

HF

Fig. 17a C. Sauvageot after E. Viollet-le-Duc, *Maison à Pompei–Regio VII, Insula XII, N° 28: Impluvium*, lithographic transfer [?] from engraving (image 200 x 290 mm), from *Encyclopédie d'architecture: Revue mensuelle des travaux publics et particuliers*, Paris, 1873.

18

CHARLES-FRANCOIS DAUBIGNY

**French
1817-1878**

STREET IN A VILLAGE (possibly
LE CHEMIN DES VALLÉES)
(UNE RUE D'AUVERS SUR
OISE)

Ca. 1865

**Black and red chalk on tan
wove paper**

11⅛ x 17½ in. (279 x 441 mm)

Exhibitions: Oshkosh, Paine Art
Center and Arboretum, "Charles
François Daubigny," 1964, no. 8
repr.; Ann Arbor, The University
of Michigan Museum of Art, "A
Connoisseur's Choice: Selections
from the Collection of Paul L. Gri-
gaut," 1969, no. 83

References: "Acqusitions July 1,
1968–June 30, 1970, *UMMA Bul-
letin*, 1970-71, 69, 50 repr.

Provenance: collection of Paul
Leroy Grigaut

The Paul Leroy Grigaut Memorial
Collection

1969/2.70

This simple and straight-
forward street scene is
typical of Daubigny's
interest in unspoiled
rural life. An advocate of *plein-air*
painting, Daubigny launched a
floating studio boat in 1857 in
which he traveled the Seine and
Oise Rivers. J. Bailly-Herzberg has
dated the drawing to circa 1865,
and has identified the view as that
of Auvers-sur-Oise, possibly Le
Chemin des Vallées, where Dau-
bigny resided (letter in object file,
27 April 1976).

Daubigny secured his reputation
as a graphic artist with his scenes
of the country and with reproduc-
tions of his Salon paintings, and
Street in a Village has the same
forceful composition and line
found in his numerous etchings.
He presents the thatched roofs of
the houses as a series of firmly
drawn diagonals, while the build-
ings' end walls, bathed in sunlight,
are conveyed by untouched areas
of the paper. This architectonic
construction, alternating areas of
light and shadow, creates convinc-
ing depth, while the wall and trees
at the left side of the sheet are more
softly rendered. Daubigny fre-
quently employed this pronounced
X-shaped composition, juxtaposing
areas of hard and soft textures.
CM

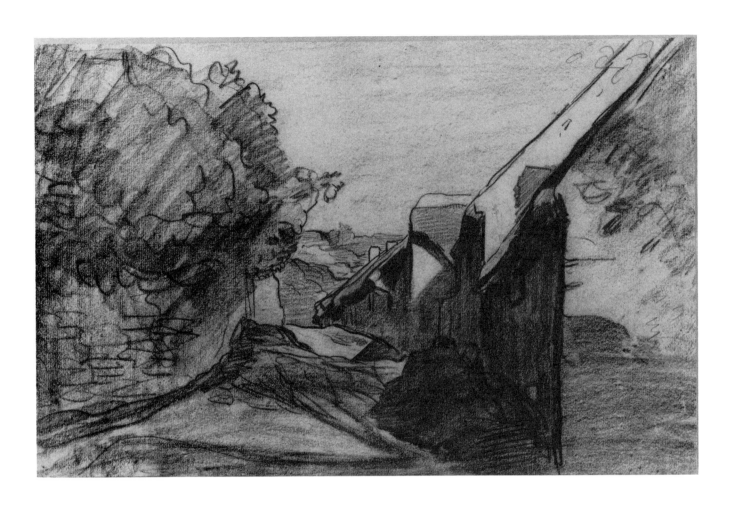

19

HENRI-JOSEPH HARPIGNIES

French
1819-1916

LE CANNET (UN TORRENT
AU CANNET)

1896

Watercolor on white wove paper

6¾ x 9¾ in. (173 x 248 mm)

Signed and dated l.r.: *h. harpignies
96. fec / . Cannet.*

Inscribed in pencil, verso, top: *un
Torrent au Cannet*

References: "Acquisitions July 1,
1961–June 30, 1964," *UMMA
Bulletin,* 1966-67, 43

Provenance: collection of Charles
Russell; sold 19 June 1963 at Sotheby & Co., London, lot 4; purchased by P. & D. Colnaghi & Co.,
Ltd., London

1963/2.19

*H*arpignies was a great admirer of Corot (7), and this charming watercolor of a stream and bridge in the countryside of southern France is evidence of the influence of the structure and palette of Corot's lyrical landscapes. Like Corot before him, Harpignies constructed his views with particular attention to planar recession, building his design in a series of tonal washes that are unified spatially through the S-curve of the meandering torrent. Harpignies used the white paper as part of his composition, especially in the highlights in the rapids and in the distant buildings. Le Cannet, located slightly inland on the Côte d'Azur just east of Cannes, may have reminded Harpignies of Italy, where he had traveled in 1851 and 1863-65.

CM

20

JOHAN BARTHOLD JONGKIND

**Dutch
1819-1891**

**DELIVERY OF WORKS TO THE
SALON OF 1874**

1874

**Pencil on grayish-green paper,
mounted on heavy paper**

9⁷⁄₁₆ x 16¾ in. (240 x 425 mm)

Signed, dated, and inscribed, l.l.:
Jongkind l'envoi au salon 1874

Reference: John Rewald, *The
History of Impressionism*, fourth
ed., rev., Greenwich, 1973, 7 repr.

Provenance: Galerie Robert
Schmit, Paris, collection of John
Rewald

Gift of John Rewald

1983/2.200

Before the twentieth century, the Paris Salon provided the most conspicuous and important opportunity for the public to view the works of living artists. Acceptance by the Salon jury promoted careers; rejection stalled or destroyed them. Although exhibition dates varied, submissions were due ten days before the opening, and were brought to the Louvre in all types of vehicles, including carriages, carts and wheelbarrows. Hundreds of hopeful entrants contributed thousands of works to the selection committee, resulting in enormous traffic jams in front of the august building. Artists, art admirers, and passersby mingled before the entrance and watched the spectacle, which, like the exhibition itself, was one of the highlights of the Paris season (see Jacques Lethève, *Daily Life of of French Artists in the Nineteenth Century*, trans. by Hilary Paddon, New York and Washington, 1968, pp. 108-28).

Jongkind's direct observation of the scene, with his loose handling and rapid execution, suggests the clatter of the coaches and the crowds and the confusion of the porters and the painters as they struggle to bring their submissions to the galleries. The depiction is worthy of a Victorian narrative artist: at the left, a little boy (possibly a pickpocket ?) tugs on a gentleman's coat. Numerous groups of figures converse, such as the artist (recognizable by his attire) and the top-hatted man at the right. Another man shouts orders from a platform or window at the right edge of the composition. The throng presses towards the Louvre as paintings large and small are presented at its portals.

Jongkind enjoyed a moderately successful but erratic career as a landscape and marine painter, exhibiting periodically at the Salons from about 1850. He is known today for his *plein-air* sketches and paintings of France and Holland, and for his relationship with Monet and the Impressionists. Ironically, when the Salon opened its doors to the public on 1 May 1874, Jongkind was not an exhibitor, nor did he contribute that spring to the independent, rival exhibition of the Impressionists. In fact, after rejection by the jury at the Salon of 1873, Jongkind decided never to participate again in official exhibitions. Nevertheless, his years of familiarity with the annual event are readily apparent in this study, which captures all the sights and sounds of the frenetic day of delivery to the Salon.
HF

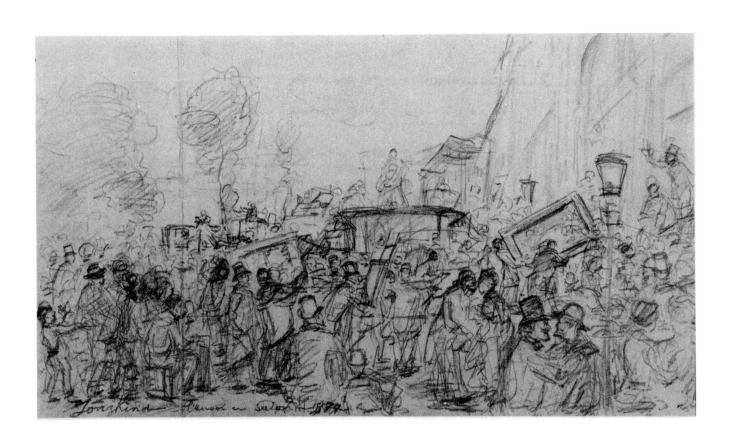

Jongkind — Renvoi au Salon — 1873

21

ALFRED STEVENS

Belgian
1823-1906

MALE NUDE

1844

Charcoal and stump on beige wove
paper, mounted on paper

23⅝ x 13¹³⁄₁₆ in. (600 x 351 mm)

Dated in pencil, l.r.: *1844 16 mars*

Inscribed in ink, on old tag,
formerly on mount: *D'après nature
Ecole des Beaux arts 1844 /
concours d'admission reçu 42ᵐᵉ / AS*

Exhibitions: Ann Arbor 1982-83

Reference: "Acquisitions July 1,
1981–December 1982," *UMMA
Bulletin*, 1983-84, 77

Provenance: purchased from a pri-
vate dealer in Paris by Lisa Schiller,
New York, purchased from her by
William A. Coles, Boston

1982/2.43

Drawing from the nude
has constituted the
foundation of academic
art education from the
time of the Renaissance. In the
nineteenth century, prior to gain-
ing entrance to the École des
Beaux-Arts – the prestigious art
school for gifted pupils – a student
had to submit to rigorous training.
Tutelage usually began in a private
school supervised by an artist affil-
iated with the art establishment.
The instructor himself had been
educated by the proper teachers
and by the École, and had earned a
degree of success at the Salons or
through official patronage. Within
the French academic system, paint-
ing was not taught (pupils learned
this craft from teachers outside the

École). Rather, emphasis was
placed on drawing, first from
engravings, then from casts after
antique sculpture, and finally from
the model. The study of the nude
constituted the basis of this curric-
ulum, the ultimate aim of which
was to promote the painting of his-
torical, literary, and mythological
subjects, since heroic deeds and
their moral messages embodied the
highest ideals of humankind to the
academic mind (see Albert Boime's
essays in University Art Gallery,
State University of New York at
Binghamton, "Strictly Academic:
Life Drawing in the Nineteenth
Century," 1974; and Hempstead,
New York, The Emily Lowe Gal-
lery, Hofstra University, "Art
Pompier: Anti-Impressionism,"
1974).

The Belgian-born Stevens began
his training in the atelier of Cam-
ille Roqueplan (1803-55), a suc-
cessful Romantic painter who had
been a pupil of the Baron Gros.
There Stevens drew numerous
académies – studies from the nude
– including the works at The Uni-
versity of Michigan Museum of
Art, dated 16 March 1844, and
another, from a different model,
dated 10 February 1844, now in
the Sterling and Francine Clark Art
Institute, Williamstown (Fig. 21a).
While there is no reason to doubt
the authenticity of the inscription
on the drawing's original mount
(in object file), Stevens's name, in
fact, does not appear in the regis-
ters of the École in 1844, and it is
questionable if he was ever its "of-
ficial" pupil (letter from Philippe
Grunchec in object file, 11 Septem-
ber 1985). It is more likely that the
inscription was added by Stevens
later in life, perhaps when his
memory was less keen, and that
the drawing was actually executed
in Roqueplan's studio. The inscrip-
tion from the old mat belonging to

the Williamstown study corrobor-
ates this supposition, as it reads:
*"d'après nature, Atelier Roqueplan
1844."* One can surmise that the
contest to which Stevens referred
was actually staged in Roqueplan's
atelier for the recommendation to
gain entrance to the École des
Beaux-Arts, rather than for a con-
test administered within the
École itself.

Whatever its ultimate origin, the
Michigan drawing demonstrates
the twenty-one-year-old artist's
attempt to realize the structure of
the human body through its tonal
modulation. Light falls from the
left onto the front of the model,
presented in profile. The model
assumes the stance of an orator or
preacher, and may at one point
have held a staff. His pose and the
line of his profile are accentuated
by the shadow which starts at the
top of his head, and runs on the
vertical through his neck, shoulder,
arm, torso and legs, and ends at his
right heel. The lighting emphasizes
the flatness of his stark silhouette,
and this outline, in turn, is further
underscored by the model's
shadow on the floor and by the
two-dimensional, abstract arc
which indicates the ground plane.

Stevens achieved renown for
painting beautiful women in ele-
gant interiors, such as *Hide and
Seek* in Michigan's collection
(1955/1.85). He also continued to
draw the male figure, in works
such as his study of Victor Hugo
for *The Panorama of the Century
(Le Panorama du siècle;* Fig. 21b).
Studies such as the Michigan *Male
Nude* served as the basis for his
accomplishments as a figural artist.
HF

82

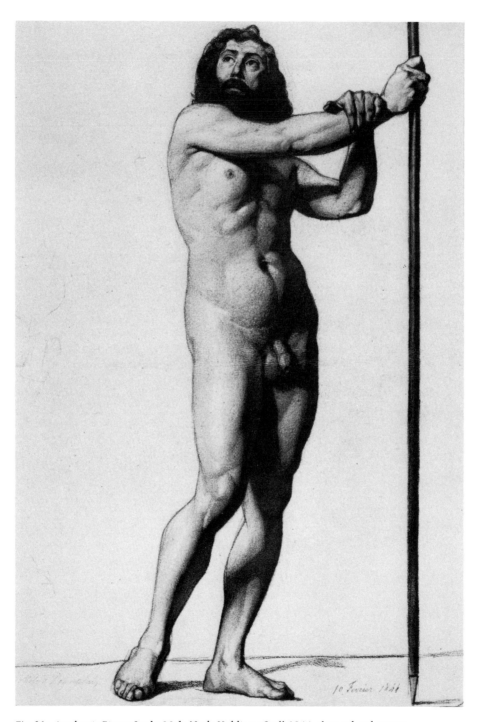

Fig. 21a *Academic Figure Study: Male Nude Holding a Staff*, 1844, charcoal and stump
(583 x 299 mm), Sterling and Francine Clark Art Institute, Williamstown, Massachusetts (1982.36).

Fig. 21b *Study of Victor Hugo for "The Panorama of the Century" (La Panorama du siècle)*, ca. 1889, pencil on paper (322 x 245 mm), The University of Michigan Museum of Art, gift of Peter Heydon (1984/1.280).

22

FREDERIC, LORD LEIGHTON

English
1830-1896

STUDY FOR "THE DANCE"

Ca. 1883

Black and white chalk on brown
wove paper

9⅜ x 12⁹⁄₁₆ in. (237 x 317 mm)

Inscribed in pencil, l.r.: *Projects*

Blind estate stamp (Lugt 1741a), l.l.:
LLC

Exhibitions: London, Christopher
Wood Gallery, "Nineteenth-Century English Watercolours and
Drawings," 1981, no. 51, pl. 3l (incorrect technique and medium);
Ann Arbor 1984

References: "Acquisitions July
1981–December 1982," *UMMA
Bulletin*, 1983-84, 77

Provenance: estate of the artist
(Lugt 1741a), to the Fine Art Society, London, 1896; Julian Hartnoll,
London

1981/2.131

*L*eighton received several requests from private patrons in the mid-1880s to paint decorative projects. J. Stewart Hodgson, one of his most avid collectors and supporters, commissioned two friezes of *The Dance* and *Music* for his drawing room at 1, South Audley Street. Preparatory to painting these oils of *The Dance* (Figs. 22a, b) and *Music* (Leighton House), exhibited at the Royal Academy in 1883 and 1885, Leighton drew dozens of figure and drapery studies, as was his practice. Many of them are in the collection of Leighton House.

In this remarkably fresh sheet for *The Dance*, Leighton drew the statuesque figures for the opposite ends of the design, which serve as its compositional parentheses. The two leftmost figures in the Michigan drawing are sketches for the tambourine player at the right of the oil (for which Leighton ultimately chose the pose of the model at the left of the study). The two figures at the right of the drawing appear at the left of the painting, although in the final work, the woman at the right of the study is enlarged, and placed behind the tambourine player with the outstretched, upraised arms.

The solid placement of the figures in space, and their convincing volume, give testimony to Leighton's talents as a painter and a sculptor. Moreover, the study beautifully illustrates Leighton's technique as a draughtsman and his intellectual method. His investigation into and experimentation with the positions of compositionally-related figures, demonstrate his overriding concern with the process of making art and with pictorial construction.

HF

Fig. 22a *The Dance* (left half), ca. 1881-83, oil on canvas (entire composition, 88.9 x 530.8 cm), Leighton House, London.

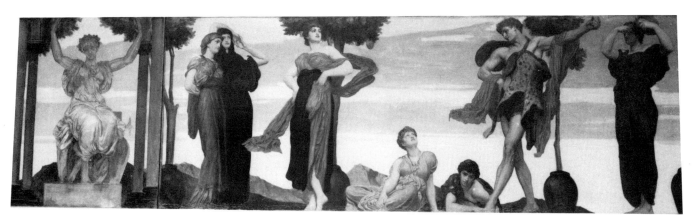

Fig. 22b *The Dance* (right half), ca. 1881-83, oil on canvas (entire composition, 88.9 x 530.8 cm), Leighton House, London.

23

CAMILLE PISSARRO

**French
1830-1903**

**STUDIES OF A PEASANT
DIGGING (ÉTUDES D'UN
PAYSAN BÉCHANT)**

**Pencil on greenish-yellow
wove paper**

8⅛ x 4¾ in. (208 x 119 mm)

Inscribed l.r.: *O.C.P.(B)IIia5*

**Stamped in dark gray
[Lugt 613a (?)], l.r.:** *C.P.*

References: "Acquisitions July 1,
1961-June 30, 1964," *UMMA Bulletin*, 1966–67, 47

Provenance: collection of the artist;
Orovida Pissarro; Craddock &
Barnard, London; collection of J.
Reiss, sold 19 June 1963 at Sotheby & Co., London, lot 119, purchased by P. & D. Colnaghi & Co.,
Ltd., London

1963/2.21

*A*mong the Impressionists, Pissarro was most closely allied by temperament to Millet (*15, 16*), and the sheet in the Museum of Art comprising a series of studies of a man with a shovel shows the influence of Millet's imagery of peasants and labor and his method as a draughtsman. In his essay on Pissarro's drawings, Christopher Lloyd discusses Pissarro's process (London, Hayward Gallery, "Camille Pissarro: 1830-1903," 1980-81, pp. 157-58). Shown from behind, these sketches of a laborer with a short-handled shovel reveal Pissarro's interest in conveying the physicality of the task; the figure strains as he throws his weight into his work. After exploring the pose and its variations, rendering the figure with an active, nervous line, Pissarro chose to concentrate on one of the versions at the center left of the sheet. Faint preliminary lines were reworked with firmer strokes and the shadow on the man's right leg was strengthened. The sketch may have served as a source for a pose to be used either in a painting or a print.

The Museum of Art has in its collection another pencil drawing by Pissarro, *Children Conversing (Enfants Causant,* 1963/2.20).
CM

GUSTAVE DORÉ

**French
1832-1883**

**RIVER VALLEY IN THE
VOSGES (?)**

Watercolor on white paper

13¾ x 20⅞ in (356 x 531 mm)

**Stamped in red, in oval (not in
Lugt), l.r.:** *ATELIER / G^{ve} Doré*

Exhibitions: Maryland 1977-78,
113, no. 48, 28 repr.

References: "Acquisitions July 1,
1971–June 30, 1976," *UMMA
Bulletin*, 1976-77, 17

Provenance: purchased from the
Swetzoff Gallery, Boston, by Leon-
ard Baskin, purchased from him by
R.M. Light & Co., Boston

1972/1.159

Composed of transparent layers of colored washes, this striking watercolor by the painter and printmaker Gustave Doré is a tour-de-force example of its technique. Doré used layers of washes like colored veils to indicate the rocks and boulders along the river and the pine trees behind the crevice of the river bed. He has also left portions of the paper untouched to indicate the cows pastured at the upper left, and to suggest the foam of the spray from the water in the foreground. Traditionally, the site has been identified as the Vosges mountains in Doré's native Alsace, yet whatever the site, the work displays Doré's marvelous control over this stubborn medium. His considerable talent eventually led to his membership in 1878 in the Société des Aquarellistes.
CM

SIR EDWARD BURNE-JONES

English
1833-1898

DORIGEN OF BRETAIGNE LONGING FOR THE SAFE RETURN OF HER HUSBAND

Ca. 1870

Pencil on off-white wove paper

14¾ x 20 in. (375 x 507 mm)

Inscribed, verso bottom: *Dorigen cursing the rocks, (in Chaucers Canterbury Tales) / A Study by Edward Burne-Jones for his water colour picture in the Ionides bequest V.+ A. Museum (mainly for the drapery) / given to me soon after 1870 TM Rooke.*

Exhibitions: London, Alpine Club Gallery, "Old Master Drawings," 1966, no. 48 repr.; Providence, Brown University, Bell Gallery, List Art Center, "Ladies of Shalott: A Victorian Masterpiece and its Contexts," 1985, no. 8 repr.

References: "College Museum Notes: Acquisitions, 1800 to the Present, Drawings," *Art Journal*, XXVI, 1, Fall 1966, 60; "Acquisitions July 1, 1964–June 30 1968," *UMMA Bulletin*, 1969, 38; John F. Martin, "Sir Edward Burne-Jones and His Dorigen of Bretaigne Longing for the Safe Return of Her Husband," *UMMA Bulletin*, 1972-73, 7-18, fig. 1

Provenance: given ca. 1870 by the artist to Thomas Matthews Rooke; P. & D. Colnaghi & Co., Ltd., London

1966/2.3

Throughout his career Burne-Jones repeatedly chose the poetry of Geoffrey Chaucer, especially the *Canterbury Tales*, for his subjects. *Dorigen of Bretaigne Longing for the Safe Return of her Husband* is based on a story recounted in "The Franklin's Tale." The fair Dorigen, wed to the chivalrous knight Arveragus, is left alone when he journeys to England to fight for glory and honor. Arveragus's extended absence, and Dorigen's unnatural fear of the treacherous shoreline he will encounter on his return, cast her into a deep depression. Enter Aurelius, who has long loved Dorigen, and she half-heartedly promises herself to him if he can remove the rocks. Aurelius commissions a magician in Orléans to cast a spell, deceiving the Breton population into believing that the craggy peaks have disappeared. Aurelius comes to claim Dorigen and discovers that Arveragus has returned. Living by his code and Dorigen's word, Arveragus gives his wife to Aurelius, but Aurelius releases Dorigen, allowing her to rejoin her adoring husband. The magician, hearing of Aurelius's magnanimity, frees Aurelius from his indebtedness to him.

The drawing is a study for a gouache of the same title, dated 1871, in the Victoria and Albert Museum (Fig. 25a). The inscription on the verso suggests that the drawing was undertaken as a drapery study, and was given by Burne-Jones to Thomas Matthews Rooke (1842-1942), his studio assistant and friend.

Burne-Jones conveyed the desperation of Dorigen and her feelings of hopelessness through the shallowness and compressive space of her cell-like room. Even her view from the peculiarly low and narrow window is literally blocked by the horizon of foreboding rocks. As a tale of unrequited love and duty, *Dorigen of Bretaigne* offers aspects of the romantic and the supernatural, which obsessed Burne-Jones and other second-generation artists of the Pre-Raphaelite movement.

HF

Fig. 25a *Dorigen of Bretaigne Longing for the Safe Return of her Husband*, 1871, gouache (267 x 374 mm), Victoria and Albert Museum, London.

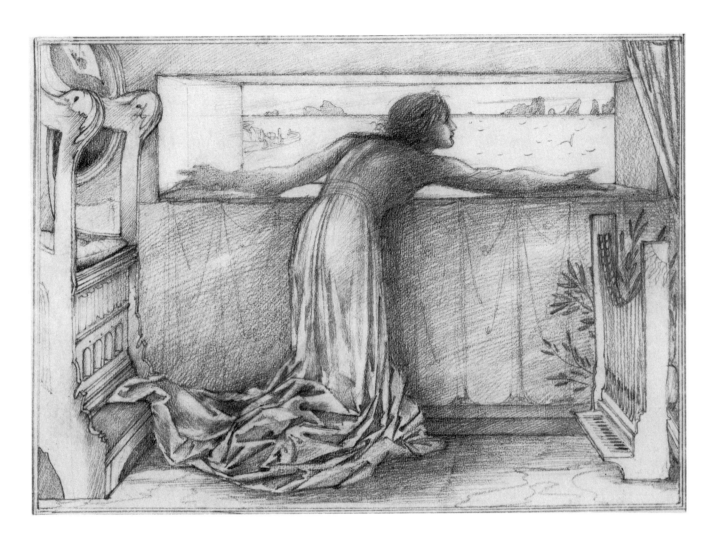

26

SIR EDWARD BURNE-JONES

STUDY FOR ANDROMEDA IN "THE DOOM FULFILLED"

Ca. 1875

Pencil on off-white wove paper

10 1/16 x 7 1/4 in. (253 x 182 mm)

Exhibitions: Saginaw 1954; Indianapolis, Herron Museum of Art, "The Pre-Raphaelites: A Loan Exhibition of Paintings and Drawings by Members of the Pre-Raphaelite Brotherhood and their Associates" (traveled to: New York, Gallery of Modern Art, Including The Huntington Hartford Collection),1964, no. 20 repr.; Ann Arbor 1982-83

References: Helen B. Hall, "Several English Water Colors and Drawings," *UMMA Bulletin*, 1952, 13-14; Martin Harrison and Bill Waters, *Burne-Jones*, New York, 1973, 193

Provenance: collection of the artist, sold 5 June 1919 at Christie's, London, possibly lot 45; collection of Col. Robert Adeane, Babraham Hall, Cambridge, sold 13 May 1949 at Christie's, London, lot 26 or 29, bought by P. & D. Colnaghi & Co., Ltd., London

1951/2.37

*L*ike the drawings by Delacroix (9), Lord Leighton (22) and Albert Moore (34) in the collection, Burne-Jones's *Study for Andromeda in "The Doom Fulfilled"* is a preparatory work for a decorative project. Arthur James Balfour, later Prime Minister and first Earl of Balfour, commissioned Burne-Jones in 1875 to paint a series of designs of his choice for his drawing-room at 4, Carlton Gardens. Burne-Jones selected the subject of the Perseus legend, for which he drew and painted innumerable works until his death in 1898. (See Kurt Löcher, *Der Perseus-Zyklus von Edward Burne-Jones*, Stuttgart, 1973, especially pp. 105-106). The Michigan drawing is related to the ninth picture of the group, *The Doom Fulfilled*, 1888 (Fig. 26a, Stuttgart, Staatsgalerie), in which Perseus frees the captive Andromeda.

Burne-Jones considered his drawings as precious and significant as his large, finished oils. The careful process by which he constructed his paintings is apparent from the number of extant, full-length sketches of Andromeda for *The Doom Fulfilled*. These works, which date from about 1875-85 and were probably studied from the model, include a sheet in a sketchbook in the Fitzwilliam Museum (Fig. 26b) and drawings in the Tate Gallery (Fig. 26c) and the British Museum (Fig. 26d).
HF

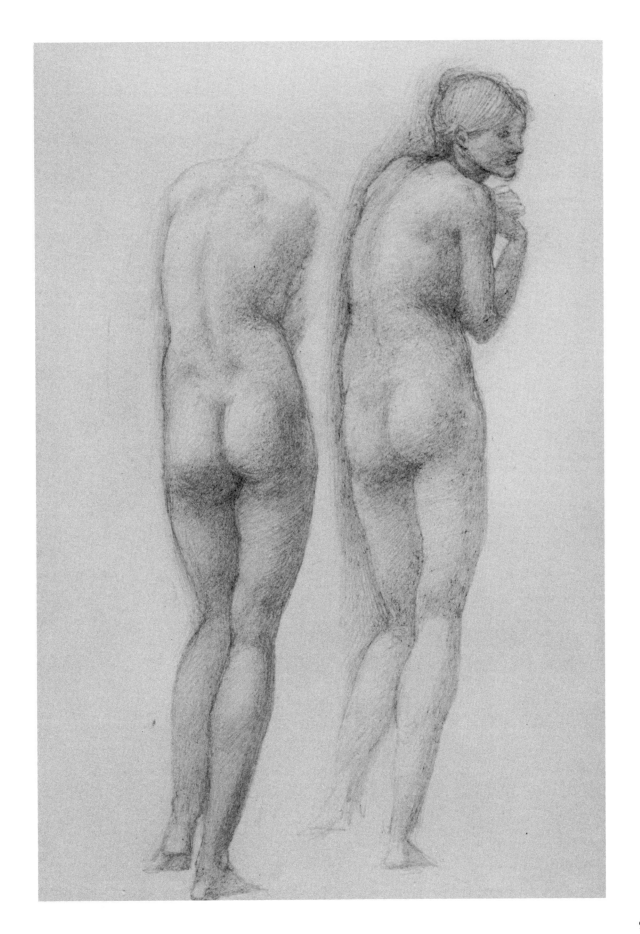

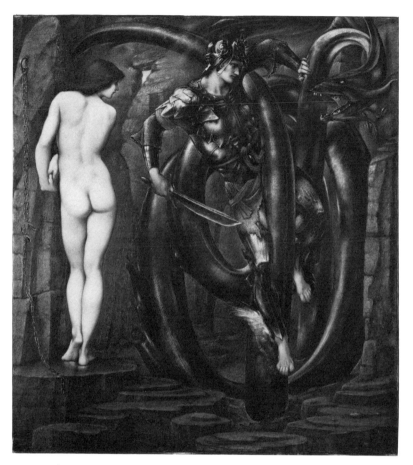

Fig. 26a *The Doom Fulfilled (Der Erfüllung der Schicksals)*, 1888, oil on canvas (755 x 740.5 cm), Staatsgalerie, Stuttgart.

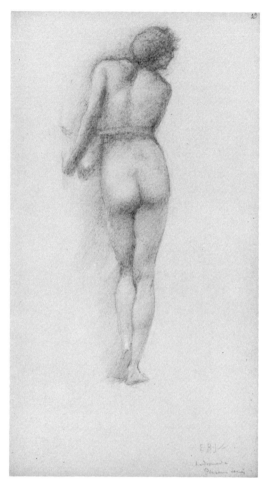

Fig. 26b *Andromeda*, pencil on paper (268 x 149 mm), sketchbook no. 1991b, p. 23 recto, Fitzwilliam Museum, Cambridge.

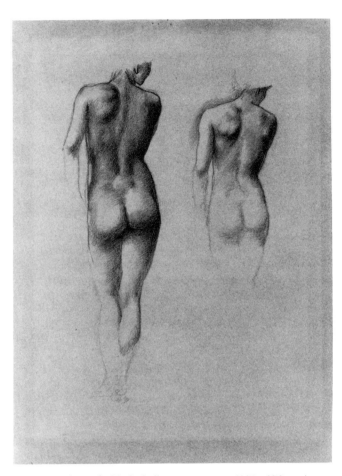

Fig. 26c *Andromeda*, black chalk on green paper (381 x 279 mm), The Tate Gallery, London.

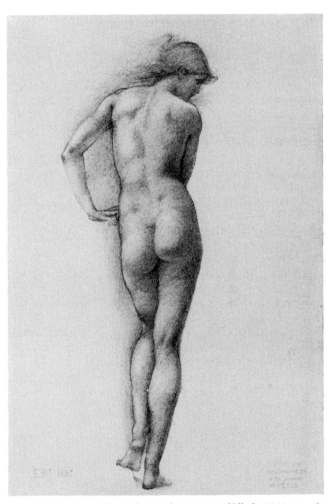

Fig. 26d *Study for Andromeda in "The Doom Fulfilled,"* 1885, pencil (272 x 182 mm), reproduced by courtesy of the Trustees of the British Museum, London.

JAMES McNEILL WHISTLER

American
1834-1903

**LADY WITH FAN (Recto);
STANDING WOMAN (Verso)**

Early 1870s

**Recto: black and white chalk on
brown wove paper**

Verso: black chalk

8¼ x 5⅛ in. (210 x 130 mm)

Signed with butterfly, c.r.

Exhibitions: Iowa City 1964, no.
113; Battle Creek, Civic Art Center, "Early American Art," 1965;
The Art Institute of Chicago,
"James McNeill Whistler," (traveled to: Utica, Munson-Williams-
Proctor Institute), 1968, no. 79, 37
repr.; Omaha, Joslyn Art Museum,
"Mary Cassatt Among the Impressionists," 1969, no. 49; 55 repr.;
Berlin, Staatliche Museen Preussischer Kulturbesitz, Nationalgalerie, "James McNeill Whistler
(1834-1903)," 1969, no. 70, 51
repr.; Ann Arbor, The University
of Michigan Museum of Art,
"Whistler: The Later Years," 1978,
no. 76 (cat. ms.); Ann Arbor, The
University of Michigan Museum
of Art, "Margaret Watson Parker:
A Collector's Legacy," 1982, no.
13 repr.; New York, M. Knoedler
& Co., Inc., "Notes, Harmonies &
Nocturnes: Small Works by James
McNeill Whistler," 1984, no.
31 repr.

References: Herbert Barrows,
"Four Works by Whistler,"
UMMA Bulletin, 1956, 31, fig. 20;
Handbook 1962, no. 37 repr.;
Washington, D.C., Freer Gallery of
Art, Smithsonian Institution,
"James McNeill Whistler at the
Freer Gallery of Art," 1984, 253,
no. 236 (not in exhibition)

Provenance: purchased in December 1905 from Obach & Co., London, by Margaret Watson (Parker)

Bequest of Margaret Watson
Parker, through Dr. Walter R.
Parker

1954/1.266

*I*n the mid-1950s, with the
bequest of Margaret Watson Parker and her husband Dr. Walter R. Parker
of Grosse Pointe, the Museum of
Art received the spectacular gift of
several hundred objects of Asian,
European and American Art. Like
the great collection formed by Mrs.
Parker's friend, Charles Lang Freer,
the Parker gift was dazzling in its
Whistler holdings, which included
a major oil, several marvelous drawings and watercolors, and hundreds of excellent prints in a
variety of graphic techniques.
Thanks to this donation, the University of Michigan Museum of Art
has one of the finest collections of
Whistler's works in North America.

David Park Curry (see above,
Freer Gallery, "James McNeill
Whistler...") and Nesta Spink (see
above, The University of Michigan
Museum of Art, "Whistler: The
Later Years"), have noted that *Lady
with a Fan* was drawn in the early
1870s, while Whistler was working on a portrait of Mrs. Leyland,
the wife of his most famous patron.
The sitter in this drawing is
unknown, and could not be Mrs.
Leyland, but the same model does
appear in several drawings from
this time (see above, Freer Gallery,
"James McNeill Whistler...," p. 253,
nos. 235, 236). These drawings are
executed in black and white chalk
on brown paper, are identical in
size, and depict a full-length length
figure viewed from the back, her
body turned in motion, her face
visible in profile or *profile perdu*.
Her pose has been compared to fashion prints in illustrated ladys' magazines, which is not only in keeping
with the scale, size, and design of
the image, but also with Whistler's
concerns as an artist allied with the
Aesthetic Movement.
HF

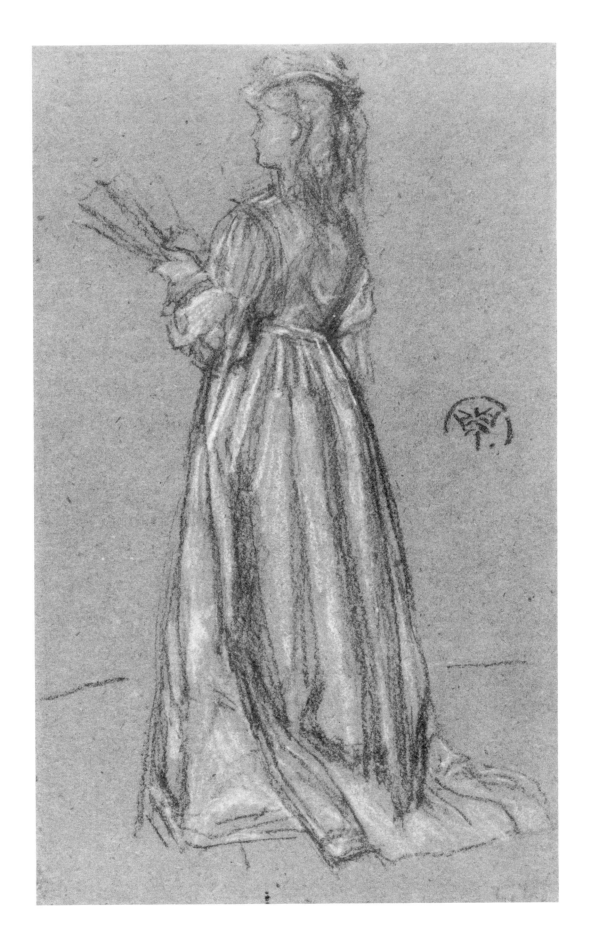

101

JAMES MCNEILL WHISTLER

STREET SCENE, PARIS [RUE LAFFITTE (?)]

Ca. 1883-85

Watercolor on brown prepared board

8½ x 5 in. (216 x 127 mm)

Signed c.r. with butterfly

Exhibitions: Battle Creek, Civic Art Center, "Early American Art," 1965; The Art Institute of Chicago, "James McNeill Whistler," (traveled to: Utica, Munson-Williams-Proctor Institute), 1968, no. 68; Berlin, Staatliche Museen, Preussischer Kulturbesitz, Nationalgalerie, "James McNeill Whistler (1834-1903)," 1969, 90, no. 94; Claremont, Montgomery Art Center, Pomona College, "Whistler: Theme and Variation," (traveled to: Sacramento, Crocker Art Gallery; Stanford University Museum of Art), 1978, no. 74; Ann Arbor, The University of Michigan Museum of Art, "Whistler: The Later Years," 1978, no. 21 (cat. ms.)

References: D. Croal Thomson, "James Abbott McNeill Whistler: Some Personal Recollections," *The Art Journal*, LXV, September 1903, 266 repr.; Herbert Barrows, "Four Works by Whistler," *UMMA Bulletin*, 1956, 28-30, fig. 19

Provenance: purchased in 1901 from Obach & Co., London, by Thomas Agnew & Sons, Ltd., London, sold in 1904 to Wallis & Sons, London; purchased in December 1906 from W. Scott & Sons, Montreal, by Margaret Watson (Parker)

Bequest of Margaret Watson Parker

1955/1.91

Although traditionally this watercolor has been titled *Rouen* and dated in the early 1890s, it appeared in the stockbooks of Thomas Agnew & Sons, Ltd. in the early years of this century as *Street Scene, Paris,* and was reproduced in *The Art Journal* in 1903 as *Rue Lafitte* [sic]. The traditional date is also in question, as the form of the butterfly signature is more typical of the years 1883-85, than a decade later. Nesta Spink (see above, The University of Michigan Museum of Art, "Whistler: The Later Years"), noted these discrepancies and suggested that the drawing could well represent a London cityscape. Actually, numerous picture dealers transacted business on or in the vicinity of the rue Laffitte, making it a spot frequented by artists, and one which Whistler might have known quite well in his time [see Jacques Hillairet (A.A. Coussillan, pseud.), *Dictionnaire historique des rues de Paris*, II, 1963, pp. 12-13].

Whatever the locale, the subject of the elevated bird's-eye viewpoint of the street parenthetically framed by buildings, the high horizon line and summarily indicated pedestrians, was a favorite motif of the Impressionists and Whistler. Rather than presenting an extensive prospect, Whistler employed transparent tones of muted, rectangular washes to suggest architectural elements and to call attention to the patterns created on the surface of his paper. Broad, flat areas of brown and gray wash establish the buildings, which are further articulated by more delicately applied touches of black, with white for the highlights. Pigment applied to the saturated paper lends the feeling of instantaneity and movement to this busy street scene, an effect not unlike contemporary photographs.
HF

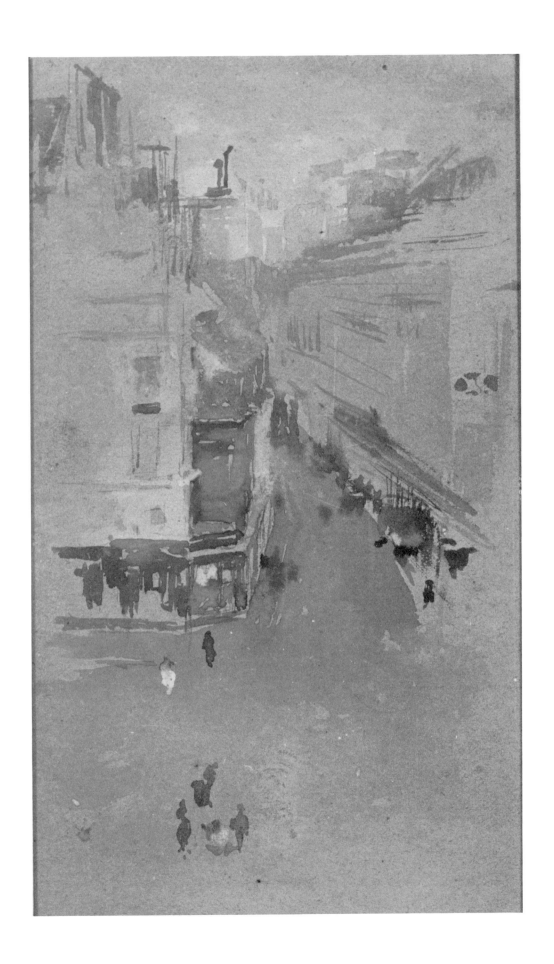

103

JAMES MCNEILL WHISTLER

**BLUE AND SILVER:
MORNING, AJACCIO** (Recto);
BUILDING WITH TREES
(Verso)

1901

**Watercolor on Japan paper,
mounted on board**

9⅞ x 5¾ in. (251 x 146 mm)

**Inscribed and signed with butterfly
on backing label:** *Blue & Silver– /
Morning. / Ajaccio.*

Exhibitions: Copley Society of Boston, Copley Hall, "Oil Paintings, Water Colors, Pastels and Drawings: Memorial Exhibition of the Works of Mr. J. McNeill Whistler," 1904, 18, no. 146; Berlin, Konigliche Academie der Künste, "Ausstellung Amerikanischer Kunst in Berlin," 1910, 80; Buffalo Fine Arts Academy, "Oils, Water Colors, Pastels and Drawings by James McNeill Whistler lent by Richard Canfield," 1911, 24, no. 15, 30 repr.; New York, M. Knoedler & Co., "Whistler Exhibition," 1914, no. 17; London, Arts Council Gallery, "James McNeill Whistler: An Exhibition of Paintings and Other Works," (traveled to: New York, The Knoedler Galleries), 1960, 85, no. 104; Battle Creek, Civic Art Center, "Early American Art," 1965; The Art Institute of Chicago, "James McNeill Whistler," (traveled to: Utica, Munson-Williams-Proctor Institute), 1968, 97, no. 70; Berlin,

Staatliche Museen, Preussischer Kulturbesitz, Nationalgalerie, "James McNeill Whistler (1834-1903)," 1969, 92-93, no. 111; Claremont, Montgomery Art Center, Pomona College, "Whistler: Theme and Variation," (traveled to: Sacramento, Crocker Art Museum; Stanford University Art Museum), 1978, no. 84, 71 repr.; Ann Arbor, The University of Michigan Museum of Art, "Whistler: The Later Years," 1978, no. 70 (cat. ms.)

References: Elizabeth Luther Cary, *The Works of James McNeill Whistler*, New York, 1907, 180, no. 143; Herbert Barrows, "Four Works by Whistler," *UMMA Bulletin*, 1956, 27, 30-31, 29 repr.; Margaret F. MacInnes, "Whistler's Last Years: Spring 1901 – Algiers and Corsica," *Gazette des Beaux-Arts*, LXXIII, nos. 1204-1205, May - June 1969, 334, 340, 342; Donelson Hoopes, *American Watercolor Painting*, New York, 1977, 63, 113, pl. 17

Provenance: purchased from the artist by Richard A. Canfield, New York and Providence, sold in April 1914 to M. Knoedler & Co., New York, purchased in May 1914 by Margaret Watson Parker

Bequest of Margaret Watson Parker

1955/1.90

Early in 1901 Whistler traveled to Ajaccio, Corsica, to seek respite from overwork and ill-health. He did not cease his artistic activities, however, and continued to paint, draw, and etch as the trip, planned for two weeks, lengthened into a stay of several months (see above, Margaret MacInnes, "Whistler's Last Years..."). As with *Street Scene, Paris (28)*, Whistler again selected an elevated vantage point, which raised the horizon, the garden, the coastline, and the Mediterranean to the upper portions of the sheet. The zigzagging diagonals of the rooftops and the shore lead the eye into and across the vertical landscape, which is spacious and panoramic. Cool blue and silver harmonies suggest the stillness of a limpid morning on the quiet island.
HF

HENRI FANTIN-LATOUR

French
1836-1904

"SARA LA BAIGNEUSE" (THE SWING; LA BALANÇOIRE)

1884

Pen, brush and brown ink heightened with white, on off-white wove paper

12¹³/₁₆ x 10 in. (326 x 254 mm)

Signed l.r.: *Fantin*

Exhibitions: Paris, Galerie Tempelaere, "L'Atelier de Fantin-Latour," 1905, no. 88; New York, Wildenstein & Co., Inc., "An Exhibition of XIX Century Drawings," 1947-48, no. 21; New York, Wildenstein & Co., Inc., "Drawings Through Four Centuries," 1949, no. 58; London, Wildenstein, "The Art of Drawing 1500-1950," 1953, 10, no. 91; New York, Wildenstein & Co., Inc., "Timeless Master Drawings," 1955, no. 129; Ann Arbor, The University of Michigan Museum of Art, "A Generation of Draughtsmen," 1962, no. 59, pl. VIIIa; The Detroit Institute of Arts, "Night Thoughts and Day Dreams: Symbolism and Art Nouveau," 1982

References: François Daulte, *Le Dessin français de Manet à Cézanne*, Lausanne, 1954, 49, fig. 6; Jacquelynn Baas Slee, "A Drawing after Berlioz: 'Sara la Baigneuse' by Fantin-Latour," *UMMA Bulletin*, 1979, 26-35, fig. 1; Paris, Grand Palais, "Fantin-Latour" 1983, 348, no. 148, (not in exhibition)

Provenance: collection of Mme de Basily-Callimaki; collection of Mrs. Cornelius J. Sullivan, sold 6 December 1939 at Parke Bernet, New York, lot 4; collection of Mrs. George A. Martin, sold 19 October 1946 at Parke Bernet, New York, lot 310, purchased from her sale by Wildenstein & Co., Inc., New York

1962/1.115

Both Jacquelynn Baas Slee in her 1979 article and Douglas Druick in his essay in the 1983 Fantin-Latour retrospective catalogue (see above), have discussed the Museum of Art's drawing by Fantin from 1884. The original source for the image was Victor Hugo's poem "Sara la Baigneuse," number XIX of his collection of poems of 1829 titled *Les Orientales*. Hugo suggests the idyllic, sybaritic world of the indolent Sara:

Sara, languid beauty/
Gently swings/
In a hammock above/
The fountain pool.../
And from the rippling waters/
Quickly slips/
Her beautiful foot....

Many artists were touched by Hugo's lines. Berlioz, Fantin's direct inspiration, set them to music twice, in 1834 and 1850. Louis Boulanger drew a lithograph in 1830 (an impression was owned by Fantin), and Octave Tassaert painted the subject in 1850, after which lithographs by two different artists were published in 1855 and 1864.

Fantin treated the subject of the luxurious Sara in a variety of media at least ten times between 1883 and 1900 (see Slee, *ibid.*, p.

28, fn. 9). The earliest of the images was a lithograph of 1883 (Fig. 30a). The Michigan work is one of two similar drawings from 1884, both executed after the pastel of the subject exhibited at the Salon in that year (the pastel was later painted over in oil by Fantin). The first of the two drawings was produced specifically for reproduction in heliogravure (Fig. 30b), and is nearly identical in design to Fantin's lithograph of 1883. Slee suggests that the second drawing, in Michigan's collection, was probably made for a private patron. As she points out, the Michigan drawing is important because it shows small deviations from the lithograph of 1883 and the drawing for the heliogravure of 1884, specifically in the manner in which Sara's right hand grasps the rope, in the drapery under her right hip, and in her more animated and athletic body. Although these are small changes, they foreshadow Fantin's treatment of the figure in his lithograph of 1892 of *Sara la baigneuse* (Fig. 30c).

To those who know Fantin only from his marvelously realistic portraits and still lifes, neo-romantic works such as *Sara la baigneuse*, reminiscent of eighteenth-century themes, are indeed surprising. But besides his pictures of contemporary, upperclass life, Fantin, like Whistler and other artists of the Aesthetic Movement and fin-de-siècle, was attracted to evocative, musical sources for inspiration; many of his paintings and prints are related to the works of Wagner, Schumann, and Berlioz.

HF

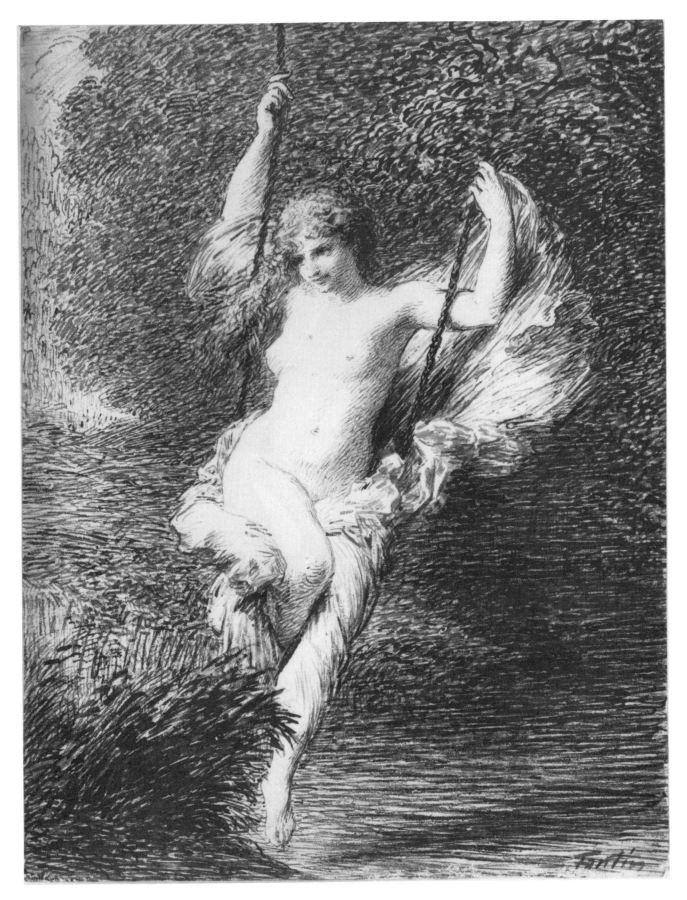

107

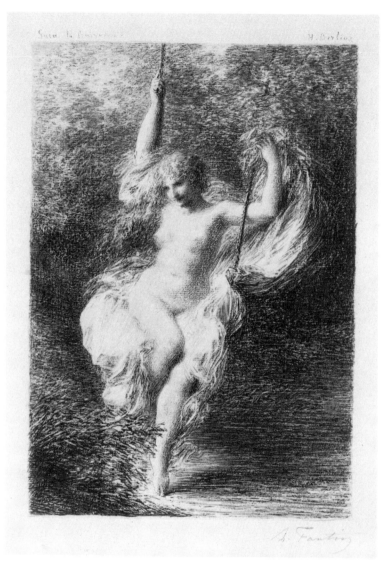

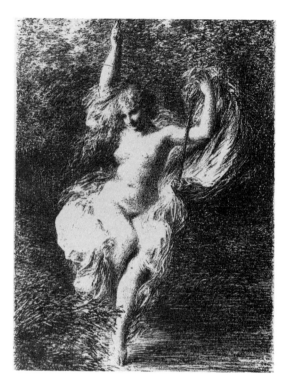

Fig. 30b *Sara la Baigneuse*, 1884, crayon drawing reproduced in heliogravure, from *Gazette des Beaux-Arts*, 1884.

Fig. 30a *Sara la Baigneuse*, 1883, lithograph (345 x 241 mm), Museum of Fine Arts, Boston.

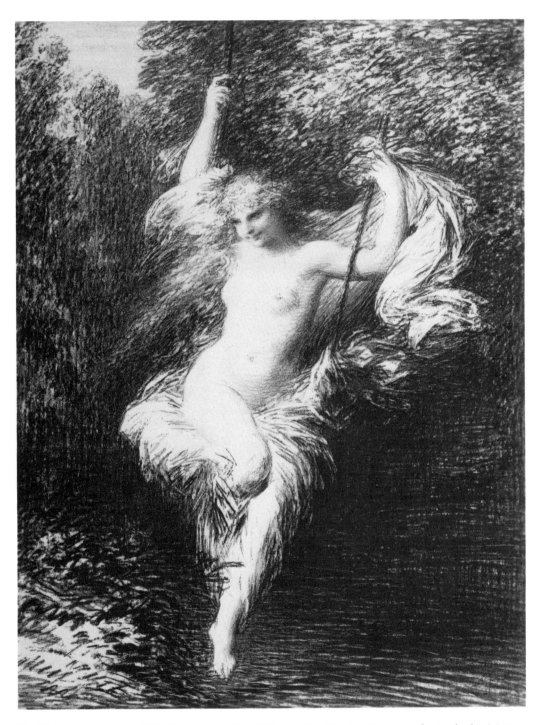

Fig. 30c *Sara la Baigneuse*, 1892, lithograph (349.3 x 260 mm), The Cleveland Museum of Art, gift of Ralph King (21.48).

JULES-JOSEPH LEFEBVRE

French
1836-1912

VIOLETTA

1895

Pencil, black and colored chalks on beige wove paper

21⅝ x 14⁹⁄₁₆ in. (549 x 360 mm)

Signed and dated l.r.: *Jules Lefebvre / X^bre 1895*

Inscribed u.l.: *Violetta*

Exhibitions: New York, Shepherd Gallery Associates, Inc., "The Non-Dissenters: Fifth Exhibition," 1976, no. 117 repr.; Ann Arbor, The University of Michigan Museum of Art, "Recent Acquisitions: Works of Art on Paper," 1977

References: Albert Soubies, *Les Membres de l'Académie des Beaux-Arts depuis la fondation de l'Institut. Quatrième série de 1876 à 1901. Peintres, sculpteurs, architectes, graveurs,* Paris, 1917, 63; "Acquisitions June 1976–July 1977," *UMMA Bulletin,* 1978, 79 repr.

Provenance: purchased in September 1975 from Hazlitt, Gooden and Fox Ltd., London, by Shepherd Gallery Associates, Inc., New York

1976/2.141

One hundred years ago the reputation of academician Jules-Joseph Lefebvre was at its zenith, for the painter had unwaiveringly followed the regimented path leading towards acclaim as an "official" artist. In fact, the course of his career reads like a "how-to-succeed" textbook for fame in the nineteenth-century art establishment. Lefebvre began as a student of Cogniet (who trained under Pierre-Narcisse Guérin); he entered the École des Beaux-Arts in 1852, and received the prestigious *Prix de Rome* in 1861. Lefebvre won medals at the Salons of 1865, 1868, and 1870; garnered the First Class Medal at the Exposition Universelle in 1878, a Medal of Honor in 1886, and a Grand Prize at the Exposition in 1889. Election to the Institut followed in 1891, and investiture as a Commander in the Legion of Honor in 1898 crowned his artistic achievements. Yet today, if Lefebvre is remembered at all, it is as a correct but often cold artist, who essayed portraiture and who specialized in monumental allegorical, literary, and historical oils of eternally nubile and sexually pure post-pubescents, whose chastity was simultaneously their bane, blessing, and *raison d'être* (for example, *Lady Godiva, Diana Surprised, The Sorrow of Mary Magdalen*).

In the more intimate, small-scale drawing *Violetta*, however, one sees Lefebvre's sensitivity. The work is a draughtsman's *tour-de-force*: Lefebvre masterfully balances light and shadow, planarity and plasticity, the linear and the painterly, as well as a variety of textures, in this grisaille-like drawing. Out of his amazingly fluid diagonal chalk and pencil lines, and his delicate and diffuse perpendicular cross-hatchings, steps a palpable and beautiful young woman. An old reproduction from an unidentified text in the Frick Art Reference Library, New York, illustrates a painting entitled "Violet," and represents the identical model in the same pose, only her features are somewhat sharpened.

Although there is no proof, it is interesting to speculate that Lefebvre drew *Violetta* in late 1895, as homage to the author Alexandre Dumas *fils*, who died in November of that year. Dumas's protagonist in *La Dame aux Camélias* had been renamed "Violetta" in Verdi's operatic adaptation *La Traviata*. Both Dumas *fils* and Lefebvre enjoyed enormous popularity, and both were prominent members of their respective Academies. It is even possible that they were friends (Dumas *fils* owned several of Lefebvre's paintings, including a portrait of Mme Dumas *fils*). Whatever its source and purpose, *Violetta* stands as proof of Lefebvre abilities as a gifted draughtsman.

HF

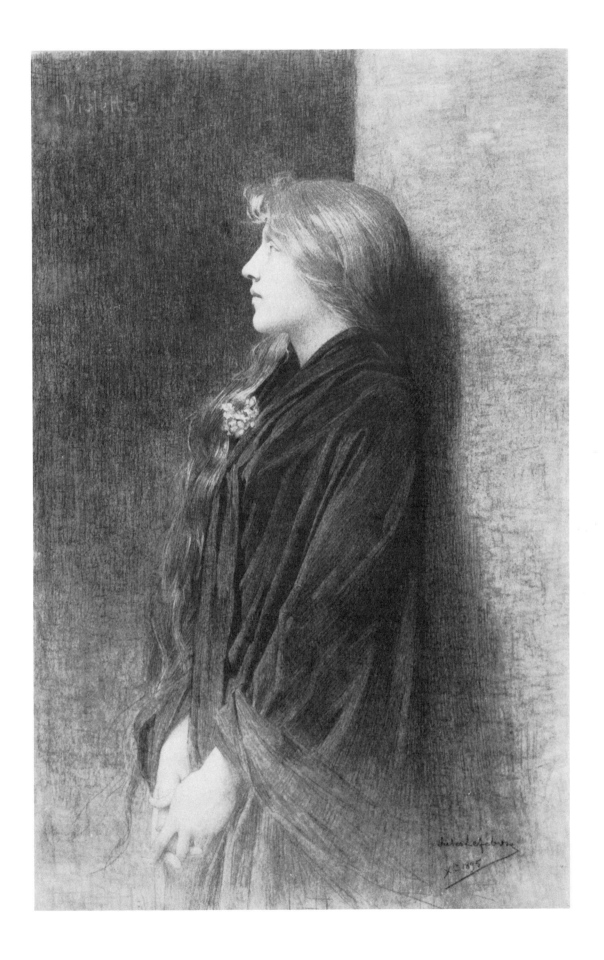

32

JAMES TISSOT

French
1836-1902

LES ÉCLAIREURS DE LA SEINE

Ca. 1870-71

Pencil and watercolor on off-white wove paper

11¾ x 9⅛ in. (298 x 232 mm)

References: "College Museum Notes: Acquisitions, 1800 to the Present, Drawings," *Art Journal*, XXVI, 1, Fall 1966, 62, fig. 18; Providence, Rhode Island School of Design, "James Jacques Joseph Tissot 1836-1902: A Retrospective Exhibition," 1968, nos. 46, 62 (not in exhibition); "Acquisitions July 1, 1964–June 30, 1968," *UMMA Bulletin*, 1969, 40; The Minneapolis Institute of Arts, "James Tissot: Catalogue Raisonné of his Prints," 1978, 82, no. 15, pl. 15c (not in exhibition; incorrect accession number given)

Provenance: purchased at De Zon, Amsterdam, by Bernard Houthakker, Amsterdam

1966/2.4

*L*ike many of his fellow artists, James Tissot defended Paris during the siege of the city in the Franco-Prussian War in 1870. Sometime in the autumn of that year he joined a company of sharpshooters, "Les Éclaireurs de la Seine," a division of the Garde Nationale de la Seine. Tissot reportedly fought bravely during the siege, especially at the sortie at Malmaison-La Jonchère in October-November, 1870 (for Tissot's activities as a soldier, see Thomas Gibson Bowles, *The Defence of Paris; Narrated as it was Seen*, London, 1871, pp. 150ff. and 334ff.; see above, the chronology in Rhode Island School of Design, "James Jacques Joseph Tissot," n.p.; and Michael Wentworth, *James Tissot*, Oxford, 1984, pp. 78-80).

A number of oils, watercolors, and drawings by Tissot record his military experiences during the siege. He also produced six etchings documenting his life in combat, which were printed between 1875 and 1878 and subtitled "Souvenir du siège du Paris" (see above, The Minneapolis Institute of Arts,

"James Tissot: Catalogue Raisonné...," nos. 15, 16, 19, 27, 41, and 42). Some of the designs for these prints were also published after wood engravings in Bowles's book.

Michigan's watercolor is a relatively straightforward, non-anecdotal depiction of the members of Tissot's military company. The two sitters at the right of the watercolor have been identified as Bastien Pradel and Sylvian [sic?] Perier, on the basis of Tissot's two full-length portrait etchings of the men (see above, The Minneapolis Institute of Arts, "James Tissot: Catalogue Raisonné...," nos. 15, 16, respectively). The names of the other soldiers are unknown, but it seems that Tissot also represented the moustachioed, bespectacled figure in the center of Michigan's composition in a small watercolor from this same period (see above, Rhode Island School of Design, "James Jacques Joseph Tissot," no. 46 repr.).

HF

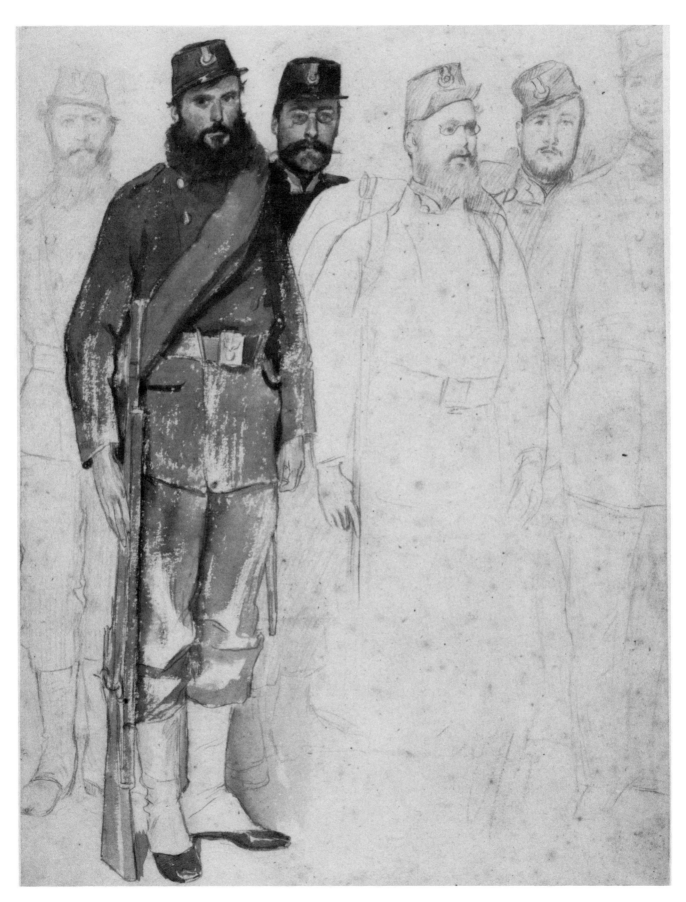

33

GUSTAVE ACHILLE GUILLAUMET

French
1840-1887

STUDY OF MAPLE TREES (LES ÉRABLES)

Black and white chalk on violet laid paper, mounted on heavier paper

18½ x 24⅛ in. (470 x 613 mm) irregular

Inscribed l.r.: *ERABLES*

Stamped in blue (not in Lugt), l.r.: *ATELIER / GUILLAUMET*

Exhibitions: London, P. & D. Colnaghi & Co., Ltd., "French Drawings: Post Neo-Classicism," 1975, no. 94

References: "Acquisitions July 1977 – June 1978," *UMMA Bulletin*, 1979, 79

Provenance: P. & D. Colnaghi & Co., Ltd., London

1977/1.167

Guillaumet, an Orientalist, was most famous for his paintings of North Africa. This landscape, *Study of Maple Trees*, is therefore an unexpected delight. The use of violet-colored paper, with soft highlights in white chalk, and branches delicately modeled in black chalk, evokes the stillness and tranquillity of a forest in late afternoon, and the drawing possesses the same atmospheric nuance as Guillaumet's more exotic pictures. A sketch in the Cleveland Museum of Art possibly represents a nearby site presented in broad daylight, with bolder chalk strokes and starker contrasts between the areas of light and shadow (Fig. 33a).

In 1882 Guillaumet began to exhibit pastels at the Société des Pastellistes, and the Museum of Art's drawing attests not only to his skill as a draughtsman, but to his ability as a subtle colorist and accomplished *plein-airiste*.
CM

Fig. 33a *Trees on a Rocky Hillside*, black chalk with touches of white chalk on gray paper (573 x 455 mm), The Cleveland Museum of Art, Delia E. Holden Fund (75.28).

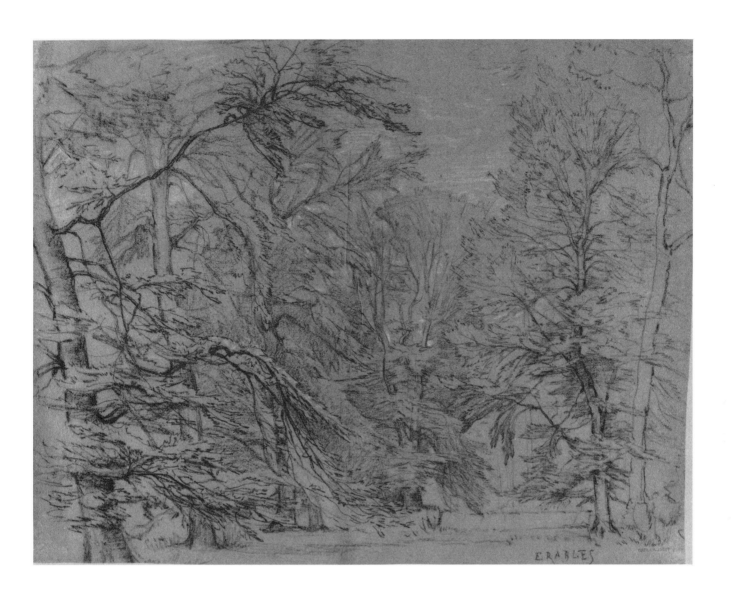

ERABLES

34

ALBERT MOORE

**English
1841-1893**

**STUDY OF OEDIPUS FOR
"A GREEK PLAY"**

Ca. 1867

**Black and white chalk on brown
wove paper, mounted on tissue**

14½ x 6¼ in. (368 x 160 mm)

Signed with anthemion, l.l.

Provenance: purchased in December 1919 from Scott & Fowles, New York, by Margaret Watson Parker

Bequest of Margaret Watson Parker through Dr. Walter R. Parker

1954/1.233

Many painters allied with the Aesthetic Movement were interested in the interdependence of the fine, the applied, and the performing arts. A good example is Albert Moore's tempera painting *A Greek Play*, for the proscenium of the New Queen's Theatre, Long Acre, which opened on 24 October 1867. The decoration depicted an ancient Grecian audience watching the staging of *Oedipus at Colonnus* by Sophocles. The original life-size composition for the theater belongs to the Victoria and Albert Museum, which also possesses a reduced watercolor study (Fig. 34a), full-size designs for some of the individual figures, and smaller sketches for the project (see Newcastle, Laing Art Gallery, "Albert Moore and his Contemporaries," 1972, no. 21). Michigan's drawing is a study for the figure of Oedipus, represented at the left of the design.

Moore's painstaking, almost tedious method required great expenditures of time, much of which was devoted to the making of preparatory designs. Studies of the composition, the individual figures reduced and full-size, nude and dressed, as well as drapery studies, often preceded the painting, which was then executed through an equally complex and laborious process.

Moore drew from life and from antique sculpture and reliefs. The influence of the latter is apparent in the figure of Oedipus. It recalls the treatment of several of the men from the Panathenaic procession on the frieze of the Parthenon, which Moore would have known from the British Museum.

Although he is less well-known today than other Victorian artists, Moore was enormously admired by his contemporaries, especially Lord Leighton (*22*) and Whistler (*27, 28, 29*) . In this context, it is interesting to note that this drawing, and another by Moore in the collection, *Figure of a Woman* (1955/1.108), were gifts of Margaret Watson Parker, who acquired and later bequeathed scores of works by Whistler to the Museum.
HF

Fig. 34a *Design for "A Greek Play,"* watercolor and gouache over black chalk (127 x 530 mm), Victoria and Albert Museum, London.

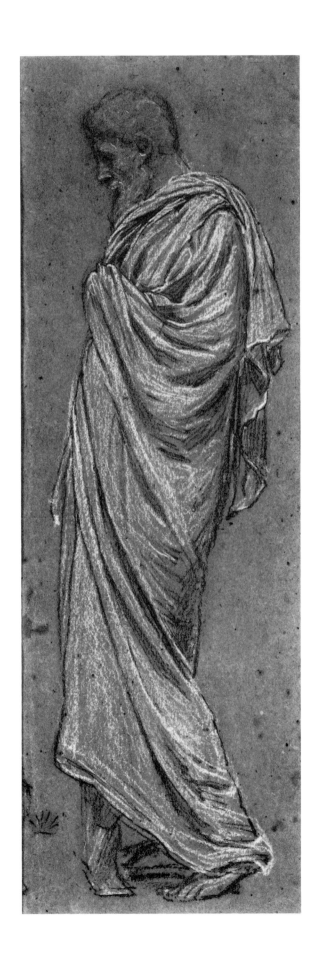

35

PIERRE-AUGUSTE RENOIR

French
1841-1919

**LANDSCAPE IN THE MIDI
(PAYSAGE DU MIDI)**
 HILLSIDE WITH TREES
 (Recto);
 SOUTHERN LANDSCAPE
 (Verso)

Ca. 1885-88

Recto: pencil, pen, blue ink, and
watercolor on off-white wove paper

Verso: pencil and watercolor

11½ x 17⅝ in. (294 x 448 mm)

Exhibitions: Los Angeles, Munici-
pal Art Gallery, "The Collection of
Mr. and Mrs. John Rewald," 1959,
no. 116

Provenance: purchased in summer,
1948 at Hôtel Drouot, Paris by
John Rewald, Sotheby, London,
7 July 1960, lot 102, bt. in

Gift of John Rewald

1983/1.144

*I*n 1881 Renoir journeyed to Italy, and in the mid-1880s he returned to the French Mediterranean. *Landscape in the Midi* has been identified by John Rewald as the countryside near Martigues, a town on the southern coast, east of Marseilles (annotated copy of a photograph in object file, 28 January 1986).

Different approaches are explored in this double-sided watercolor, a medium Renoir began employing most fully after 1880. *The Hillside with Trees*, a rolling landscape with a path indicated in pencil, contains an incline with trees vividly captured with blue ink and watercolor washes. The fecundity and heightened color of the south were of great interest to Renoir, and his pen strokes have recorded the site's botanical diversity and luminescence. The drawing on the verso, *Southern Landscape* is, in contrast to the recto, more summarily rendered, with a hill in the distance. Drawn rapidly in watercolor over pencil, the verso study lacks the detail of the recto, broad washes in green, chartreuse and red sufficing for the foliage, trunk, and remote hill.

Renoir considered Martigues "the Venice and the Constantinople of the pictures by Ziem and the Swedish painters" (quoted in London, Hayward Gallery, "Renoir," 1985-86, p. 303), and these studies from the surrounding countryside (possibly from a sketchbook), reveal how exuberantly Renoir responded to the foliage and color of southern France.
CM

119

LOUIS HENRY SULLIVAN

**American
1856-1924**

DESIGN FOR THE FRIEZE OF THE WAINWRIGHT TOMB

1892

Pencil on brown paper

15¾ x 24¾ in. (400 x 628 mm)

Signed, faintly, l.c.: *L·H·S*

Dated and inscribed, faintly, l.l.: *Jan 21.[?] '92 Wainwright Memorial / A & S*

Exhibitions: The Art Institute of Chicago, "Louis Sullivan and the Architecture of Free Enterprise," 1956; New York, Cooper-Hewitt Museum, "Frank Lloyd Wright and the Prairie School," 1983-84, no. 3 repr.

References: Leonard K. Eaton, "The Louis Sullivan Spirit in Michigan," *The Quarterly Review of the Michigan Alumnus*, LXIV, Spring 1958, 216-17; "Acquisitions July 1, 1971–June 30, 1976," *UMMA Bulletin*, 1976-77, 33; Paul E. Sprague, *The Drawings of Louis Henry Sullivan: A Catalogue of the Frank Lloyd Wright Collection at the Avery Architectural Library*, Princeton, 1979, 45, fig. 36; François Loyer, *Architecture of the Industrial Age: 1789-1914*, Geneva, 1983, 167 repr.

Provenance: acquired through George Elmslie, Chicago, before 1936 by Professor Emil Lorch for the College of Archictecture and Design

Transfer from the College of Architecture and Design, 1972

1972/2.58

*I*n the last years of the nineteenth century, while he was a partner in the Chicago firm of Adler & Sullivan, the pioneering modernist architect Louis H. Sullivan designed a number of sepulchral monuments for important American families. These included the Ryerson and Getty Tombs in Graceland Cemetery in Chicago, and the Wainwright Tomb in Bellefontaine Cemetery in St. Louis. For the tombs' exterior decorations, Sullivan drew numerous elaborate ornamental friezes, composed of intricate interweavings of repeated botanic and geometric elements. In this drawing, which has been identified as a study for the Wainwright Tomb, Sullivan realized an appropriate decoration for a memorial project: the series of interlocking circles, with their intersections ornamented with organic motifs, suggest permanence and regeneration. Other aspects of the design, such as the horizontal undulating borders and the flame-like motifs that flare and taper in the circles' centers, also evoke a sense of timelessness and eternity. The elegant and complex composition, with its sophisticated use of light and shadow, line and tone, and carefully modulated interdependent elements, reveals Sullivan's talent as a powerful draughtsman.

Two other drawings by Sullivan in the Museum of Art date from about the same time, but are more floriated. One is dated *Jan 30/90.* and is inscribed *"Wainwright Memorial"* (Fig. 36a), although it predates Mrs. Wainwright's death in April, 1891. Sullivan's disciple, employee, friend, and executor George Elmslie told Professor Emil Lorch of the College of Architecture and Design at The University of Michigan, that the drawing was a design for the Getty Tomb (letter dated 27 October 1936 in The Michigan Historical Collections, The University of Michigan, Bentley Historical Library). It is not impossible, however, that Elmslie was mistaken; or, if he was correct, that Sullivan reused a drawing sketched earlier in his career for the Getty Tomb in this commission for the 1892 Wainwright memorial project. Another drawing in the Museum of Art has also been connected to the Wainwright memorial (Fig. 36b; see above, Paul E. Sprague, *The Drawings of Louis Henry Sullivan...*, pp. 45, 67).

Sullivan's relationship with the University of Michigan dated from 1905, when he was a rejected applicant for the re-established chair of architecture in the Engineering Department (see Edward J. Vaughn, "Sullivan and the University of Michigan," *The Prairie School Review*, V, 4, 1968, pp. 21-23). The successful candidate and colleague of Sullivan, Emil Lorch, was married to George Elmslie's sister, and it was through the Lorch/Elmslie/Sullivan relationship that the drawings came to Ann Arbor (letter from Lorch to Talbot Hamlin, 26 October 1936, in The Michigan Historical Collections, The University of Michigan, Bentley Historical Library).

Other drawings and pieces of ornamental work by Sullivan are located in the Museum of Art, in the Lorch Papers at the Bentley Library, and in the College of Architecture and Design.

HF

Fig. 36a *Design for the Frieze of the Wainwright Tomb*, 1890, pencil on brown paper (399 x 630 mm), The University of Michigan Museum of Art, transfer from the College of Architecture and Design (1972/2.59).

Fig. 36b *Design for the Frieze of the Wainwright Tomb*, 1892 (?), pencil on brown paper (399 x 632 mm), The University of Michigan Museum of Art, transfer from the College of Architecture and Design (1972/2.60).

37

JOSEPH PENNELL

American
1857-1926

THE MARKET IN FRONT OF ST. TROPHIME, ARLES

1890

Watercolor on off-white wove paper

8⅝ x 17⅛ in. (219 x 435 mm)

Signed and dated in pencil, l.r.: *Jo Pennell / 1890*

Inscribed on verso, c.l.: *Mar[...] Square / Pennell*

Stamped in purple, c.r.: *This Picture is presented to / The / by THE CENTURY CO. 18.. / It has been [...] published and / copyrighted by THE CENTURY CO., / NEW YORK, and must not be repro- / duced or published without consent.*

Provenance: collection of Carl Fredric Clarke

Gift of Carl Fredric Clarke

1949/1.122

*I*n the late summer of 1890, while working on illustrations of French cathedrals for a book, the American-born, London-based artist, Joseph Pennell, and his wife, the author Elizabeth Robins Pennell, toured the south of France. Impressed with the picturesque customs, people, and sites of a number of Provençal towns, the Pennells decided to write several articles about their experiences, and include images with the text. They offered these essays to the Century Company, a publishing concern for which Pennell had worked since the early 1880s. The Century Company accepted and printed the Pennells' observations, entitled "Play in Provence," in several short installments throughout 1891 and 1892 in the periodical, *The Century Magazine*, before issuing them in a slightly different version as a book in 1892 (Elizabeth Robins Pennell, *The Life and Letters of Joseph Pennell*, I, Boston, 1929, pp. 227-31).

Among the places they visited in Provence, Arles stood as a particular favorite. The Pennells enormously enjoyed the festive music, dances, races, and rituals accompanying the town fair coinciding with their summer tour. Pennell commented on the atmosphere in the market in front of the great medieval church at Arles, St. Trophime, and illustrated the scene with this watercolor, which was translated into a wood-engraving, and then reproduced for the publication (Fig. 37a). Pennell described

the process of preparation for printing: "...most illustrations were drawn in reverse on box wood blocks in pen and ink or wash, mostly the latter. The lines of the artist's drawings were made into relief by the engraver cutting away with a knife all the undrawn parts of the block, leaving the lines of the drawing standing like type – and these blocks could then be printed with type...." (*The Adventures of an Illustrator*, Boston, 1925, p. 85). Of the Provençal scene that inspired the watercolor, Pennell wrote: "In front of St. Trophime and on the Lices, the wide, shady boulevard, market-women were driving hard, noisy bargains over their fruit, vegetables and poultry, and traveling showmen had set up their gilded vans" ("Play in Provence: The Grand Arrival of the Bulls ...," XLII, 4, August 1891, pp. 548-49). Pennell focuses on the hubbub of the scene before the church, filling the upper half of the composition with vendors and their curious equipage, who are chatting with their customers in noisy patois. The empty lower half of the design – a device used by Whistler – and the compaction of the figures, emphasizes the activities of the sun-filled town square at market time.

The interesting combination of picturesque townsfolk and the magnificent cathedral so impressed Pennell that he included a similar illustration of the scene from 1890 in his book *French Cathedrals, Monasteries and Abbeys, and Sacred Sites of France*, published nearly two decades later (Fig. 37b).
HF

Fig. 37a *The Market in Front of St. Trophime*, 1890, from *The Century Magazine*, 4 August 1891.

Fig. 37b *Doorway of St. Trophime at Arles*, 1890, from Joseph Pennell, *The Adventures of an Illustrator*, Boston, 1925.

38

GEORGE LUKS

American
1867-1933

RIVER JUNKMEN

Plumbago on tracing paper,
mounted on heavier paper

11¼ x 9¼ in. (286 x 234 mm)

Signed and inscribed, l.r.: *River*
Junkmen / George Luks

References: "Acquisitions July 1,
1971–June 30, 1976," *UMMA*
Bulletin, 1976-77, 33

Provenance: Kraushaar Gallery,
New York; Galleries of the Cran-
brook Academy of Art, Bloomfield
Hills, Michigan, sold 2 May 1972
at Parke Bernet, New York, lot 173

1972/2.36

*W*ith broad sweeps of black, this rough, rapid sketch conveys the choppy dark waters of a bustling city riverfront. Luks used the thick, almost inky blackness of the graphite to give solidity to the pier and it bindings, and to indicate the movement and forms of the two figures loading scrap into the waiting dory. The two men in the boat are more carefully indicated by Luks, one man tending the rudder while his partner reaches up to take the load.

Probably drawn from life, the rapid zigzag stroke that Luks chose for this drawing is exceptionally compatible with the scene being portrayed – the busy activity of an industrialized riverfront. Luks, along with his colleague John Sloan (43,44), preferred to sketch and paint city views, believing them to be more powerful, realistic statements on American life than the popular (but frequently insipid) bucolic or late-Victorian genre scenes prevalent at the time.

Three other works by Luks entered Michigan's collection from the Cranbrook sale in 1972 – *Woman and Child* (1972/2.37), *Woman Seated* (1972/2.38), and *Wrestlers* (1972/2.39).
LA

River Junkmen
George Luks

HERMANN DUDLEY MURPHY

American
1867-1945

THE LAVENDER SHAWL

Ca.1899

Gouache and pencil on paper mounted on board

18 x 9⁷⁄₁₆ in. (458 x 240 mm)

Signed with artist's cipher circled in red, l.l.: (m)

Exhibitions: Philadelphia, Pennsylvania Academy of the Fine Arts, "Sixty-Eighth Annual Exhibition," 1899, no. 648; St. Louis, Universal Exposition, 1904, no. 1197

References: New York, Graham Gallery, "Hermann Dudley Murphy: Realism Married to Idealism Most Exquisitely," 1982, 36 (not in catalogue)

Provenance: collection of the artist, 1904; collection of Charles M. Kurtz; Albright Art Gallery, Buffalo; The Park Avenue Gallery, Inc., New York; The Graham Gallery, New York

Gift of the Friends of the Museum

1982/1.264

Born in Marlboro, Massachusetts and educated in Boston, Murphy's career encompassed painting, illustration, etching, and teaching at Harvard. With Edmund Tarbell, William Paxton and Frank Benson, Murphy was one of the major figures in the Boston School in the first decades of this century.

This drawing undoubtedly represents Murphy's first wife, Caroline Bowles, whom he met in Paris when both were students of Jean-Paul Laurens. They married in 1895, and eventually settled in Winchester, Massachusetts, where Murphy built a large house and studio. He began to exhibit widely, and became quite influential for his designs for frames, which came to be called by his studio's name, "Carrig Rohane."

Most of Murphy's figure studies and portraits were done during the late 1890s and the first decade of this century. The influence of Whistler is unmistakable in this gouache of Caroline, especially in its vertical format and refined sense of color and design. The cool palette used by Murphy in this drawing – the watery blue background, the pale green dress, the lavender shawl – accentuates the quiet, introspective mood of the work. Despite the fragility of the coloring, however, Murphy has given Caroline a palpable solidity, and warmed the composition somewhat by emphasizing her golden-brown hair, the rosy skin on the back of her neck, and the flesh tones visible through her sheer green dress. This drawing was exhibited at the Universal Exposition in St. Louis in 1904, where Murphy won a silver medal for works he submitted to the juried competition.

LA

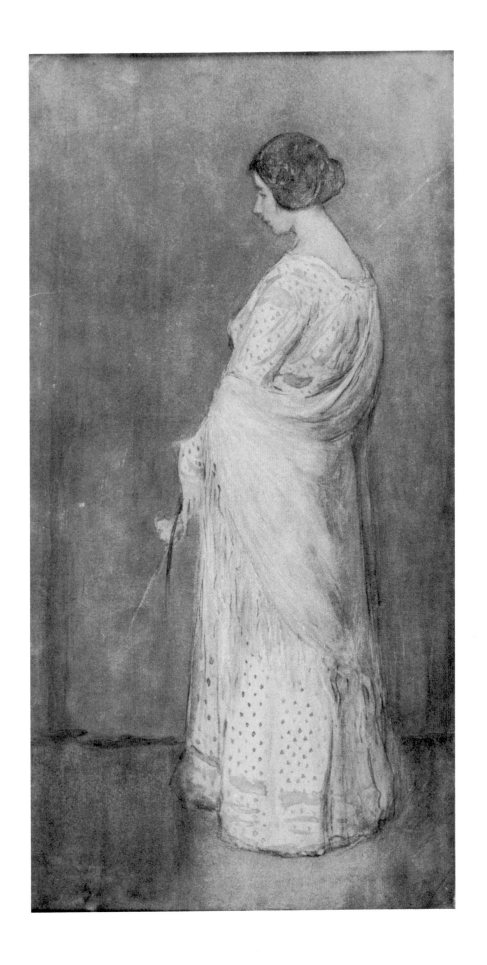

EMIL NOLDE

**German
1867-1956**

**FRISIAN LANDSCAPE
(FRIESISCHE LANDSCHAFT)**

1930s

Watercolor on Japan paper

13½ x 18½ in. (343 x 470 mm)

Signed l.r.: *Nolde.*

Exhibitions: Oberlin 1956; Lincoln 1957; Michigan Artrain 1974; Ann Arbor, The University of Michigan Museum of Art, "Pechstein to Penck: German Expressionist Art," 1985

Provenance: Galerie Günther Franke, Munich

1951/2.39

Nolde excelled at watercolor, a medium ideally and inherently suited to his quest for immediacy in the artistic process. *Frisian Landscape* combines the high-keyed palette of German expressionist art with the serenity of Nolde's late seascapes to create an indisputable masterpiece.

By dampening the paper before applying the pigments, and controlling their fluidity with cotton, Nolde physically and visually fused earth, sea, and sky (New York, Museum of Modern Art, "Emil Nolde," 1963, pp. 38, 60, 67). Yet for Nolde, spontaneity did not deny structure; the penetration of color played as active a role in his composition as the did the natural forms of the landscape. Nolde strikes a harmonious balance between the violets and yellows at the horizon and in the sky by co-mingling the complementaries, anchoring them with a black cliff and a black cloud. A sea-green foreground, the admixture of celestial blue and golden light, buoys the horizon and the black rock, as they are caressed by the luminiscent fingers of the hazy atmosphere. With a palette limited to four hues, the artist has evoked a scene of great beauty and depth. Nolde here ranks with Turner for sublimity, and is equal to Friedrich in endowing this isolated landscape with the spirituality of the infinite.

Nolde's works are difficult to date and show few changes in subject matter or style after 1920. Dr. Martin Urban has compared the Michigan watercolor to Nolde's pictures of the marshes of North Friesland, and dates it to the 1930s (letter in object file, 9 September 1985).

HF

CHARLES CONDER

**English
1868-1909**

DESIGN FOR A FAN

Ca. 1900

Watercolor on parchment

7½ x 23¼ in. (190 x 590 mm)

Exhibitions: New York, The Alan Gallery, "Sculpture, Drawings, Watercolors, Prints of Three Centuries," 1962, no. 11

References: "Acquisitions July 1, 1961–June 30, 1964," *UMMA Bulletin*, 1966-67, 43

Provenance: The Alan Gallery, New York

Gift of the estate of Marion Lehr Simpson

1962/2.119

Few nineteenth-century English artists owed as great a debt to the ethereal spirit of the French rococo as did Charles Conder. His idyllic imagery, ebullient designs, and pastel-toned palette, keyed to the colors of precious gems (turquoise, carnelian, amethyst, chrysophrase, and moonstone), recall that Elysian eighteenth-century world inhabited by voluptuaries destined for the Island of Cythera. Moreover, Conder's numerous projects for interior decoration, his preference for fan-shaped compositions with decorative borders (of which this *Design for a Fan* is typical), and his use of silk, vellum, and parchment, epitomize eighteenth-century elegance. Yet, while Conder's paintings are tributes to Watteau and Fragonard, they are equally characteristic of the fin-de-siècle. This epoch produced Beardsley's linear refinement, the bejewelled garden luncheons of Bonnard, and the fauvist *fêtes galantes* of Derain in *The Age of Gold* and Matisse in *Luxe, calme et volupté* . Like his predecessors and contemporaries, Conder preferred a universe of gilded daydreams and memories to one of hard actuality.

During his short life Conder painted scores of fan-shaped watercolors, many of which were on silk. He exhibited them at the turn of the twentieth century in London, primarily with the New English Art Club and at the Carfax, Dutch, Leicester, and New Galleries. He also showed at the International Society of Sculptors, Painters and Gravers, of which Whistler was the first president. His works were collected by important patrons and cognoscenti of art such as Samuel Bing in Paris and John Quinn in New York (see Frank Gibson, *Charles Conder: His Life and Work*, London, New York, and Toronto, 1914, pp. 39-40, 61-62). The creation of a beautiful world existing absolutely for art and art's sake was Conder's ultimate goal and achievement.
HF

42

HENRI MATISSE

French
1869-1954

SEATED NUDE

1907

Pencil on beige wove paper

12 5/16 x 9½ in. (319 x 242 mm)

Signed l.r.: *Henri Matisse*

Exhibitions: Saginaw 1954; Lincoln 1957; East Lansing 1963; Ann Arbor 1965-66, no. IXa; Ann Arbor 1982-83

Provenance: sold in 1928 by the artist to a Parisian dealer; John Becker

1948/1.283

*M*atisse's early drawings were rarely dated, and were rarely used as preparatory studies for direct translation into painting or sculpture. Rather, as John Elderfield has noted, they served as crystallizations of immediate ideas, ways to "...set down first sensations, then to analyze subjects for their characteristic expressive forms prior to their further 'condensation' in painting itself" (London, Hayward Gallery, "The Drawings of Henri Matisse," 1985, p. 46). After 1906, according to Elderfield, Matisse's drawings assumed greater clarity; the design is rhythmically set within the confines of the sheet, the proportions of the space lending the composition a vitality as significant as the figure itself (*ibid.*, p. 47). The bounding arcs of the pencil line in *Seated Nude*, secure, fresh, and pliable like the sitter's flesh, reduce the figure to a series of curves and countercurves. While undoubtedly inspired by the model, the human form is simplified, superfluous detail is omitted, establishing a harmonious counterpoise of circles, ovals, and ellipses.

Marguerite G. Duthuit, Matisse's daughter, has dated the drawing to 1907 (letter in object file, 17 June 1975).

HF

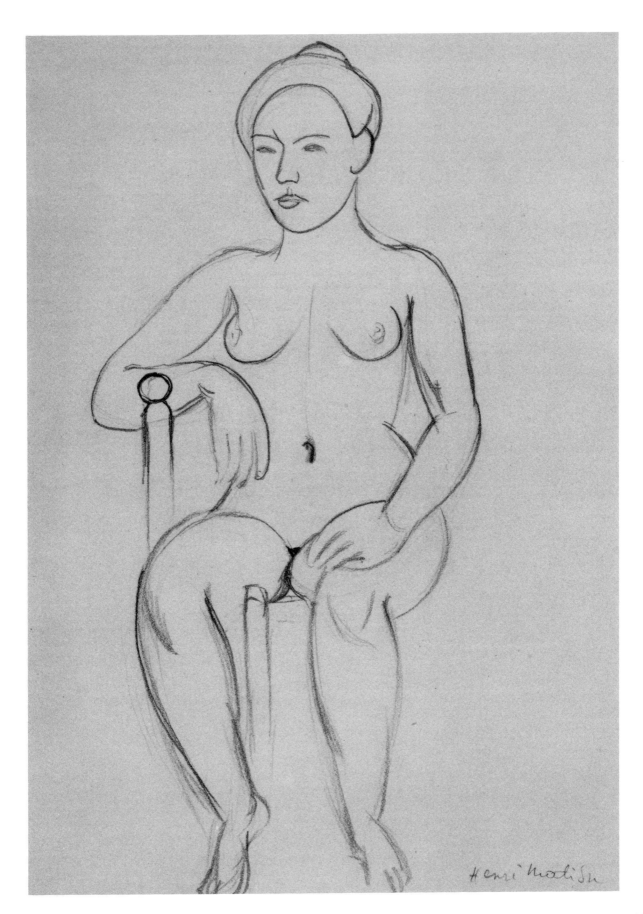

Henri Matisse

43

JOHN SLOAN

American
1871-1951

STRIKERS AND SCABS (or INFERIORS AND EQUALS)

1910

Crayon, pencil, black ink on tracing paper mounted on rice paper

17¼ x 18¹¹⁄₁₆ in. (437 x 475 mm)

Signed, dated, and inscribed, l.l.:
John Sloan/ The New York Call Jan. 1910 / The Scab

Inscribed in red pencil l.r.: *JS # 624*

Inscribed on drawing, since removed:
The Boss has just told the young lady Scab that she is his equal because she is a Scab / That she is an American for the same reason! That only "foreigners" go on strike! / and that by being a Scab she is gaining the respect of the community–she believes all this! / The two strikers [sic] pickets respect themselves they believe themselves the superior of any parasite on their class / and that the striker for liberty against tyranny is the only true American

References: *The New York Call*, January 1910, 6; "Acquisitions July 1, 1971–June 30, 1976," *UMMA Bulletin*, 1976-77, 33

Provenance: estate of the artist (JS # 624), to Kraushaar Galleries, New York

1972/1.158

Sloan was politically active during the years 1909-14, when he contributed time and drawings to several socialist journals, particularly *The Call* and later, *The Masses*. A friend, Rollin Kirby, stated that Sloan had "lost his sense of humor" over socialism (David Scott, *John Sloan*, New York, 1975, p. 111). But if this was true in a personal sense, it was not reflected in the drawings Sloan did for the journals. These are uniformly satiric, yet humorous in their commentary on political and social issues. A case in point is this drawing done for *The Call* (Fig. 43a). This particular issue of *The Call* focused several articles and an editorial on the plight of striking garment workers, and Sloan's drawing supported the general theme of the issue. But the artist has added a twist to the predictable political rhetoric by making a visual commentary on a more universal situation–the inequality of male/female relationships.

The center of attention in the drawing is "The Scab," the attractive young woman gorgeously bedecked in fox, being helped down the steps of a shirtwaist factory by a portly gentleman, who is obviously the boss. As the caption explains, they are being watched by two women strikers. Yet the disdainful look on the face of "The Scab," the courtly leer of her smitten patron, and the knowing stares of the two plainly-dressed women strikers watching the scene by lamplight, make this more than a socialist commentary on unfair labor practices. Sloan's observation on the nature of the modern industrial workplace is apparent here, because "The Scab's" physical attractiveness is obviously being exploited to her advantage. Sloan makes it clear that she is a traitor in more than one sense – not only to her fellow workers but to her sex as well.

John Sloan had a long and influential artistic career. In addition to his work as a painter and graphic artist, he was a newspaper illustrator, political activist, and beloved teacher at the Art Students League in New York, where his list of students included Alexander Calder (77), Adolph Gottlieb (84), and David Smith (88). With his friend George Luks (38), Sloan was one of "The Eight," a notorious group of artists that introduced the American public to realistic depictions of city life

Other drawings by Sloan in Michigan's collection include *A Sand Party* (1964/ 1.106), *Women March* (1964/2.154), and *Prone Nude* (1972/1.157).
LA

STRIKERS AND SCABS OR INFERIORS AND EQUALS

The boss has just told the young lady scab that she is his equal—became she is a scab! That she is an American for the same reason! That only "foreigners" go on strike! And that by becoming a scab she gains the respect of the community! And she believes all this! The two pickets respect themselves. They believe themselves superior to any parasite on their class, and the striker for liberty against tyranny is the only true American.

Fig. 43a *Strikers and Scabs or Inferiors and Equals*, from *The New York Call*, January 1910.

John Sloan

The New York Call Jan. 1910 The Scab

JOHN SLOAN

NEWS OF THE TITANIC

1912

Crayon, ink, and pencil on off-white paper

14⅛ x 18½ in. (360 x 471 mm)

Signed and inscribed, l.r.: *John Sloan* / *"News of the Titanic"* 1912

Inscribed in red pencil, l.r.: *JS#1029*

Inscribed in blue crayon, verso: *Mr John Sloan* / *155 East 22nd St* / *2 proofs*

References: *The New York Call*, 1 May 1912, 9; "College Museum Notes: Acquisitions, 1800 to Present, Prints and Drawings," *Art Journal*, XXIV, 1, Fall 1964, 60; "Acquisitions July 1, 1961–June 30, 1964," UMMA Bulletin, 1966-67, 48

Provenance: estate of the artist (JS#1029), to Kraushaar Galleries, New York

1964/1.107

The Titanic sank on 16 April 1912, and repercussions from the enormous sea disaster were still being felt several weeks later when Sloan published this drawing in *The Call*, a socialist journal (Fig. 44a). The timely news of the sinking of the Titanic was used by Sloan to stress a critical social issue of his time: hazardous working conditions endured by miners. The drawing depicts two miners eating lunch in a tunnel, reading the newspaper by the light of their hat-candles. The newspaper headline screams "Titanic Horror Grows / 1490 Lives Lost / ... Went Down to Their Deaths..." Under one miner's lunch pail and sandwich lies another section of the paper with the headline "542 Miners Doomed / Rescuers Give Up Hope." The caption in *The Call* reads: "The dry land for mine, Bill. It's what I always said and I'll stick by it."

The huge number of lives lost in the spectacular sea tragedy stupified people everywhere, and Sloan's drawing is a biting comment on the public uproar that occurred after the sinking, as the enormity of the loss was realized. As Sloan points out in this drawing, news of the Titanic completely overshadowed more "ordinary" disasters, such as miners' lives lost beneath the earth, the tragedy of their deaths largely unremarked.

Sloan contributed drawings to socialist journals from 1909 until the beginning of World War I. His political opinions during the time were fervid, but did not overwhelm his artistic sense; he was always careful to reclaim any drawings that were used for publication. To insure the return of his works, he frequently put his name and address on the back, as he did on Michigan's drawing.
LA

Fig. 44a *Dry Land*, from *The New York Call*, 1 May 1912.

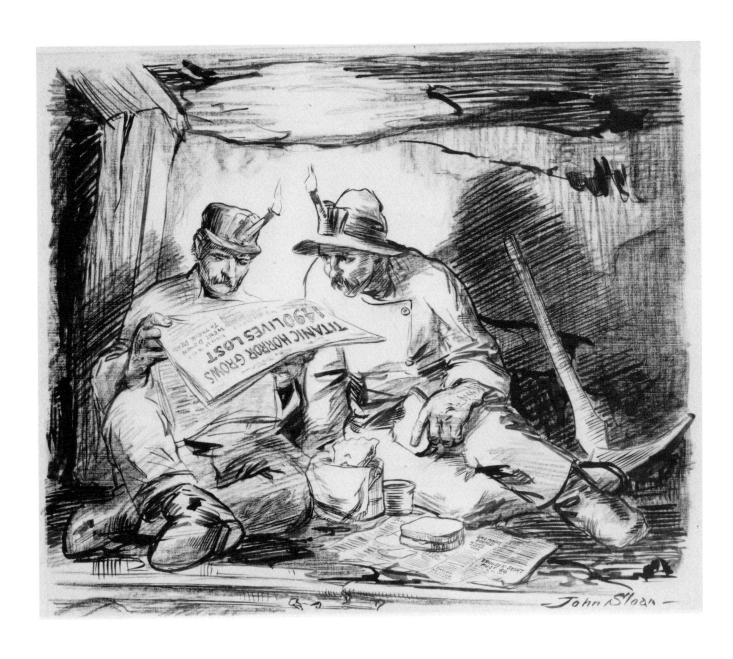

SIR MAX BEERBOHM

**English
1872-1956**

**HOMAGE TO AUGUSTUS
JOHN (HOMMAGE À JOHN)**

1907

**Pencil, ink, and watercolor on
off-white paper**

15 x 11 in. (381 x 280 mm)

Signed and dated, l.r.: *Max / 1907*

Inscribed, l.l: *Hommage à John*

**Collector's stamp in red (Lugt 595),
l.l.: *CLR***

Exhibitions: Buffalo, Albright-
Knox Art Gallery, "Gifts to the
Albright-Knox Art Gallery from A.
Conger Goodyear," 1963, no. 40

References: "Check List of Draw-
ings in the Collection of the Gal-
lery," *Gallery Notes* (Albright Art
Gallery), XVIII, 3, May 1954, 8;
"Acquisitions July 1, 1964–June
30, 1968," *UMMA Bulletin*, 1969,
38; Rupert Hart-Davis, *A Cata-
logue of the Caricatures of Max
Beerbohm*, Cambridge, 1972, 84

Provenance: collection of Charles
Lambert Rutherston (Lugt 595);
collection of A. Conger Goodyear
until 1953, given to the Albright-
Knox Art Gallery, Buffalo, sold in
1965 to the Museum of Art

1965/2.6

Beerbohm regularly lam-
pooned well-known per-
sonalities, and this cari-
cature of fellow artist
Augustus John is an amusing
depiction of John's public persona,
where he played the role of rebel-
lious bohemian to the hilt.

The crowd of skinny women,
with a sprinkling of arty-looking,
bespectacled men, stand in awe or
puzzlement behind the dominating
figure of John. Their bemused
expressions are understandable –
John is wildly disheveled, his eyes
and facial features hidden by great
sweeps of hair and beard–giving
the impression of a modern-day
John the Baptist (indeed, John's fel-
low students at the Slade had joked
"There was a man sent from God,
whose name was John" [Malcolm
Easton and Michael Holroyd, *The
Art of Augustus John*, Boston,
1975, p. 2]) John's outlandish,
gypsy-like costume includes a
green serape thrown over his
shoulder and the wide-brimmed
hat pushed far back on his shaggy
head. One boot is so badly in need
of repair that all of John's pink toes
poke through the opening. Com-
pleting the wildly unconventional
costume is a rough wooden staff in
John's left hand, held with all of
the hauteur of an Edwardian dandy
with an elegant cane.

John's irregular domestic situa-
tion (he lived with his wife and his
mistress and had children by them
both, in addition to numerous
other attachments), and his well-
known affinity for gypsies and the
nomadic life, made him a contro-
versial figure from the earliest days
of his career. Beerbohm's inscrip-
tion *"Hommage à John"* provides a
commentary on John's notoriety:
the crowd contemplating the artist
contains as many who are amused
or bored with John, as those who
adore him. One figure in the crowd
has been given more than cursory
attention by Beerbohm, however.
The gaunt woman in the orange-
checked dress with the saucer-
shaped hat directly behind John's
left shoulder is also caricatured;
she is clasping her hands in a ges-
ture of adoration, and with her
thin face with prominent nose and
jaw she suggests Lady Ottoline
Morrell, a special friend and patron
of John.

This drawing contains the collec-
tor's mark of Charles Rutherston, a
Yorkshire manufacturer who was
the brother of artist William Roth-
enstein (the family's name was
anglicized during World War I);
Rothenstein was a very close friend
of John. One other work by Beer-
bohm is in Michigan's collection,
his *Caricature of Pinero* (1965/2.5).
LA

Hommage à John

1907

MARSDEN HARTLEY

**American
1877-1943**

TREES

Ca. 1927

Pencil on heavy off-white paper

14¹⁵⁄₁₆ x 12⅛ in. (377 x 305 mm)

Exhibitions: Grand Rapids Art
Museum, "Pioneers: Early 20th-
Century Art From Mid-Western
Collections," 1981, no. 14 repr.

References: "Supplément à la
Gazette des Beaux-Arts," *Gazette
des Beaux-Arts*, no. 1225, February
1971, 107, fig. 489; "Acquisitions
July 1, 1970–June 30, 1971,"
UMMA Bulletin, 1971-72, 47, 35
repr.

Provenance: Kraushaar Galleries,
New York

1970/2.6

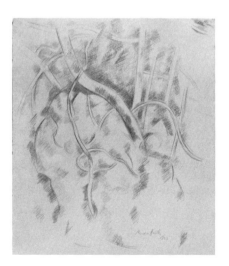

Fig. 46a *Trees and Rocks*, 1927, silverpoint
on prepared paper (379 x 331 mm), The
University of Michigan Museum of Art,
bequest of Florence L. Stol (1968/1.83).

H artley spent the years
1926-27 in Aix-en-
Provence, finding
inspiration in
Cézanne's superbly executed
studies of the region's rugged land-
scape, a debt apparent in this pen-
cil drawing of sinuous trees on a
rocky ridge. Nevertheless, the
impression of almost chaotic,
clinging growth, coupled with
heavy diagonal shading on the tree
trunks (indicating conifer branches
hiding the sky), suggests that Har-
tley had absorbed and then moved
away from Cézanne's geometric,
formal approach. *Trees*, with its
main tree trunk bent backward in a
sickle-shaped arc, and the
abstracted, almost knotted inter-
twining of forms, is not a vision of
benign nature. Hartley conveys the
confusion of uncontrolled natural
growth in this pencil sketch, and in
another related work in Michigan's
collection, a silverpoint, *Trees and
Rocks*, (Fig. 46a). One other draw-
ing by Hartley is owned by the
Museum: *Study for Bavarian Alps
Series* (1955/2.2).
LA

GEORG KOLBE

German
1877-1947

NUDE WOMAN BENDING

Ca. 1920-21

Pen, brush, and sepia ink on off-white wove paper

18⁷⁄₁₆ x 13¹³⁄₁₆ in. (469 x 351 mm)

Signed l.r.: *GK*

Exhibitions: Lincoln 1957; AFA 1957-58, no. 45; East Lansing 1959-60; Flint 1961; East Lansing 1963; Ann Arbor 1966

References: Helen B. Hall, "Contemporary Drawings," *UMMA Bulletin*, 1950, 12

Provenance: E. Weyhe, New York

1948/1.89

Georg Kolbe was born in 1877 in Waldheim in Saxony. He studied painting first in Dresden and Munich, and then in Paris, where he attended the Académie Julian in 1897. At the beginning of the twentieth century, he turned to sculpture and is best known today for his portraits and figures in bronze.

In the early 1920s Kolbe drew numerous studies of the nude in motion. This life drawing demonstrates the surety of Kolbe's art. From the awkward pose of the bending nude, Kolbe has created an extraordinarily stable image. The figure is a triangular monument, her (invisible) hands and feet on an imaginary ground line supporting her bulk, the center of gravity at the apex of this humanoid mountain. Across the surface are residues of sepia, the results of Kolbe's quick execution, while shadows at the left of the figure, cast by the strong light from the upper right, lend the form its palpable mass.

This study is one of a group of fine drawings by twentieth-century sculptors which Jean Paul Slusser purchased from E. Weyhe in New York in 1948. Other drawings of nude figures from this purchase include works by Gill (58), Lachaise (59), Archipenko (63), Zadkine (66), and Lipchitz (69).
HF

48

AUGUSTUS JOHN

**English
1878-1961**

**AT THE PIANO (THE
ARTIST'S SISTER, WINIFRED)**

Ca. 1894-99

**Sanguine chalk and eraser on gray
prepared paper**

14¹⁵⁄₁₆ x 11 in. (380 x 280 mm)

Inscribed in pencil, verso, l.l.:
Augustus John - Girl at Piano

Exhibitions: AFA 1957-58, no. 29;
East Lansing 1959-60; Ann Arbor
1984

Reference: A.L. Bader, "Augustus
John Drawings," *UMMA Bulletin*,
1956, 33-36, fig. 24

Provenance: purchased in August
1925 by Margaret Watson Parker
from Walker's Galleries, London

Bequest of Margaret Watson
Parker, through Dr. Walter R.
Parker

1954/1.229

*A*t the Piano is one of the
Museum's six drawings
by John, five of which
entered the collection
with the bequest of Margaret Watson Parker. One of the earliest and
most interesting is this drawing of
the artist's sister, Winifred (born
1879). She had moved to London
in 1897 from the family home in
Haverfordwest, Wales, in order to
study music, and set up house with
John and their sister Gwen at 21
Fitzroy Square.

John's drawing of Winifred
recalls the domestic genre scenes
popular in seventeenth-century
Dutch art, as well as the work of
John's Impressionist contemporaries such as Renoir. John's technique in this drawing is particularly intriguing; it baffled the conservation staff at the Fogg

Museum where it had been sent
for treatment after it was accessioned. Conservators at first feared
that the drawing was a reproduction, since gray paper was overlaid
with red chalk, but the white highlights, visible on Winifred's dress
and on the piano, appeared to be
the white of the paper. Upon more
careful scrutiny, however, they
reached another conclusion – John
used a prepared support, erased the
paper to create the white highlights, and drew the figure and
piano in sanguine. John corroborated their findings in a letter to
Agnes Mongan in 1955: "The
drawing of which you send me a
photograph is one of my sister
Winifred, done when I was a student at the Slade School of Art,
University College, London. It was
drawn in sanguine on some new
sort of paper with a grey surface
removable with hard india-rubber.
I have not used this paper since and
am not surprised [sic] that it puzzled you" (transcription of letter
from Agnes Mongan, in object file,
26 August 1955).

Another John drawing in the
bequest, *A Girl Seated* (Fig. 48a),
was executed in same technique,
and dates from about the same
time.
HF

Fig. 48a *A Girl Seated*, ca. 1894-99, sanguine and black chalk and eraser (541 x 365
mm), The University of Michigan Museum
of Art, bequest of Margaret Watson Parker
through Dr. Walter R. Parker (1954/1.230).

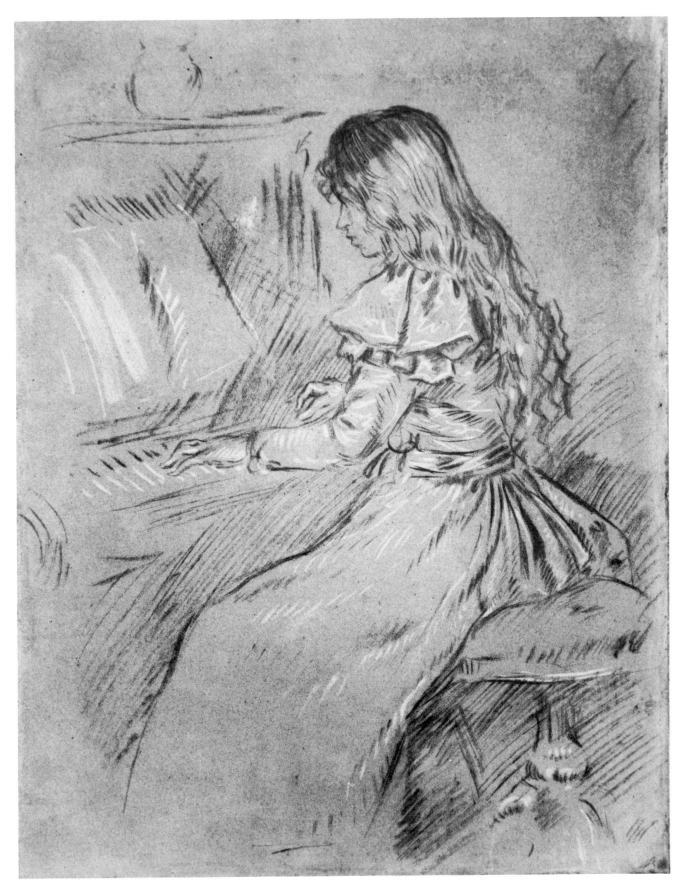

AUGUSTUS JOHN

WOMAN WITH SHAWL

Ca. 1908

Pencil on white wove paper

16 x 9¼ in. (406 x 236 mm)

Signed l.r., in pencil: *John*

References: A.L. Bader, "Augustus John Drawings," *UMMA Bulletin*, 1956, 33, fig. 23

Provenance: collection of Margaret Watson Parker

Bequest of Margaret Watson Parker, through Dr. Walter R. Parker

1954/1.232

From the time of his student days in London in the mid-1890s, Augustus John's talents, particularly as a draughtsman, were recognized by his teachers and fellow pupils. In his second year at the Slade in 1895, John won a certificate for figure drawing, a prize for drawing from the antique, and a scholarship of £35 for each of the following two years. In 1896, he again received the accolade for drawing from the antique, and he also obtained a £3 prize for a study from the nude. During his last year at the Slade he won several certificates and monetary awards for his paintings of the figure and for composition (Michael Holroyd, *Augustus John: A Biography*, New York, 1975, 49). It is the consensus that the next decade, the first of the twentieth century, marks the highpoint of John's development as a draughtsman. He made hundreds of drawings at this time, many of which were of female sitters, and most especially of his mistress Dorelia, whom he had met in 1903. For this drawing, and another similar to it in the collection (Fig. 49a, *Study of a Woman Draped, No. 1*), Dorelia served as model. *Woman with Shawl* is closely related to other drawings by John of Dorelia, and most especially to his *Standing Woman, Draped in a Shawl* in the Fitzwilliam Museum (Fig. 49b). Dorelia's pose is almost the mirror image of that in the Michigan drawing, and it is not inconceivable that both works were executed in the same sitting. In 1964 Dorelia John annotated a photograph of the Fitzwilliam drawing, identifying herself as the sitter, and placing its date as "fairly early about 1908" (letter in the files of the Fitzwilliam Museum, 24 August 1964). The date and identification of the sitter are further corroborated by other drawings from this time, including *The Blue Scarf* in the Art Gallery of Ontario (Fig. 49c), which is dated 1908, and *The Blue Shawl*, also in the Fitzwilliam Museum (Fig. 49d).

The elegant sweep of elongated line, the compact triangular shape of the figure, and the downcast eyes of the sitter contribute to the work's feeling of repose. John maximized the expressive potential of the pencil: the various types of strokes convey the texture of the fabric's fold, and the lines, as an ensemble of parallel strokes, give the figure volume and solidity. The softer shading of the model's face, and a second, lighter study of the sitter's head, tilted at a more pronounced inclination, demonstrate that John was equally adept in suggesting the subtleties of personality.
HF

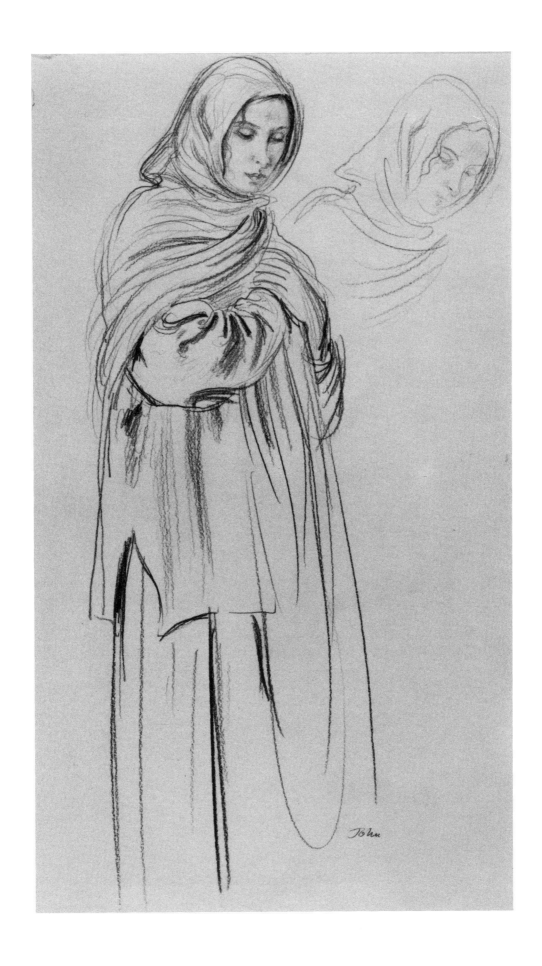

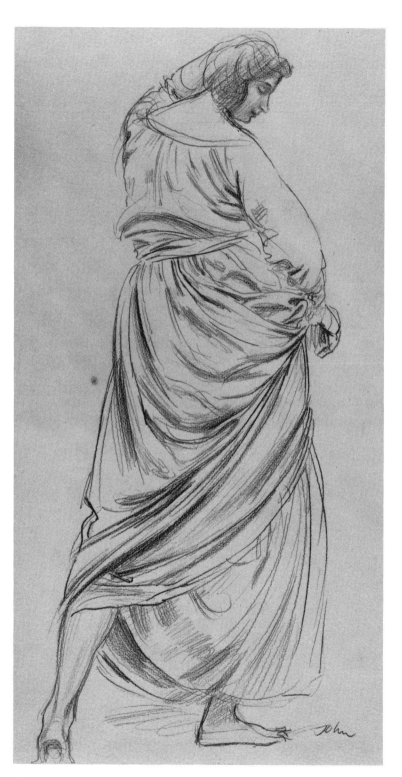

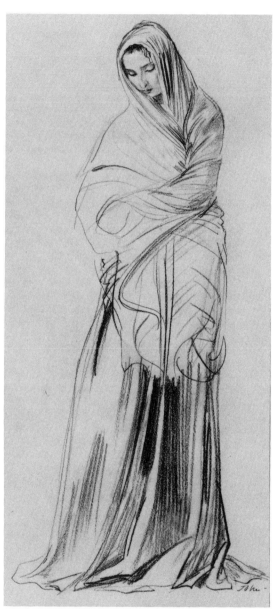

Fig. 49b *Standing Woman, Draped in a Shawl*, 1908, pencil (439 x 204 mm), Fitzwilliam Museum, Cambridge.

Fig. 49a *Study of a Woman Draped, No. 1*, ca. 1908, pencil on off-white paper (458 x 305 mm), The University of Michigan Museum of Art, bequest of Margaret Watson Parker, through Dr. Walter R. Parker (1954/1.231).

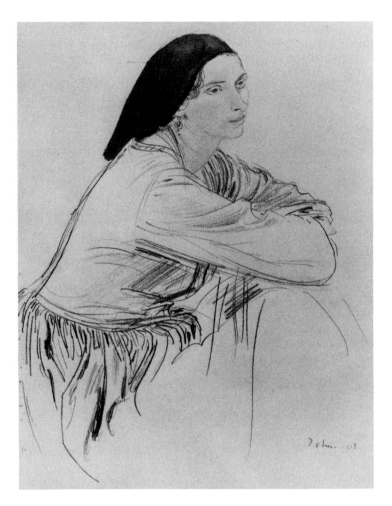

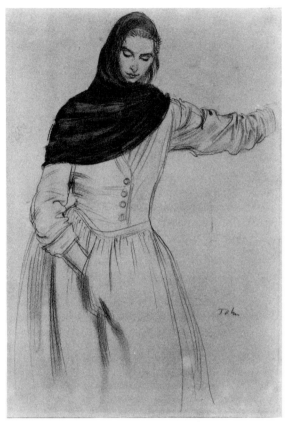

Fig. 49d *The Blue Shawl*, ca. 1908, pencil and watercolor
(356 x 254 mm), Fitzwilliam Museum, Cambridge.

Fig. 49c *The Blue Scarf*, 1908, pencil and watercolor on paper (289 x 226 mm),
Art Gallery of Ontario, Toronto, bequest of Miss L. Aileen Larkin, 1967.

PAUL KLEE

**Swiss
1879-1940**

JULIA

1937

**Colored paste on off-white paper,
mounted on heavier paper**

19⁹⁄₁₆ x 13¾ in. (496 x 349 mm)

Signed in ink, l.l.: Klee

**Dated and inscribed on the
mount, bottom center:** *1937 V17
Julia*

Provenance: purchased in
August 1966 by John Torson,
New York, at auction at Lem-
perz, Cologne, sold May 1967 to
Felice Wender of Dayton's Gal-
lery 12, Minneapolis, sold in
October 1967; Kunstadter
Collection

Gift of the estate of Maxine W.
Kunstadter, in memory of Sig-
mund Kunstadter, class of 1922

1983/1.405

Paul Klee's *Julia* is one of a number of drawings from 1937 that mark an important turning point in the artist's development. Following a series of professional, personal, and physical crises that had brought his creative production to a virtual halt, Klee commenced a process of experimentation that dramatically reinvigorated his art. Already an acknowledged master of the graphic medium, he sought to fuse his drawing style with a more powerful, painterly approach.

Julia is one of his earliest "brush-drawings," and is an example of the importance the large, flat, and vigorous line would have in his work. By loading the brush with a fluid black paste, Klee combined the rich effects inherent in gouache or oil with the graphic qualities resulting from the limitation of black on white. In addition, the broad, assertive stroke was the antithesis of Klee's previous tendency toward an intimate but sometimes fragile line, giving his new work a strength and monumentality that transcended its actual size.

Klee wrote that "the formal elements of graphic art are the dot, line, plane, and space – the last three charged with energy of some kind" ("Creative Credo," quoted in *Paul Klee. Watercolors. Drawings. Writings.*, trans. by Norman Guterman, second ed., New York, 1969, p.5). In *Julia*, Klee minimizes his composition to these few entities, revealing his debt to the reductive art of children. Yet, while his drawing is whimsical, it is not naive; its abstract, minimal nature reflects choices that mirror the development of modern art.

KW

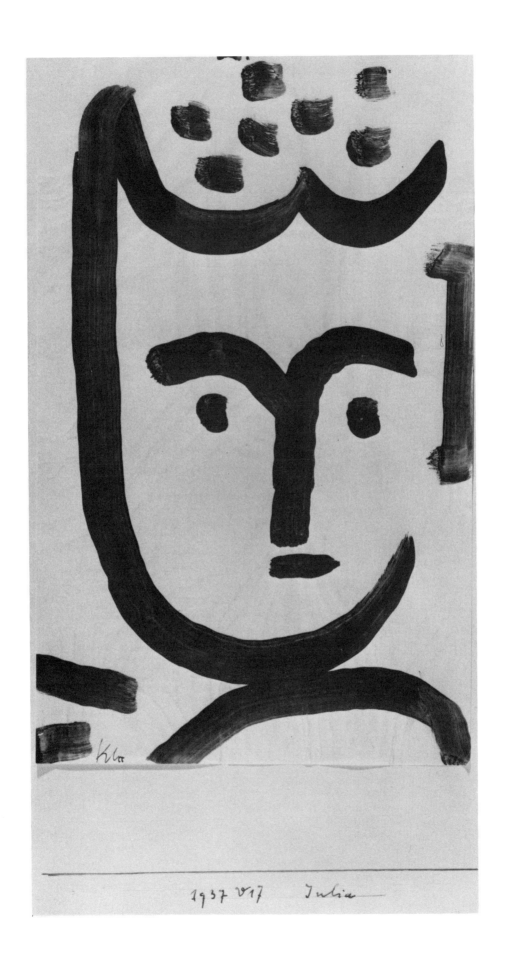

1937 V17 Julia

PAUL KLEE

A WALK WITH THE CHILD (EIN GANG MIT DEM KIND)

1940

Black crayon on off-white paper, mounted on heavier paper

Watermark: a beaver on a dam

19⅜ x 13¾ in. (492 x 349 mm)

Signed in red ink, l.l.: *Klee*

Dated and inscribed in ink on the mount, l.c.: *1940 S13 ein Gang mit dem Kind*

Inscribed in pencil on the mount, l.l.: *Ein Gang mit dem Kind S13*

Exhibitions: Saginaw 1954; Lincoln 1957; AFA 1957-58; East Lansing 1959-60; Ann Arbor 1965-66; Ann Arbor 1966; Ann Arbor, The University of Michigan Museum of Art, "Homage to Arnheim: Principles of Art and Visual Perception," 1985

References: Jean Paul Slusser, "Drawings by Moore and Klee," *UMMA Bulletin*, 1952, 15-19, fig. 6; *Eighty Works ... A Handbook* 1979, no. 74; Jean Paul Slusser, "Art in Review: Display at Rackham Building Features 20th-Century Drawings," *The Ann Arbor News*, 7 December 1966, 27

Provenance: Galerie Louise Leiris, Paris

1951/2.38

Of the over 9000 works Paul Klee produced during his lifetime, nearly 5000 were drawings. Michigan's *Ein Gang mit dem Kind* dates from January of 1940, when Klee was in the last stages of a terminal illness. According to Jürgen Glaesemer, the designation "S 13" identifies the work as number 153 in the artist's personal inventory (letter in object file, 7 January 1986). There are at least fifteen drawings in the Paul Klee Stiftung in the Kunstmuseum in Bern, all quite similar in style, medium and execution, in this "S" series, and several of these make reference to children in their titles (Bern, Kunstmuseum, *Paul Klee Handzeichnungen III: 1937-1940*, Bern, 1979, pp. 361-65; 456-57).

The simplicity and concentrated expression of this work is characteristic of Klee's last drawings. He preferred working in pencil, not only because the technique was less taxing on his diminishing strength, but because it emphasized his formal concerns. The dark crayon creates a line of medium weight that is flexible but sure in its articulation.

This work is closely related to Klee's *Torch Bearer* of the same year (see Will Grohmann, *Paul Klee Drawings*, New York, 1960, p. 163). Both are dated and numbered by the artist as part of the same sequence, and are so similar in mood and execution that the two works may well have been drawn during the same session. Here again is the continuous bounding line, which Klee used to create wide-eyed monumental figures that fill the page as they look out at the viewer. Klee carefully chose his works' titles after their completion, as he considered words to be an additional way of communicating his intentions. While not specifically part of the ensemble, both drawings may be associated with one of Klee's last major series, "The Eidola" ("The Archetypes"), which is contemporary with the creation of the Michigan drawing.

KW

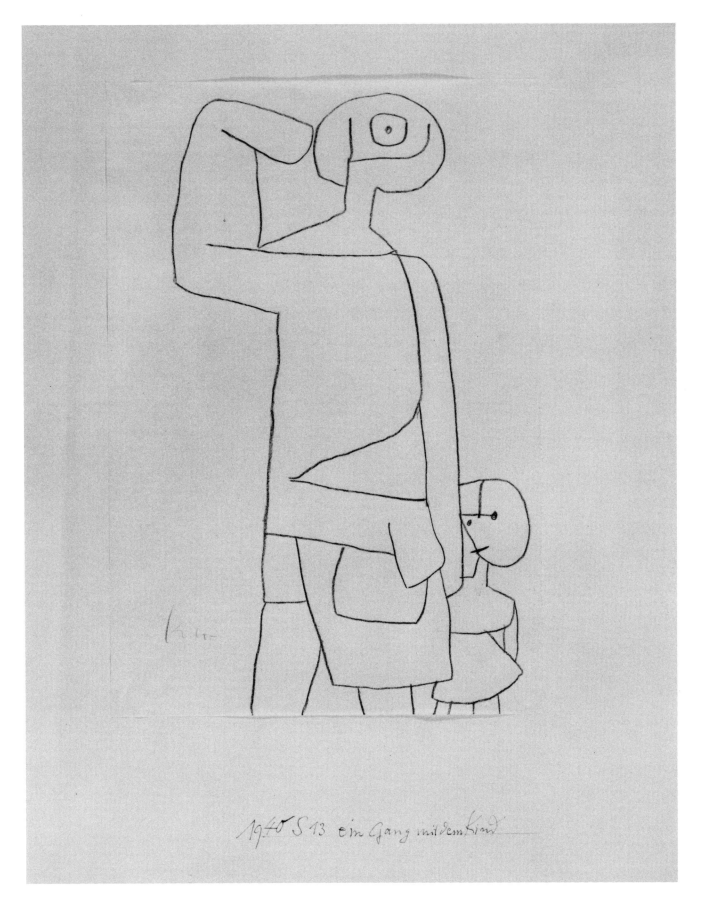

1940 S 13 ein Gang mit dem Kind

52

HANS HOFMANN

American (born Germany)
1880-1966

UNTITLED (Double-sided drawing)

Ca. 1952

India ink on paper

14 x 10¹⁵/₁₆ in. (355 x 278 mm)

Signed recto, in white ink, l.c.: *hans hofmann*

Inscribed verso, in blue ink, l.r.: *M607-2 / SP4*

Inscribed verso, in pencil, l.c.: *3270*

Exhibitions: Washington, D.C., Corcoran Gallery of Art, "Hans Hofmann: Fifty-Two Works on Paper," 1973; Michigan Artrain, "The Changing Canvas," 1980

References: "Acquisitions July 1, 1971–June 30, 1976," *UMMA Bulletin*, 1976-77, 32

Provenance: estate of the artist, to the André Emmerich Gallery, New York, purchased from exhibition in 1973

Purchase through the Friends of the Museum

1973/2.2

*T*he career of Hans Hofmann was marked by great stylistic diversity and innovation. His artistic fluctuations are not surprising, however, as he straddled two continents; his early roots were in the School of Paris, and later he became allied with German expressionism and American abstract expressionism. While Hofmann is associated with a highly colorful art, he struggled repeatedly with the dynamics of black and white, as in this untitled drawing.

For Hofmann, as with many painters, drawing was a means of exploring new pictorial problems and performing graphic exercises. Even between the years 1915 and 1938, when Hofmann virtually abandoned painting to devote his energies to teaching, he continued to draw regularly. Throughout his career, he remained preoccupied with the dynamics of the picture plane, a concern he repeatedly voiced in his classes and theoretical writings. Another constant in his career was an attachment to nature, taking external reality as a point of departure even in his most non-objective works.

These two abiding considerations find expression in the Museum of Art's double-sided drawing of 1952, one of many such works executed in that year. The starkly contrasting black and white encourage both a positive and negative reading, with dark and light alternating as figure/ground. More than an abstract exercise, this image was inspired by Hofmann's surroundings. It has been suggested that this sketch makes particular reference to an oscillating fan in the artist's own studio, loosely conjured here through radiating lines and roughly hewn blade contours (lecture by Professor Al Mullen at the Museum of Art in 1973; Mullen studied with Hofmann).

SR

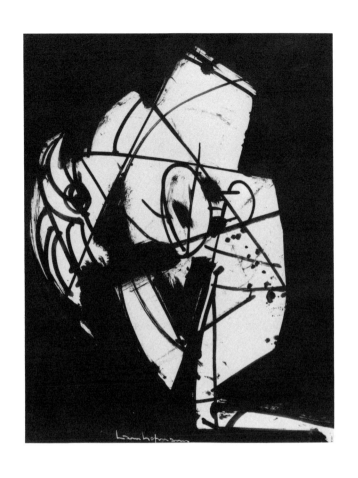

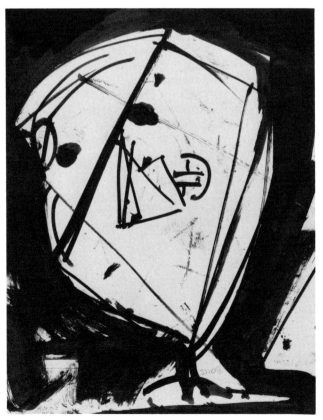

ERNST LUDWIG KIRCHNER

**German
1880-1938**

SEATED WOMAN (GERDA SCHILLING)

1913

Pencil on off-white satinized paper

21 x 15¼ in. (533 x 387 mm)

Exhibitions: Saginaw 1954; AFA 1957-58, no. 44; East Lansing 1959-60; Iowa City 1964, no. 141; Ann Arbor 1966

References: *Handbook* 1962, no. 44 repr., "European and American Art: 20th Century," *The Research News*, The University of Michigan, XXII, 2 and 3, August-September, 1971, 36, 23 repr.

Provenance: Frankfurter Kunstkabinett, Frankfurt

1951/2.44

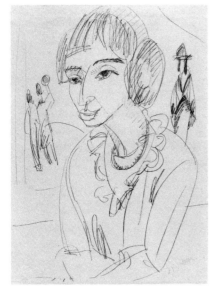

Fig. 53a *Bust of a Woman*, 1913, pencil (530 x 390 mm), The Art Institute of Chicago, Print and Drawing Club Fund (51.55).

*I*n 1911 in Berlin, Ernst Ludwig Kirchner met Gerda Schilling and her younger sister Erna, who was to become his lifelong companion. The women, daughters of a printer, had left home owing to ill-treatment by their stepmother, and while they resided in the city they earned their livelihood as dancers. Both Erna and Gerda epitomized Kirchner's ideal of feminine beauty, and they frequently served as his models. By 1916, the year Gerda mysteriously disappeared, she sat for at least three portraits in oil, two portrait etchings, and two portrait lithographs (see Donald E. Gordon, *Ernst Ludwig Kirchner*, Cambridge, Massachusetts, 1968, p. 320, no. 375; p. 324, no. 400; p. 327, no. 422; and Annemarie and Wolf-Dieter Dube, *E.L. Kirchner: Das Graphische Werk*, Munich, 1967, nos. 163, 196, 209 and 285, respectively). It is likely that Gerda also posed for many of Kirchner's numerous scenes of dancers, bathers, nudes, and figures in interiors.

Kirchner drew several portraits of Gerda in a variety of media. She appears as a *Seated Dancer* in a pencil portrait from 1913 in Darmstadt (see Roman Norbert Ketterer, ed., *Ernst Ludwig Kirchner: Drawings and Pastels*, New York, 1982, pl. 37), and is represented with her sister in a conversation piece of 1912 (see Berlin, Galerie Nierendorf, "E.L. Kirchner zum fünfundzwanzigsten Todestag: Aquarelle, Bilder, Zeichnungen," 1963, no. 15). Two ink drawings of Gerda of identical size in private collections probably come from the same sketching session (see Ketterer, *ibid.*, pl. 55; and R.N. Ketterer, *E.L. Kirchner*, Lugano, 1963, n.p.). Closest to the Michigan drawing is a pencil portrait in Chicago (Fig. 53a); both the Museum of Art and Chicago drawings might be the the result of a single sitting. Kirchner has simplified Gerda's prominent features – her large eyes, aquiline nose, full mouth, long neck, and coiled coiffure – to create clear, geometric forms, that give the figure its monumentality. Traditionally, the Chicago drawing has been entitled *Bust of a Woman Seated in Front of a Painting*, but no particular picture has been named. It has also been proposed that the figure on the right in the painting in a Japanese costume may be an allusion to Gerda herself, who appeared on the stage in such attire (see Ketterer, *ibid.*, pl. 39). Whatever the source of this secondary figure, its presence animates the composition, adding the psychological element that is typical of Kirchner's portraits of this haunting young woman.

HF

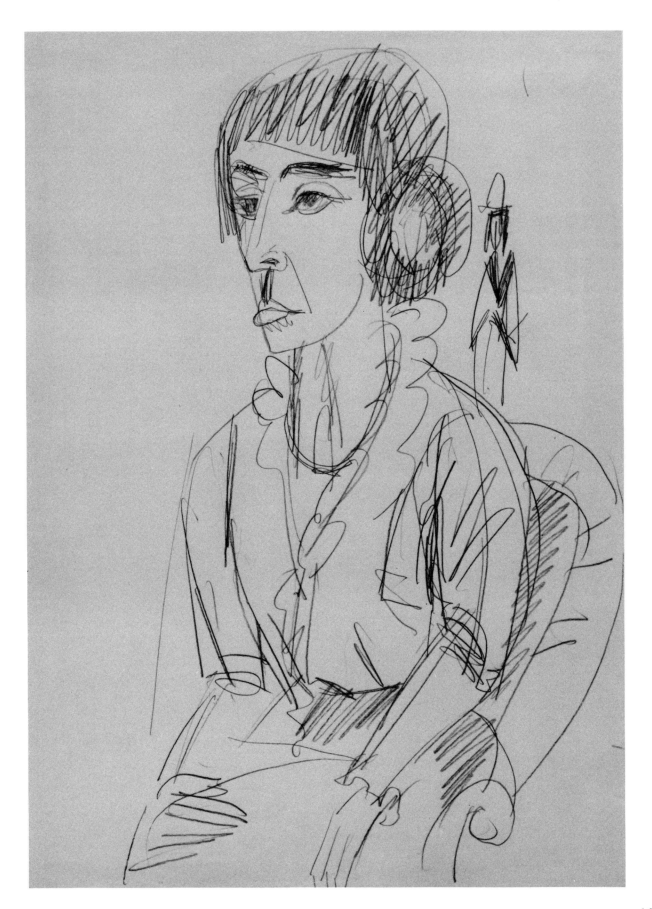

54

HEINRICH NAUEN

German
1880-1940

STUDY FOR
"THE HARVEST"

1909

Watercolor and colored crayons
over pencil on beige wove paper

9⅝ x 14½ in. (245 x 369 mm)

Signed and dated l.r.: *H. Nauen 09*.

Provenance: E. Weyhe, New York

1950/1.168

Fig. 54a *Peasant with Raised Fist (Bäuerin mit erhobener Rechten)*, 1909, charcoal (265 x 170 mm), Städtisches Museum Abteiberg, Mönchengladbach.

Nauen's youthful works reflect his grappling with and assimilation of the styles and subject matter of modernist pioneers such as Cézanne, Gauguin, and Van Gogh, as well as those of artists affiliated with the School of Pont Aven and the Fauves. In the watercolor, *Study for "The Harvest*," the bold, sinuous contours delineating the fields, the elevated viewpoint, the high horizon line, and the theme of peasant labor are reminiscent of Breton paintings by Bernard and Gauguin. Nauen's workers possess greater vigor than their post-impressionist forebears, especially in their contorted, expressionistic poses that rhyme with the undulating lines of the landscape.

Like Courbet, Millet, and Pissarro before him, and like his German contemporaries and the Russian Malevich, Nauen discovered a heroic, primeval power in figures of manual laborers. Although he moved to Berlin in 1906 (where he was to remain for five years), many of Nauen's depictions of agrarian life date from the second half of the first decade of the twentieth century.

The Museum's drawing and a lost drawing very similar to it (reproduced in Max Creutz, *Heinrich Nauen*, Mönchengladbach, 1926) are compositional studies for a lost painting of *The Harvest*, 1909 (see Bonn, Städtisches Kunstmuseum, *Die Rheinischen Expressionisten: August Macke und seine Malerfreunde*, 1979, no. 12 repr.). A charcoal drawing dated 1909, of the standing peasant woman at the upper left of the Michigan watercolor, is owned by the Städtisches Museum in Mönchengladbach (Fig. 54a), and numerous other studies for the lost painting are also in private collections.
HF

FERNAND LÉGER

French
1881-1955

SEATED NUDE

Ca. 1911

Reed pen and ink, on tan paper,
mounted on cardboard

12³⁄₁₆ x 9⅛ in. (310 x 232mm)

Signed, l.c.: *FL*

Exhibitions: Omaha, Joslyn Art
Museum, "The Thirties Decade:
American Artists and their Euro-
pean Contemporaries," 1971,
67, no. 131; Ann Arbor 1982-83

Provenance: John Becker

1948/1.273

Fig. 55a *Standing Nude*, 1911, pen and ink
on tan paper (319 x 237mm),The University
of Michigan Museum of Art (1948/1.272).

From his time as a pupil at the evening drawing ses-sions in the studios of the Académie Julian and la Grande Chaumière, Léger sketched from the live model, the human form constituting the core of his art. While unfortunately he destroyed many of his early, deriv-ative paintings, numerous draw-ings of the nude, dating from 1905 to 1912, are extant. Works such as *Seated Nude* and *Standing Nude*, 1911 (Fig. 55a), also in the Museum of Art's collection, mark an important stage in his develop-ment, a point at which, Léger later noted, he concentrated on draw-ing, bringing order and clarity to his thought, and consequently, to his art (interview with Hans Heil-maier, published in Das *Kunstblatt* in January 1932, quoted in Claude Laugier and Michele Richet, *Oeuvres de Fernand Léger (1881-1955): Collections du Musée national d'art moderne*, 1981, pp. 101-102). Léger said he was led to focus on drawing by his admira-tion for Cézanne, who "taught him to love form and volume.... It was then I felt that drawing must be rigid, unsentimental" (quoted in Jean Cassou and Jean Leymarie, *Fernand Léger: Dessins et gouaches*, Paris, 1972, p. 20).

In these nude studies, drawn from a variety of angles and in dif-ferent poses, Léger reduced the figure to its geometric equivalents: the head is an oval; breasts, hips, legs, and thighs are graceful arcs and curves; hands and feet are schematized triangles and ellipses. Breadth of line suggests volume, shadow, and movement. In its simplicity and vigor, *Seated Nude* recalls Picasso's studies for *Les Demoiselles d'Avignon*, as well as the work of the modernist pioneer Archipenko, whom Léger admired.
HF

56

FERNAND LÉGER

COMPOSITION

1931

Pencil on off-white wove paper

9¾ x 12¹³⁄₁₆ in. (247 x 324 mm)

Signed and dated, l.r.: *F.L 31*

Exhibitions: MSCA 1967-68

Provenance: John Becker

1948/1.269

*I*n the early 1930s Léger explored a new pictorial language entitled "objects in space." The artist juxtaposed unrelated subjects – representations of living and inanimate things – which he painted and drew plastically and entirely out of scale, floating free on a neutral ground. *Composition*, 1931, belongs to Léger's new vocabulary of form, and may also reflect his first trip to America in that year, a journey made by ship. The conjunction of objects in *Composition* – an eye, a coiled shape representing a piece of cord or rope or smoke, and a horizontal form, perhaps a boat afloat – might allude to this voyage, and to Léger's play on the nautical terms, "aye," "sea," and "knot." This reading, along with the work's disjunctive scale and subject matter, is reminiscent of the experiments of the surrealists, and of the unofficial statement of the group, adopted from Isidore Ducasse, "le comte de Lautréamont," about "the chance encounter of a sewing machine and an umbrella upon a dissection table."
HF

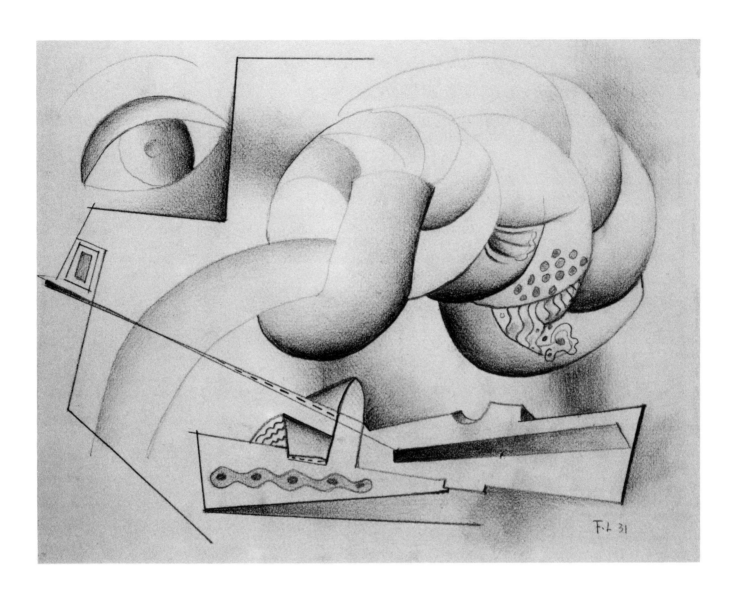

PABLO PICASSO

**Spanish
1881-1973**

WHITE HORSE

1919

Plumbago and charcoal on off-white charcoal paper

Watermark: J.WHATMAN 1909 ENGLAND

24 x 19⅜ in. (610 x 493 mm)

Signed in pencil, l.r.: *Picasso*

Exhibitions: Saginaw 1954; Oberlin 1956; Lincoln 1957; AFA 1957-58; UMMA 1959; The Fine Arts Gallery of San Diego, "The Horse in Art," 1963, no. 71; Northampton, Smith College Museum of Art, "Beauty in the Beast," 1964, no. 24; Ann Arbor 1966; Ann Arbor, The University of Michigan Museum of Art, "Homage to Arnheim: Principles of Art and Visual Perception," 1985

References: Christian Zervos, *Pablo Picasso III: Oeuvres de 1917 à 1919*, Paris, 1949, no. 410; Helen B. Hall, "Contemporary Drawings," *UMMA Bulletin*, 1950, 14, cover repr.; *Handbook* 1962, no. 43 repr.; "European and American Art: 20th Century," *The Research News*, The University of Michigan, XXII, 2 and 3, August-September 1971, 36-37, 23 repr.; Richard H. Axsom, "Pablo Picasso's 'Horse': A Master Drawing in Ann Arbor," *UMMA Bulletin*, 1979, 36-45, figs. 1-3

Provenance: John Becker

1948/1.285

*I*n his eloquent article (see above), Richard H. Axsom discussed Picasso's *White Horse* in the context of technique, style, and iconography. The firm, secure contours of the patrician animal, drawn in plumbago (a medium whose line is darker and richer than pencil), assert the horse's noble, intelligent, and creative potential. The lighter charcoal underdrawing, particularly apparent in the horse's bobbing head, moving forelegs, and flanks, is a deliberate, dynamic counterpoint to the stable plumbago outline. As Axsom noted, these agitated lighter lines suggest that the horse shifts nervously, moving at its knees, its head rocking up and down. Picasso has thus affirmed the controlled contours of plumbago over the animated charcoal lines to create a "double portrait" of the horse.

This direct yet dual image reflects a number of Picasso's stylistic concerns. The charcoal lines evoke an emotional animal in motion. They also suggest that the horse is simultaneously seen from a variety of angles – in profile, from a three-quarter's view and from the rear. The resulting sense of movement and the multiplicity of viewpoints recall the characteristics of futurism and cubism, while the overriding surety and tight control of the dominant image in plumbago, point to an adherence to a more rational, neoclassical aesthetic, which Picasso, in fact, began to explore at this time.

Although the *White Horse* is undated, it is clearly related to a number of drawings from around 1919. Furthermore, it is connected to other representations of horses from the period, executed as independent projects (see above, Zervos, *Pablo Picasso III*, nos. 112, 411; and *ibid.*, *XXIX*, nos. 428, 431) and for the ballets *Parade* (*ibid.*, *II*, no. 956) and *Le Tricorne* (*ibid.*, *XXIX*, no. 348), in which Picasso also suggested the bridled yet passionate aspects of the animal. The horse, like the minotaur, was important to Picasso's personal iconography, and Michigan's *White Horse* is thus representative of a potent subject which preoccupied the great twentieth-century master throughout his career.

HF

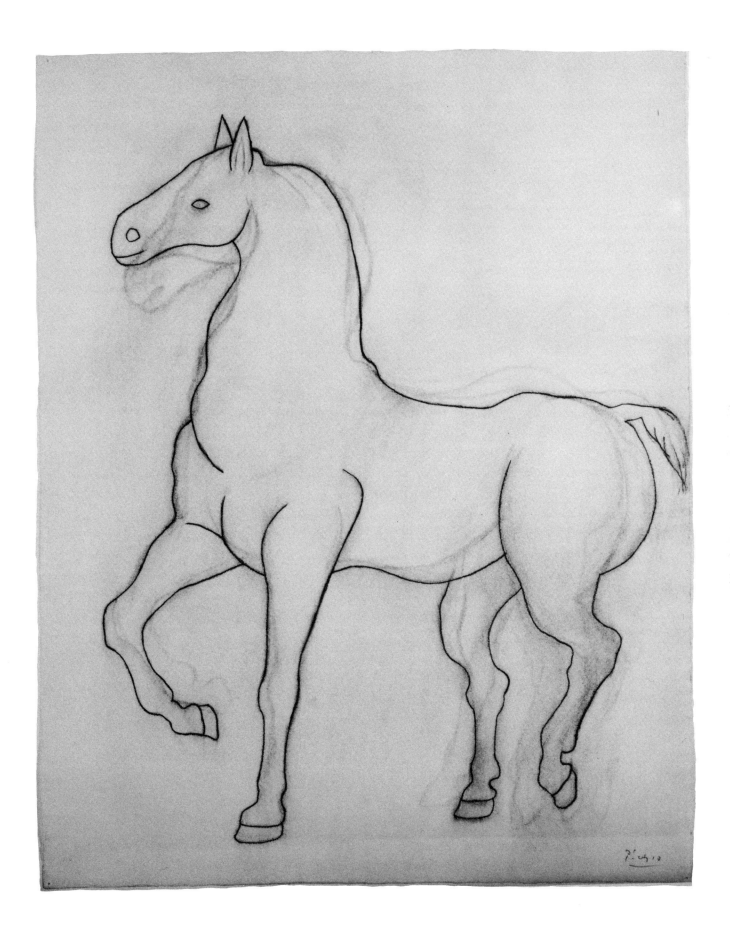

ERIC GILL

English
1882-1940

FEMALE NUDE (FROM JOANNA)

1927

Pencil on yellow laid paper

11⁹⁄₁₆ x 8¾ in. (283 x 222 mm)

Signed, l.r.: *Eric G.*

Inscribed and dated l.l.: *from Joanna / 3•4•27*

Exhibitions: Saginaw 1954; AFA 1957-58 no. 27; East Lansing 1959-60; East Lansing 1963

References: Helen B. Hall, "Contemporary Drawings," *UMMA Bulletin*, 1950, 14

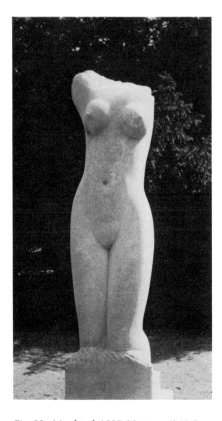

Provenance: E. Weyhe, New York

1948/1.88

Not surprisingly, Eric Gill the sculptor, printmaker, designer, and typographer, was also a draughtsman of great power and finesse. It was peculiar, therefore, that although Gill had represented the human figure in his early and mature works, he only first drew from the nude model in 1926, when he was already a well-established, forty-four-year-old professional. His explanation for this belated experience was that an artist should imbibe life and explore the world of the imagination before directly confronting nature: "If you are trying to draw from the naked model at all the best time to do it is rather later in life, when...living has filled the mind and given a deeper, a more sensual as well as a more spiritual meaning to material things." Gill was equally untraditional in his concern for his models' identities: "What is wrong with your friends and relations? Perhaps they haven't specially perfect figures; ...it is what is in your own head that matters most and not what the model has in his or her own body" (*Twenty-Five Nudes*, engraved by Eric Gill

with an introduction by the artist, London, 1938, n.p.). Michigan's study by Gill, *Female Nude (From Joanna)*, was drawn from his youngest daughter, born in 1910.

One cannot fault the conception of the figure in this drawing, in which Gill's modulation of form through lines of varying boldness, undulation, and shadow expresses the considerations of an artist who worked masterfully in two- and three-dimensions. The flatness of the outline of the model's upraised arms and the profile of her head reflect Gill's interest in the planar aspects of carving reliefs and of typographic design. The three-quarters view of the figure, turned in space, lends the study an illusion of volume. Moreover, the sinuous curves of the model's breasts, belly, back, buttocks and thighs, which are described by a softer line of varying thickness, (further emphasized by the rigorous X's and V's of Gill's unconventional cross-hatching technique), create the appearance of palpable flesh and three-dimensionality. The drawing, in a general way, is related to the subject of adolescence, which Gill explored more fully in his sculpture *Mankind*, 1927-28, (Fig. 58a) in the Tate Gallery. The composition, which beautifully illustrates Gill's formal concerns, stands between the polarities of the decorative and the sculptural, characteristic of the style of Art Deco of the latter half of the 1920s.

HF

Fig. 58a *Mankind*, 1927-28, stone (241.3 x 61 x 45.7 cm), The Tate Gallery, London.

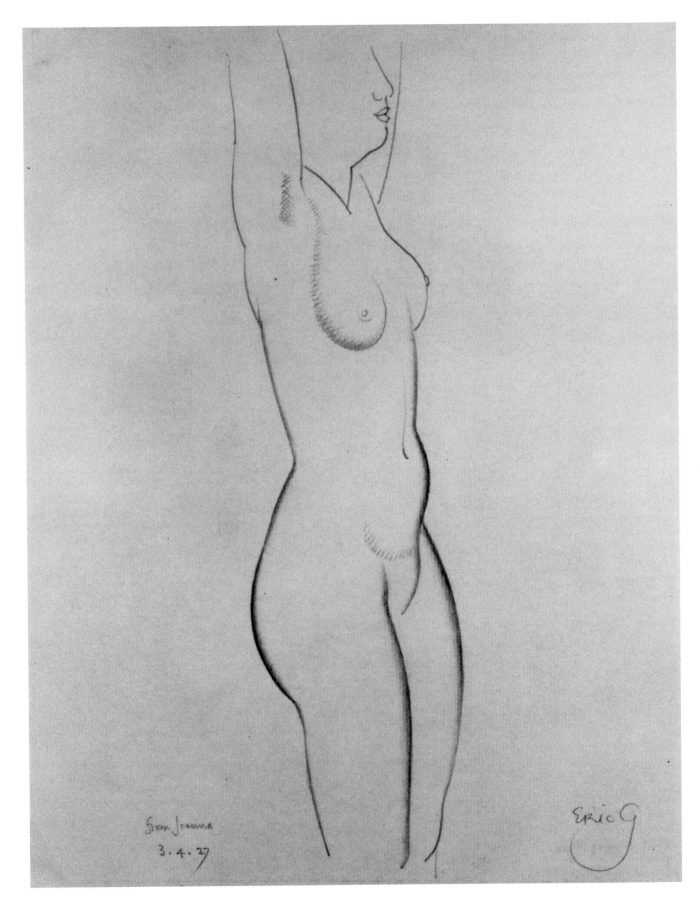

from Joanna
3.4.27

Eric G

171

59

GASTON LACHAISE

American (born France)
1882-1935

BACK OF NUDE WOMAN

1920s

Pencil on off-white wove paper

18 x 11¹⁵⁄₁₆ in. (457 x 303 mm)

Signed l.r.: *G Lachaise*

Exhibitions: Saginaw 1954; AFA 1957-58, no. 15; East Lansing 1959-60; Flint 1961; East Lansing 1963; Ann Arbor, The University of Michigan Museum of Art, "Paris and the American Avant-Garde 1900-1925," (traveled to: Kalamazoo Institute of Art; Alpena, Jesse Besser Museum; St. Joseph, Krasl Art Center; East Lansing, Michigan State University, Kresge Art Center; Jackson, Ella Sharp Museum), 1981, no. 12 repr.; Ann Arbor 1982-83

Reference: Helen B. Hall, "Contemporary Drawings," *UMMA Bulletin*, 1950, 13

Provenance: estate of the artist, to E. Weyhe, New York

1948/1.90

The heroic female body, symbolic of earth mother and the progenetrix, occupied a large portion of Lachaise's sculptural and graphic oeuvre. His standing women, expressive of nature's most primal, powerful, sexual force, found inspiration not only from prehistoric sculptures and bas-reliefs (such as the Venuses of Willendorf and Lespugue), but in the artist's own experience, for his voluptuous wife Isabel frequently served as his model. As an example of the recurrent motif of standing females, *Back of a Nude Woman*, also recalls the *Medici Venus* in its monumentality and in the demure placement of hands and cloth.

In the late teens and 1920s, Lachaise increasingly experimented with standing females in motion. Although his drawings are undated, and rarely serve specifically as preparatory studies for sculpture, *Back of a Nude Woman* relates to this group. The wonderfully sinuous pencil line that describes the nude's contours, and her delicately pointed toe and gentle contrapposto, lightly elevate the figure and mitigate her bulk. To paraphrase Gerald Nordland, Lachaise's standing nudes exude sex and mystery. They are divinities, in their prime and primal, presiding over creation and destruction (*Gaston Lachaise: The Man and his Work*, New York, 1974, p. 74).

HF

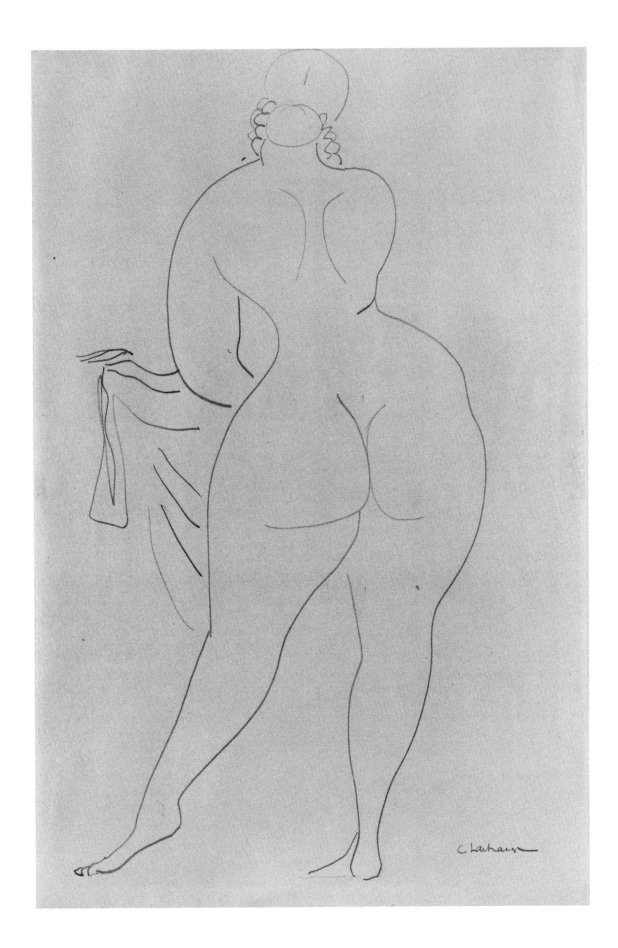

CHARLES DEMUTH

**American
1883-1935**

TWO FIGURES

1917

Watercolor and pencil on off-white tracing paper

Watermark: [...] UNE / LINEN / G / IRIS [...]

13 x 8 in. (330 x 203 mm)

Signed and dated l.l.: *C. Demuth.'17*

Exhibitions: Santa Barbara, University of California, The Art Galleries, "Charles Demuth: The Mechanical Encrusted on the Living" (traveled to: Berkeley, University of California, University Art Museum; Washington, D.C., The Phillips Collection; Utica, Munson-Williams-Proctor Institute), 1971-72, no. 36, 80

References: Helen B. Hall, "Five New Drawings," *UMMA Bulletin,* 1951, 15-19

Provenance: Arthur B. Davies Collection; E. Weyhe, New York

1950/1.166

Between the years 1915-17, Charles Demuth painted almost one-fourth of his total oeuvre of almost 900 works. Michigan's *Two Figures* is an excellent example of Demuth's mature style and watercolor technique. Beginning in 1915, Demuth experimented with the blotter method of watercolor, carefully applying color with a brush, then wiping away the excess moisture before drying. This technique was used to great effect – it created the sensual tones and delicacy of modeling seen in this drawing, typical of Demuth's style.

The intimate subject matter of *Two Figures* is related to a number of drawings Demuth did as illustrations for Emile Zola's controversial book, *Nana,* the story of a prostitute's life. Henry McBride, the art critic, commented in 1917 upon Demuth's work at the Daniel Gallery, in New York:

>...There are some watercolors that have not been hung on the walls. The subjects have been suggested by reading Zola's *Nana.* They are kept hidden in a portfolio, and are shown to museum directors and proved lovers of modern art....They are quite advanced in style.... Mr. Daniel...showed us all, surreptitiously, some figure drawings. They were not precisely shocking, but one or two of the drawings illustrated points in *Nana,* and just before the war we were sufficiently Victorian to shudder at the thought of exposing pictures of reprehensible *Nana* on the walls...Times, of course, have changed greatly since then ... but by the time our collectors had realized that 'Nanas' had become perfectly all right...the entire lot of Mr. Demuth's figure drawings had been swept into some specially well-hidden collection, and it was announced that the artist was not to do any more figures! (from *The New York Sun,* 25 November 1917, quoted in Alvord L. Eiseman, *Charles Demuth,* New York, 1982, p. 27)

Demuth's watercolors express his evident love of color and form. He stated: "Painting must be looked at and looked at and looked at – they (the good ones) like it. They must be understood, and that's not work either, through the eyes. No writing, no singing, no dancing will explain them. They are the final, the *nth* whoopee of sight. A watermelon, a kiss may be fair, but after all have other uses. 'Look at that!' is all that can be said before a great painting, at least by those that really see it" (*ibid.,* p. 27).

Marsden Hartley (*46*) knew Demuth well and observed, "Charles never made a bad picture...[he] loved the language of paint with the fervor of an ardent linguist..." (*ibid.,* p. 27).
LA

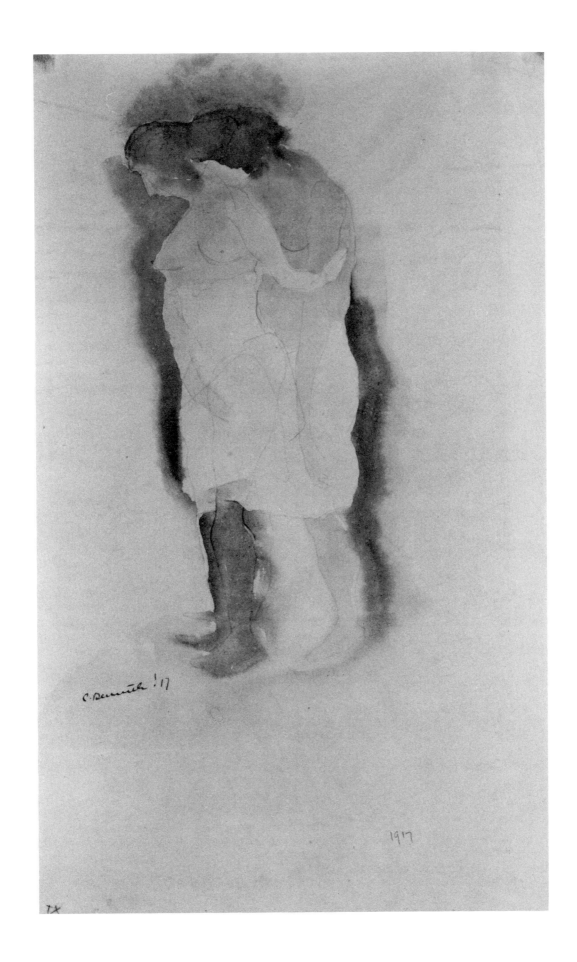

C. Demuth !17

1917

TX

MAX BECKMANN

German
1884-1950

STILL LIFE WITH TOYS AND SHELL

1934

Watercolor on pink paper

Watermark:
INGRES / L'ECOLIER / C & F

24¹³⁄₁₆ x 19 in. (630 x 483 mm)

Signed and dated, l.r.: *Beckmann / Dez. 34*

Exhibitions: Ann Arbor, The University of Michigan Museum of Art, "Pechstein to Penck: German Expressionist Art," 1985

References: Jean Paul Slusser, "Four Contemporary Water Colors," *UMMA Bulletin*, 1951, 15-19

Provenance: E. Weyhe, New York

1949/1.183

The year 1934 was a particularly bitter one for Max Beckmann. He had just suffered the humiliation of seeing his works removed from German museums, under order from the new Nazi regime to stop the display of all "degenerate art." Beckmann's troubles with the Nazis had begun the year before, with his dismissal from his teaching position at the Städel Academy in Frankfurt. Suddenly the popular artist found himself forsaken by former friends and colleagues, many of whom, says Stephen Lackner, "pretended not to know him anymore. Silence surrounded the erstwhile celebrity" (*Max Beckmann: Memories of a Friendship*, Coral Gables, 1969, p. 20). Shortly after his dismissal he moved with his wife to Berlin, feeling that the largeness of the capital city would give him the anonymity he needed to pursue his art. But his newest works went unsold; few collectors were brave enough to buy Beckmann's paintings, termed by the Nazis as "un-German." This last slur was especially difficult for Beckmann to bear; and by 1934, the quintessential German expressionist "had become a lonely figure," whose fiftieth birthday – 12 February 1934 – passed without a single mention in his country's press (*ibid.*, p. 16).

While Michigan's drawing gives little hint of the turmoil Beckmann had suffered during the past years at the hands of the new order, it can be read in several different ways. On the surface it is a marvelously engaging work, intimate in scale and subject matter, and alive with a child-like charm unusual for the characteristically grim Beckmann. The date indicates it was painted in December, and indeed, a festive aura of new toys and holiday delights pervades this refreshingly naive piece. A horn-blowing toy soldier rides a pink giraffe across a table littered with a child's treasures – a beautiful conch shell to hear the roar of the sea, four more toy soldiers, a tasseled pink fez to play dress-up, a curled horn and a lute to make noisy, cheerful music. Stephen Lackner, a friend and collector of the artist's works, observed: "Indeed, Beckmann's objects have some toy-like traits: the child, like the primitive, is surrounded by magically animated things. Each object can turn into a subject having its own well-defined character and action radius. Yet this childishness has a deeper significance: it brings back the lost naiveté with all its nostalgic charm" (*ibid.*, p. 60).

But Lackner also queried the artist's deeper intentions: "Can we trust the childlikeness of the erstwhile satirist? Is it really Beckmann's opinion that one can go around objects without wariness, that there are exits out of every impasse, that the domination of the world has become a child's play?" (quoted in *ibid.*, p. 62) Beckmann's persecution was the direct result of the Nazis' repressive view of art, expressed by the newly installed director of the Essen Museum, Count Baudissin, who stated: "the greatest work of art is the German soldier's steel helmet" (quoted in *ibid.*, p. 21). Beckmann's traumatic experience as a medic during World War I had given him a hatred of mindless militarism that was completely at odds with Hitler's regime. This drawing contains numerous objects that can be read as symbols of military authority – the fez, the horn, the soldiers. Perhaps it is not too surprising that Beckmann has reduced the terrifying enforcers of his country's new domination – the military – to mere toys in this drawing, easily moved, destroyed, or put away at a boy's whim.

Beckmann's demanding and frequently gruesome oeuvre contains few pieces as charming as this drawing. As his friend Lackner observed: "Beckmann remains a nervous, complicated man who has gone through refined tortures and strange lusts. His temporary primitivity is only a try at salvaging some loveliness from the actual world" (*ibid.*, p. 62).

LA

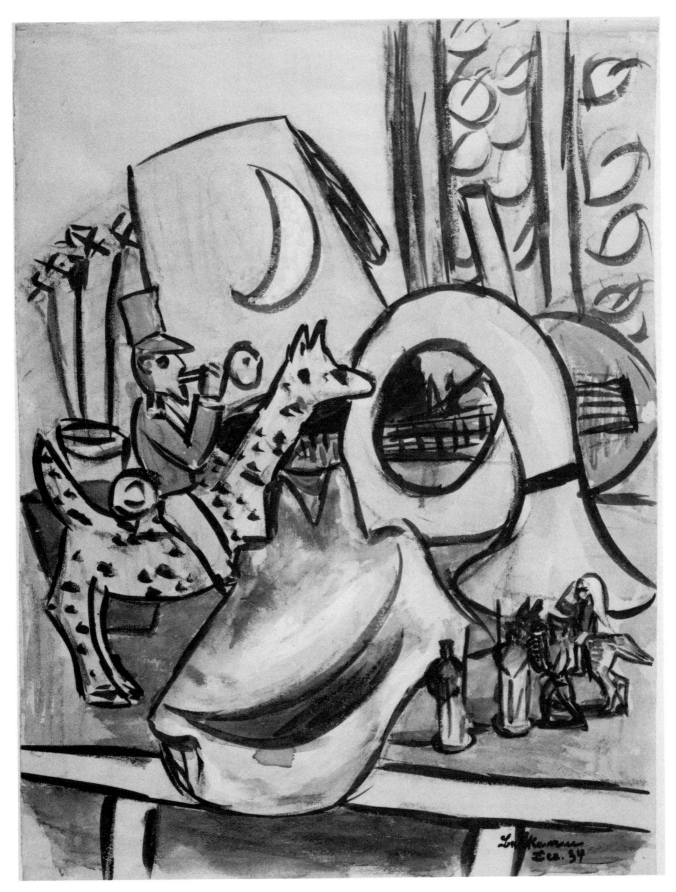

177

JULES PASCIN

**American (born Bulgaria)
1885-1930**

SERAGLIO: TUNIS

1920-21

Pen and watercolor on beige wove paper

17⅞ x 14 in. (454 x 356 mm)

Signed in pencil, l.r.: *pascin*

Inscribed verso, top center: *Tunis*

Exhibitions: Durham, University of New Hampshire, University Art Galleries, "Drawings and Paintings of Jules Pascin," 1978

References: Alfred Werner, *Pascin*, New York, n.d., fig. 45

Provenance: John Becker

1948/1.214

Pascin's cosmopolitan art and life, like that of Toulouse-Lautrec (to whom he has been compared), included familiarity with many fringe milieux – circuses, night clubs, bordellos. The lore concerning the Bulgarian-born Pascin's youth is contradictory and full of fabrications, but Pascin purportedly learned to draw while under the aegis of a madam who befriended the sixteen-year-old youth. Whatever the facts, Pascin led a lively artistic existence, first in Munich in 1903-1904, where he contributed to the magazines *Jugend* and *Simplicissimus*; then in Paris where he lived in Montparnasse and then in Montmartre, becoming a major figure in the School of Paris; and by 1914 in New York, where he immediately joined an artistic community that included Guy Pène du Bois, Max Weber, and the collector John Quinn.

Pascin's peripatetic existence led him not only to many European capitals and throughout America, but also to the Caribbean and North Africa; he visited Algeria in 1921 and returned there and traveled to Tunisia in 1924.

When *Seraglio: Tunis* was treated by conservators in 1977 and its backing removed, the inscription "Tunis" on the verso first became visible, but there is no proof that the drawing was executed there, and Alfred Werner, who has written about Pascin, dates it to 1920-21, i.e., before Pascin's North African trip. With its unflattering emphasis on overweight prostitutes, its looming foreground, elevated vantage point, and strange, funnel-like space, it is similar to other watercolors depicting social outcasts from the early 1920s, such as *The Prodigal Son*, 1921 (see above, Alfred Werner, *Pascin*, pl. 13).

Pascin was an inveterate draughtsman, who left thousands of sketches and watercolors after his suicide in 1930. His quick, agitated line and uncanny ability to capture with great ease the characters of his friends and those around him, led George Grosz (71), who had met him in 1905 in Paris, to write to Pascin later of his high estimation for this artist's talent: "We would all stand around your table and watch with admiration" (quoted in Alfred Werner, "The Draftsmanship of Jules Pascin," *The Painter and the Sculptor: A Journal of the Visual Arts*, I, 4, Winter 1958-59, p. 10).

HF

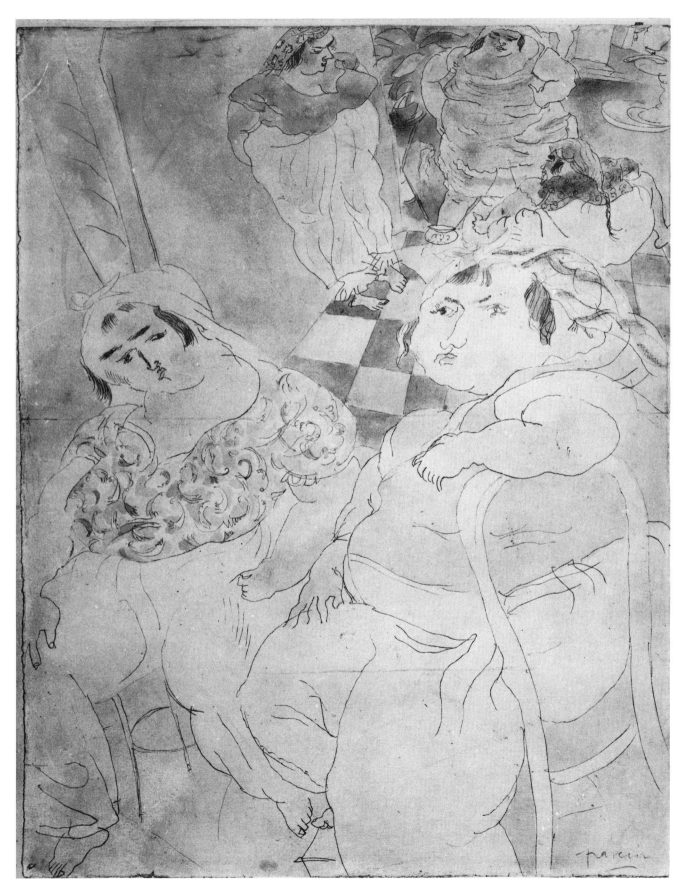

63

ALEXANDER ARCHIPENKO

American (born Russia)
1887-1964

BATHER

1921

Pencil and red conté crayon on off-white wove paper

Watermark:
FIER VIDALON-LES-ANNONAY B CRAYON ANC[...]

19⁹⁄₁₆ x 12⁹⁄₁₆ in. (491 x 319 mm)

Signed and inscribed l.l.:
Archipenko

Exhibitions: Lawrence, University of Kansas, "Contemporary Drawings and Others," 1949-50; AFA 1957-58; East Lansing 1959-60; Flint 1961; MSCA 1967-68; Ann Arbor 1982-83

References: Helen B. Hall, "Contemporary Drawings," *UMMA Bulletin*, 1950, 12; Alexander Archipenko et. al., *Archipenko: Fifty Creative Years 1908-1958*, New York, 1960, fig. 253

Provenance: E. Weyhe, New York

1948/1.85

*U*ntil Archipenko published Michigan's drawing as "Bather" and dated it to 1921 in his book *Archipenko: Fifty Creative Years 1908-1958* (see above), the undated work was simply titled *"Female Nude Bending Sideways."* The research of Donald Karshan has made it possible to place the drawing within the group of studies of bending, kneeling, and seated nudes that Archipenko drew in the early 1920s, some of which he used as preparation for his prints (*Archipenko: The Sculpture and Graphic Arts including a Print Catalogue Raisonné*, Tübingen, 1974, pp. 72-113, passim).

In 1923, the art historian Erich Weise wrote that Archipenko's works were typical of sculptor's drawings: "Air is space: in the drawings we see the contours framed by their shadows at a certain distance, thus capturing the atmosphere between themselves and the body ... And thus originate such perfect creations of rhythm, beauty of space and form, in which several colors and tonalities are sometimes used" (quoted in *ibid.*, pp. 62-63). By employing softly modulated hatchings in black pencil to suggest shadows on the flesh, and more vigorous, diagonal strokes in red crayon to evoke the body's movement in space, and leaving the sheet untouched for highlights on the bather's figure, Archipenko expresses in two dimensions the plasticity he labored for as a sculptor.
HF

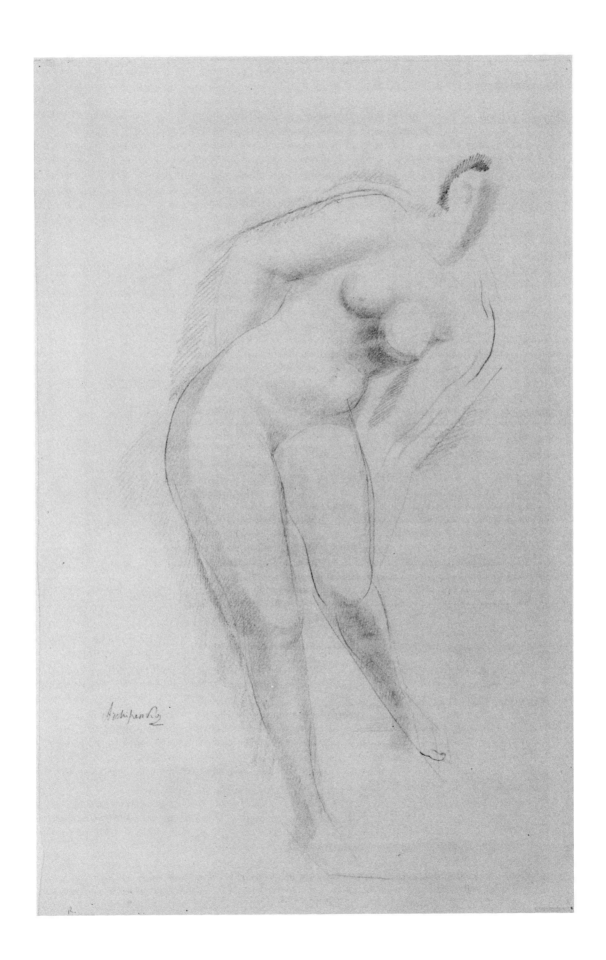

LE CORBUSIER (CHARLES ÉDOUARD JEANNERET)

**Swiss
1887-1965**

THREE FIGURES

1932

Pen, brush, and watercolor over pencil on off-white wove paper

Watermark: SPECIAL MBM

20½ x 28¾ in. (521 x 730 mm)

Signed and dated, l.l.: *Le Corbusier / 32*

Exhibitions: Ann Arbor 1966

References: Jean Paul Slusser, "Art in Review: Display at Rackham Building Features 20th-Century Drawings," *The Ann Arbor News*, 7 December 1966, 27

Provenance: John Becker

1948/1.211

The best-known paintings of the architect Le Corbusier date from the early 1920s when he, along with Amédée Ozenfant, explored the Purist canon. During the 1920s and 1930s, although he ceased exhibiting publically, Le Corbusier continued to evolve artistically, his freer figures in brighter colors supplanting the geometrically organized, monochromatic, and sober-toned still lifes of the Purist phase. From the later 1920s, painting and drawing occupied a significant portion of the architect's artistic endeavors. In 1965, shortly before his death, Le Corbusier wrote on the importance of drawing to his art:

> Drawing is a language, a science, a means of expression, a means of transmitting thought. Drawing, in perpetuating the image of an object, can become a document containing all the necessary elements to evoke that object, which itself has disappeared. Drawing permits the entire transmission of thought without the influence of written or verbal explanations
> Drawing for an artist is the means by which he searches, scrutinizes, notes and clarifies, the means of using what he wants to observe, understand and then to translate and to express....Each day of my life I have devoted partly to drawing. I have never stopped drawing and painting, searching for the secrets of form, wherever I could find them (Jean Petit, ed., *Le Corbusier dessins*, Geneva, 1968, n.p.).

Le Corbusier filled dozens of sketchbooks with various subjects and ideas during his lifetime. Many are records of personal observations. Michigan's *Three Figures* developed from such sessions, and treats two themes that concerned the artist in the later 1920s and 1930s – women in interiors and bathers at the shore. In the summer of 1932, which he passed at the resort of Le Piquey on the Arcachon Basin off the Bay of Biscay, Le Corbusier drew in at least two notebooks, sketching numerous figure studies; four of them relate to the two female figures in profile at the right of the Museum of Art's watercolor (Figs. 64a, b, c, d). These expressive, dishevelled women, drawn with a freedom of line more typical of de Kooning than Le Corbusier, are also reminiscent of Picasso's bathers from around this time. The bold color of the apparel of the women and their explosive gestures, in contrast to the rather placid, pink-costumed blond standing on the beaver-skin rug at the left, suggest that danger and distress are imminent. As Charles Sawyer mentions in this catalogue's introductory essay, Jean Paul Slusser purchased a magnificent group of drawings by twentieth-century artists from John Becker in Los Angeles in 1948. This drawing, and another by Le Corbusier in the collection entitled *Two Figures*, 1932, (Fig. 64e), may have been exhibited by Becker at his gallery in New York in 1933. A print from 1932, *Abstraction:Figure and Objects*, was also purchased from John Becker (1948/1.376).
HF

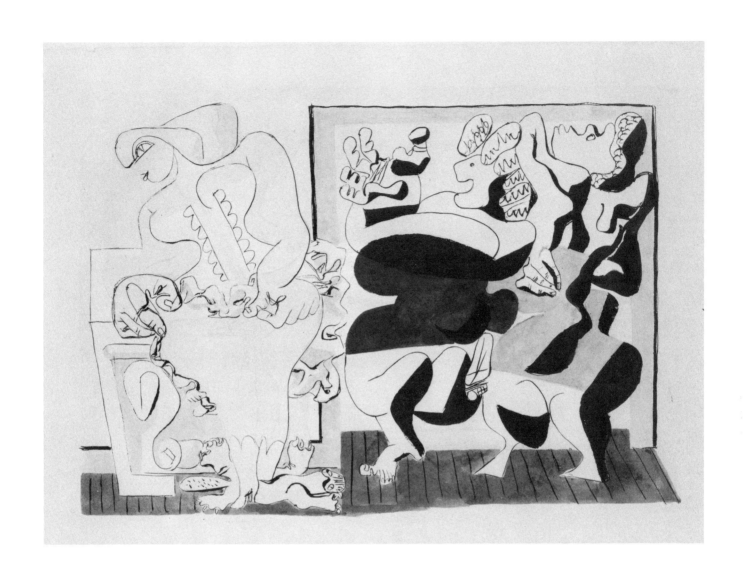

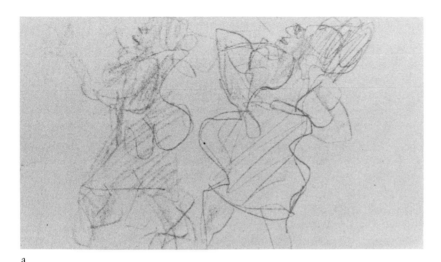

a

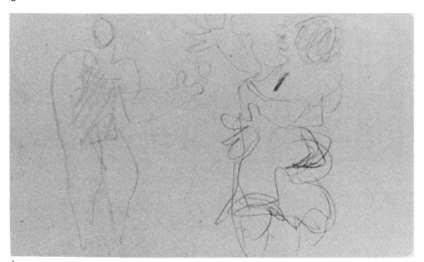

b

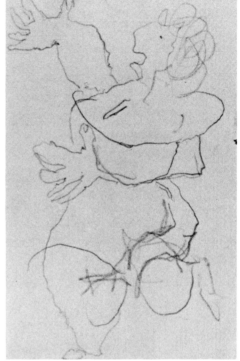

c

Fig. 64a *Sketchbook page*, 1932, colored pencil (100 x 180 mm), sketchbook B6, Fondation Le Corbusier, Paris.

Fig. 64b *Sketchbook page*, 1932, pencil (100 x 180 mm), sketchbook B6, Fondation Le Corbusier, Paris.

Fig. 64c *Sketchbook page*, 1932, pencil (165 x 100 mm), sketchbook B8, Fondation Le Corbusier, Paris.

Fig. 64d *Sketchbook page*, 1932, pencil (165 x 100 mm), sketchbook B8, Fondation Le Corbusier, Paris.

Fig. 64e *Two Figures*, 1932, brush and watercolor on white paper (718 x 508 mm), The University of Michigan Museum of Art (1948/1.212).

d

65

GERALD LESLIE BROCKHURST

**English
1890-1978**

PORTRAIT STUDY OF THE
ARTIST'S WIFE (Recto);
STUDY OF A FEMALE FIGURE
(Verso)

1920s

Pencil on off-white paper

17⅜ x 13⅞ in. (442 x 352 mm)

Signed l.l.: *G•L• Brockhurst / A.R.A.*

Signed l.r.: *GL• Brockhurst.*

Inscribed l.c.: *Portrait study of the
Artist's wife*

References: Sir Joseph Duveen,
*Thirty Years of British Art, The
Studio*, Special no., Autumn 1930,
115 repr.

Provenance: purchased in 1930
from the Savile Gallery, London,
by Margaret Watson Parker

Bequest of Margaret Watson
Parker, through Dr. Walter R.
Parker

1954/1.213

The precocious talent of Gerald L. Brockhurst emerged before the artist was twelve years old, at which time he entered the Birmingham School of Art. In 1907 he was admitted to the Royal Academy Schools in London, where he won numerous awards, culminating in the Gold Medal and Scholarship, the supreme accolade presented to R.A. pupils. After his period of studentship, Brockhurst traveled abroad and worked in Paris and Milan, where he was particularly attracted to the paintings of Botticelli, Piero della Francesca, and other artists of the fifteenth century. He passionately studied the art of Leonardo and his followers, learning from them how to represent solidity of form and the subtle use of light and shadow. Other professional and personal influences also imprinted themselves on Brockhurst's development. His half- and three-quarter-length paintings and etchings of females in shallow spatial fields pressed to the front of the picture plane and identified by exotic titles such as "*Anais,*" "*Melisande,*" or "*La Tresse,*" recall Brockhurst's Pre-Raphaelite forebears Rossetti and Sandys, and artists of the Aesthetic Movement. Perhaps Brockhurst's most important inspiration, however was his beautiful Basque wife, whom he had met by 1915, and who frequently sat as his model.

Brockhurst studied and assimilated the works of other artists, incorporating them into his own artistic temperament. *Portrait Study of the Artist's Wife* is reminiscent of drawings by Degas. The *contre-jour* effects of light which accentuate the silhouette of the seated figure who is posed against a window, and the informal yet contrived stance of the model, are found in Degas's portraits of the 1870s. The bold, parallel strokes of the pencil used to delineate light and shadow, and the solidity of the model, demonstrate that Brockhurst deserved the comments he received from one writer, who called him, at the time of the exhibition of his drawings at Colnaghi's in London in December 1924, "the most astounding academic draughtsman of the day" (quoted in Harold J.L. Wright, "Later Etchings by G.L. Brockhurst, A.R.A.," *The Print Collector's Quarterly,* XXI, October, 1934, p. 320).

Brockhurst was elected a member of the Royal Society of Painter-Etchers and Engravers in 1921 and a member of the Royal Academy in 1937.

HF

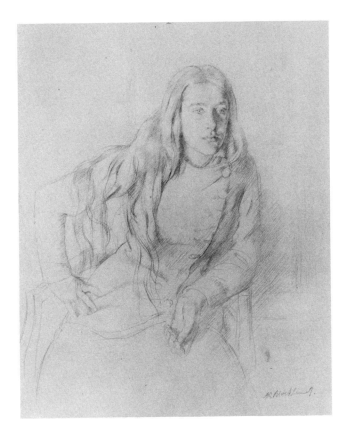

OSSIP ZADKINE

French (born Russia)
1890-1967

SEATED WOMAN HOLDING CHILD

Brown ink on beige wove paper, tipped down on blue paper

13⅜ x 10¼ in. (340 x 260 mm)

Signed l.r.: *ZAdkine*

Inscribed in pencil, l.l.: *femme assise / 169*

Exhibitions: AFA 1957-58, no. 47; East Lansing 1959-60; East Lansing 1963; Flint 1963

References: Helen B. Hall, "Contemporary Drawings," *UMMA Bulletin*, 1950, 14

Provenance: E. Weyhe, New York

1948/1.94

Zadkine executed numerous sculptures in wood, marble, bronze, and terra cotta, dealing with the theme of maternity, and of mothers and children. Although no sculpture related to the Michigan drawing has come to light, the volume, mass, and shadow suggested here link this sketch to Zadkine's three-dimensional works. The simplification of the forms, and the figures' mask-like faces, indicate the influence of African sculpture on Zadkine's art. *HF*

Femme assise
169

ZADKINE

OTTO DIX

**German
1891-1969**

**ARTILLERY DUEL
(ARTILLERIESCHLACHT)**

1917

**Charcoal and gouache on paper,
mounted on linen**

16 x 15⅝ in. (406 x 397 mm)

Signed l.l.: *DIX*

Exhibitions: Bloomington, Indiana
University Art Museum, "German
and Austrian Expressionism 1900-
1920," 1977, 28, pl. 14; Grand
Rapids Art Museum, "Pioneers:
Early 20th-Century Art from
Midwestern Museums," 1981,
no.11, repr.; Ann Arbor, The Uni-
versity of Michigan Museum of
Art, "Pechstein to Penck: German
Expressionist Art," 1985

References: "Acquisitions July 1,
1964–June 30, 1968," *UMMA
Bulletin*, 1969, 35, cover repr.

Provenance: private collection,
California; purchased in the late
1940s in Berlin by Alan Frumkin
Gallery, New York

1967/1.41

Otto Dix was a student
enrolled in the Dresden
Kunstgewerbeschule
when World War I
broke out in 1914. By the follow-
ing year he was a machine gun
guard for a field artillery regiment
on the Western Front. There, and
later in Russia, he was exposed to
the full horrors of trench warfare,
and it was in this environment that
he produced *Artillery Duel*. Dur-
ing the war years, Dix's artistic
work consisted mainly of drawings
– quickly done and easy to trans-
port. *Artillery Duel* is one of his
relatively few painted works from
this time.

The practical considerations that
necessitated a change in medium
brought about a change in Dix's
personal style. Although he was an
excellent draughtsman, he soon
found the precise academic render-
ings of his student days inadequate
to express the turmoil around him.
He looked to the example set by
the Italian Futurists, whose 1910
manifesto proclaimed their indus-
trially-inspired transformation of
art into images of "steel, of pride,
of fever, and of speed."

By 1917, however, Dix could no
longer pretend to see beauty in the
steel and fury of modernity. As
this drawing indicates, the forces
of destruction man has set into
motion are now beyond his control
and threaten to engulf him in a
cross-fire of slashing energies,
harsh colors, and shattered form.
The frightened being who stands at
the center of this drawing can only
add his silent scream.
KW

HENRI GAUDIER-BRZESKA

French
1891-1915

TWO PENGUINS

Ca. 1912

Brush and wash on off-white wove paper

10 x 7½ in. (254 x 190 mm)

Inscribed in pencil, verso bottom: *Gaudier Brzeska "Penguins" / Ex Zwemmer 1931. Ex Major Haldane MacFall. / Part of #140 College Art Ex. 1931-2*

Inscribed in pencil, verso, l.r.: *G.136*

Collector's stamp (not in Lugt), verso, l.l.: *D.F.P.*

Exhibitions: College Art Association Traveling Exhibition 1931-32; New York, Victor D. Spark, "Catalogue of the Exhibition and Sale of the Dan Fellows Platt Collection of Drawings and Watercolors...," 1949, no. 85; AFA 1957-58, no. 34; East Lansing 1959-60; Flint 1961; East Lansing 1963; MSCA 1967-68; Saginaw Art Museum, "The Animal Kingdom," 1970

References: Helen B. Hall, "Contemporary Drawings," *UMMA Bulletin*, 1950, 14

Provenance: Major Haldane MacFall; Zwemmer in 1931; Dan Fellows Platt by 1949, purchased from the exhibition of his collection at Victor D. Spark, New York

1949/1.206

Gaudier-Brzeska's art abounded with animal imagery, a penchant he shared with his German contemporary, Franz Marc, who was also killed as a young soldier in World War I. Before Gaudier-Brzeska's untimely death at the age of twenty-three – a loss mourned by Ezra Pound as one of the gravest blows the arts could endure – Gaudier had produced thousands of drawings, hundreds of them of animals, sketched on his trips to the Bristol and London zoos and to preserves such as Richmond and Arundel Parks. With whimsy, sensitivity, and surety Gaudier "captured" these two birds, not merely as ornithological specimens, but as animal personalities – the penguin on the left, well-fed and inquisitive, his large-beaked, scrawny companion a sort of antarctic adolescent.

Two Penguins came from the collection of Haldane MacFall, an important English critic who championed Gaudier's art. An additional drawing by Gaudier, *Turtle* (1983/2.11), also belonged to the Dan Fellows Platt collection.
HF

69

JACQUES LIPCHITZ

American (born Lithuania)
1891-1973

STUDY FOR "LOVERS"

Ca. 1939

Ink, wash, and red and black conté
crayon, on faded blue laid paper

15¹⁵⁄₁₆ x 12⅛ in. (406 x 307 mm)

Watermark: a heart with shell-
shaped flower on long stem/
PAPIER D'AUVERGNE / À LA MAIN

Signed u.r.: *J Lipchitz*

Exhibitions: AFA 1957-58, no. 37;
East Lansing 1959-60; Flint 1961;
East Lansing 1963; Ann Arbor,
The University of Michigan
Museum of Art, "One Hundred
Contemporary American Draw-
ings," 1965, no. 56 repr.; Ann
Arbor 1966

Reference: Helen B. Hall, "Con-
temporary Drawings," *UMMA*
Bulletin, 1950, 12

Provenance: E. Weyhe, New York

1948/1.91

This previously untitled drawing was identified for the Museum of Art by Jacques Lipchitz shortly before his death: "It is one of a series for a statue of 'Lovers' which after all I never made in sculpture, only a small maquette which was finally composed differently" (letter in object file, 3 January 1972). A similar work in gouache, depicting figures locked in an embrace, is signed and dated 1939, the approximate date of Michigan's study (see *The Drawings of Jacques Lipchitz*, New York, 1944, no. 4 repr.).
HF

CHARLES BURCHFIELD

American
1893-1967

TRACKS IN THE SNOW

1947

Watercolor on paper

26⁷⁄₁₆ x 35 in. (672 x 889 mm)

Signed in monogram and dated, l.l.:
CEB / 1947

References: Utica, Munson-Williams-Proctor Institute, *Charles Burchfield, Catalogue of Paintings in Public and Private Collections*, 1970, 319; Jean Paul Slusser, "Surprise Awaits At U Museum," *The Ann Arbor News*, 16 April 1972, 21 repr.

Provenance: from the artist to the Rehn Gallery, New York, purchased in 1949 by the family of the late Professor Louis Abraham Strauss

Given in memory of Louis Abraham Strauss, transferred from Strauss House, Residential College, The University of Michigan

1972/2.352

The vivid impression of wet slushy snow on a chill, late winter afternoon pervades this watercolor. Yet Burchfield, always the consummate observer of nature, has added hints of warmth and spring to come in soft touches of yellow light in the sky, on the snow, and on the roofs of houses and low-lying structures. The yellow-green bark of the tree also promises spring and new growth, counterbalancing the dreary gray chill of this cityscape. The tracks in the snow that give this drawing its title are recent signs of human activity, charting a curving path across the otherwise barren outdoor scene.

Burchfield probably painted this watercolor in his own backyard in Ohio. Over the years he was particularly fascinated with the transition of one season into the next, and this winter-to-spring depiction is typical of most of Burchfield's work. His own delight in climatic changes was not particularly shared by most viewers of his art, which caused the shy and usually mild Burchfield to reflect: "The great difficulty of my whole career as a painter, is that what I love most ... not only holds little interest for most people, but in most of its phases is downright disagreeable....I love the approach of winter, the retreat of winter, the change from snow to rain and vice-versa; the decay of vegetation and the resurgence of plant life in the spring. These to me are exciting and beautiful, an endless panorama of beauty and drama...." He concluded with the somewhat wistful observation that "... the mass of humanity remains either bored, or indifferent or actually hostile There seems to be no solution" (quoted in John I.H. Baur, *Charles Burchfield*, New York, 1956, p.70).
LA

71

GEORGE GROSZ

**American (born Germany)
1893-1959**

A DREAM (EIN TRAUM)

1914

Pen, ink and wash on off-white laid paper

Watermark: ERCLASS / SCHREIBMASCHINEN

8¾ x 11¼ in. (221 x 285 mm)

Inscribed and dated, recto, l.l.: *Ein Traum 26.6.14.*

Stamped recto, l.r.: *GROSZ*

Stamped verso, l.r.: *George Grosz Nachlass*

Inscribed within verso stamp: 2 115 1

References: "College Museum Notes: Acquisitions, 1880 to Present, Drawings," *Art Journal*, XXX, 1, Fall 1970, 62; "Acquisitions July 1, 1968–June 30, 1970," *UMMA Bulletin*, 1970-71, 69

Provenance: estate of the artist; The Lakeside Studio, Lakeside, Michigan

1970/1.188

George Grosz wrote the following in 1944, emphasizing his own life-long love for drawing and his ongoing attraction to the fantastic:

There must have been a reason for the invention of line. Yes, it is a guide for those who would venture into the formlessness that surrounds us on every side; a guide that leads us to the recognition of form and dimension and inner meaning....Let us then follow line wheresoever it may go. It may lead us to something quite definite and precise – a landscape, or a human face or figure. Or it may lead to the subconscious – the land of Fantasy, where fancy roams where it will. *(George Grosz Drawings*, introduction by the artist, New York, 1944, p. 5)

Grosz began his professional career in 1910, at the age of sixteen, when he sold his first cartoon to a Berlin newspaper. Grosz was already an accomplished draughtsman at this early stage, but it was not until two years later, in 1912, while studying art in Berlin, that he began to develop a distinct style. There he was encouraged to draw quickly from nature, rather than copy illustrations, edging his way towards the abbreviated style that later became his hallmark. Signs of this stylistic transformation are found in *A Dream*, evident in the cursory outlines, randomly applied wash, minimal shading, and over-all economy of means.

The year of the execution of *A Dream*, 1914, was to prove significant for Grosz's later career. In November he volunteered for the Kaiser's army, embarking on a journey that would transform the tone and content of his life and art. Although this drawing dates from late June 1914, its subject matter foreshadows the impending debacle. Here Grosz successfully imparts the ambiguity of the dream experience, by building instability with his use of restless, angling line and precarious perspective. Menacingly unresolved, this relatively early and personal work is a tribute to Grosz's expressive facility.
SR

JOAN MIRÓ

**Spanish
1893-1983**

NUDE (FRONT VIEW);

NUDE (BACK VIEW)

1917

Pencil on white laid paper

Watermark: running Hermes within five-pointed star, inscribed in circle/ COMMERC[...]

7¼ x 5¾ in. (184 x 146 mm)

Signed and dated, l.r.: *Miró - / 1917*

Exhibitions: New York, Museum of Modern Art, "Joan Miró," 1941, 16 repr.; Ann Arbor 1968; Ann Arbor 1982-83

References: "Acquisitions July 1, 1964–June 30, 1968, *UMMA Bulletin*, 1969, 40; *Eighty Works...A Handbook* 1979, no. 70 repr.

Provenance: given in 1930 by José Dalmau, Barcelona, to Mrs. Florence L. Stol

Bequest of Mrs. Florence L. Stol

1968/1.96 and 1968/1.97

Joan Miró's extraordinary artistic career was one of the longest of this century – ranging from the early teens through 1983. Miró worked in a wonderful variety of media, always challenging himself and the viewer in a creative game that was at once playful and serious, spontaneous and calculated, decorative yet mysterious. Drawings were an important element of Miró's creative process, whether for the discipline of graphic observation, or as an element in the organic process of developing a pictorial theme.

These direct and powerful drawings of a standing female nude are two of a large group of figure studies done during the artist's formative years in Spain. When he was ten, Miró was enrolled in the school of Fine Arts in Barcelona and, except for a two year gap, he continued his artistic training in several acadamies until 1918. While Miró maintained an important tie with Paris since his first visit to the city in 1919, his native Catalonia was always a significant influence on his attitudes, style, and choice of subject (see Evan Maurer, "The Kerosene Lamp and the Development of Miró's Poetic Imagery," *The Art Institute of Chicago Museum Studies*, XII, 1, 1986).

Miró's great ability as a colorist is well-known, but he admitted that he needed help and hard work to develop his draughtsmanship. Recalling his early school years, Miró told a friend:

I couldn't draw at all. I couldn't tell a curved line from a straight line....Galí, whose private school I attended from 1912 on, was very receptive to modern art...and he came up with a good dodge for me. He told me to close my eyes, feel an object or even a friend's head, then draw it from pure tactile memory. Yes, that's why I have such a feeling for volume and find sculpture so interesting....These nudes were drawn as much from my sense of touch as from life! (Gaëtan Picon, *Joan Miró Catalan Notebooks*, trans. by Dinah Harrison, New York, 1977, p. 18).

The nude figure studies from the 1915-18 period gave Miró a new facility with the use of linear elements that evoke three-dimensional form and volume – lessons that were put to use in a series of portraits produced in 1917. During that same period Miró painted three large nude female images that are obviously in debt to the drawing series to which the Michigan sheets belong (*Standing Nude*, 1918, private collection; *Seated Nude*, 1918, collection of Mr. and Mrs. Pierre Matisse, New York; *Standing Nude*, 1921, Alsdorf Foundation, Chicago). Miró's use of schematic designs to indicate form, especially in the lower legs, knees and stomach, and the similarity in pose, body type, and hair style, directly relate the frontal drawing (72) to the well-known *Standing Nude* (Fig. 72a), a large oil from 1918 that presents the figure against an audaciously busy and colorful background. These drawings were part of a major group of twentieth-century works donated to the Museum by Florence L. Stol in 1968. Mrs. Stol noted that the drawings were given to her in 1930 by José Dalmau, Miró's earliest dealer, whose gallery in Barcelona presented Miró's first one-man exhibition in February 1918.

EMM

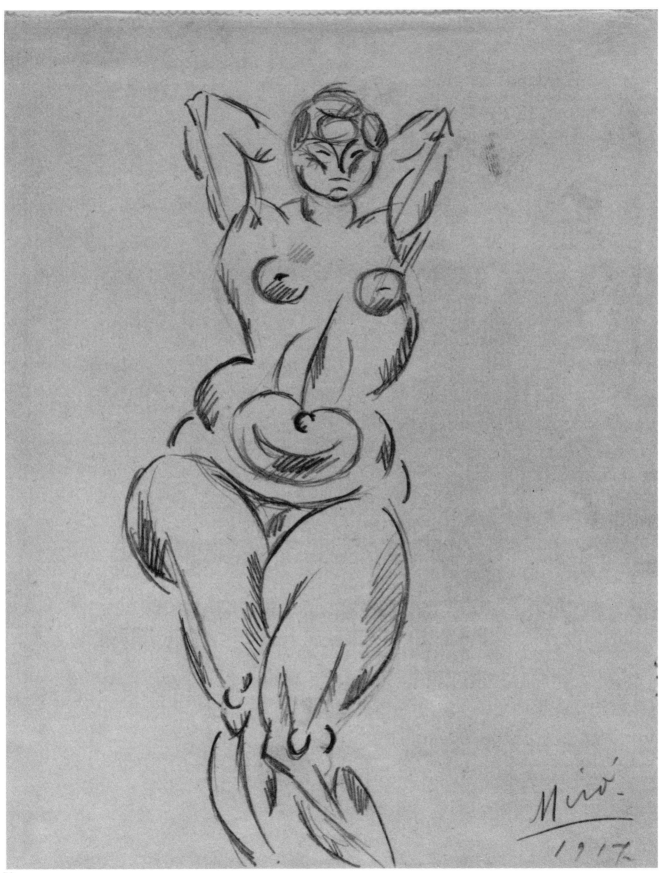

72

Fig. 72a *Standing Nude*, 1918, oil on canvas (152.8 x 120.7 cm), private collection.

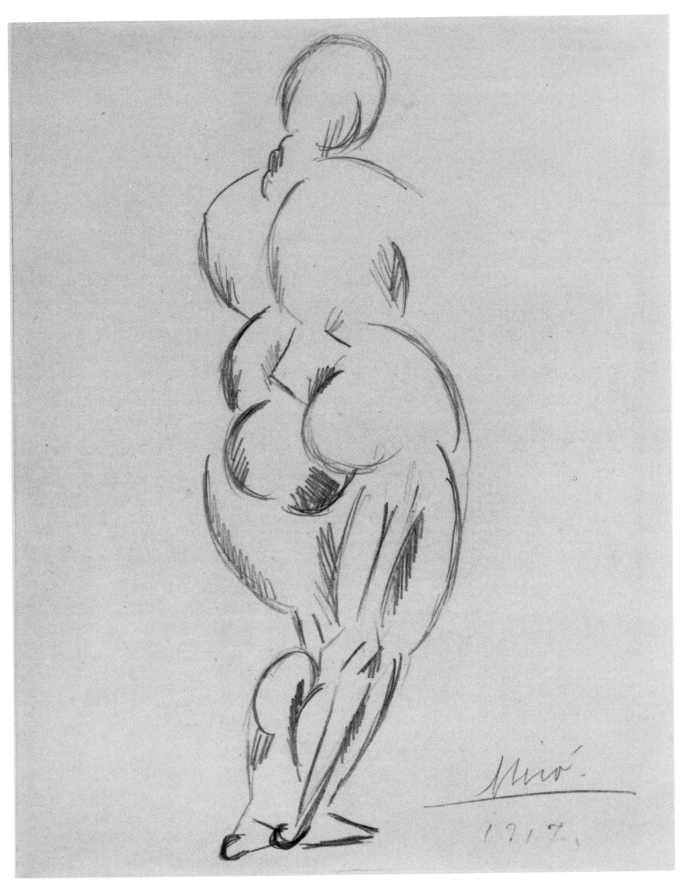

73

JOHN BERNARD FLANNAGAN

**American
1895-1942**

BUFFALO

Ca. 1929-30

Black conté crayon on white tracing paper

8⅛ x 10⅞ in. (207 x 275 mm)

Signed in pencil l.r.: *John B Flannagan*

Exhibitions: AFA 1957-58, no. 10; East Lansing 1959-60; Flint 1961; University of Notre Dame, Art Gallery, "John B. Flannagan: Sculpture, Drawings, Paintings, Woodcuts," 1963, no. 38; MSCA 1967-68; Saginaw Art Museum, "The Animal Kingdom," 1970; Omaha, Joslyn Art Museum, "The Thirties Decade: American Artists and their European Contemporaries," 1971, no. 70

References: Helen B. Hall, "Contemporary Drawings," *UMMA Bulletin*, 1950, 14

Provenance: E. Weyhe, New York

1949/1.168

As a sculptor, John Flannagan was noted for his simplicity and forcefulness of form. He stated: "My aim is to produce sculpture as direct and swift in feeling as drawing – sculpture with such ease, freedom, and simplicity that it hardly seems carved, but rather to have endured so always" (statement by the artist in New York, Museum of Modern Art, *The Sculpture of John B. Flannagan*, Dorothy Miller, ed., New York, p. 9). His particular affinity for carving animal shapes sprang from an intense personal belief in a "kinship with all living things and fundamental unity of all life, a unity so complete it can see a figure of dignity even in the form of a goat" (*ibid.*, p.7).

Flannagan drew studies for many of his sculptural projects, but observed, "preparatory drawing seems much like doing one's thinking on paper and then carving the conclusion. I prefer to think the thing out first and last in stone ..." (quoted in essay by Carl Zigrosser, *ibid.*, p. 13). Nevertheless, Michigan's drawing is a preparatory study for a stone carving of a buffalo dated 1929-30 in the Cleveland Museum of Art (Fig. 74a). In the drawing, Flannagan conveys the solidity and aggressiveness of the creature on a small scale, yet with impressive force. The animal's head is lowered, horns poised as if for attack, although Flannagan has suggested a certain ambiguity here in the half-open eye of the buffalo – perhaps it is not preparing to rush an interloper after all, but has just been interrupted while peacefully grazing. Carl Zigrosser observed that Flannagan had a gift for capturing essence: "He grasped, intuitively perhaps, and managed to suggest in his work, the essential nature, the significant gesture of an animal..." (*ibid.*, p. 13).

Michigan's collection also includes a limestone sculpture of a horse by Flannagan (1950/2.10).
LA

Fig. 74a *Buffalo*, 1929-30, stone (25.7 x 27.9 x 11.4 cm), The Cleveland Museum of Art, gift of Mrs. Malcolm L. McBride (42.153).

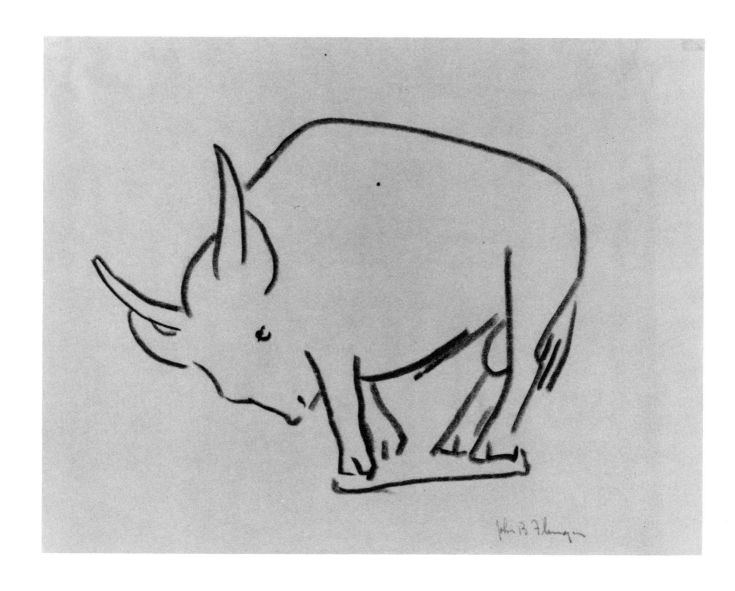

LASZLO MOHOLY-NAGY

American (born Hungary)
1895-1946

ABSTRACT COMPOSITION

Watercolor, india ink, and collage
on off-white wove paper

19⅜ x 13¹¹/₁₆ in. (491 x 347 mm)

Signed l.r.: *Moholy-Nagy*

References: *Handbook* 1962, no. 46 repr.

Provenance: Frankfurter Kunstkabinett, Frankfurt

1953/2.9

*A*bove all else, Laszlo Moholy-Nagy was a visionary thinker. He wrote: "The true function of art today is to be the seismograph of the time, intuitive research for the missing balance between our emotional, intellectual, and social existence" (*The New Vision: Fundamentals of Design, Painting, Sculpture, Architecture,* 1938, p. 67). Holding an idealistic view of art's purpose, he urged that it should serve humanistic ends, enhancing life and instigating social reform. These ideals were embodied in his career as an educator and artist, inspiring students at the Bauhaus in the 1920s and later at the New Bauhaus and the School of Design in Chicago.

In hopes of uniting art, life, and technology, Moholy-Nagy explored many media including photography, film, painting, kinetic sculpture, printmaking, and graphic and stage design. Through the innovative use of modern materials he strove to capture the dynamics of the contemporary experience, especially the element of time, the fourth dimension.

Moholy's interest in the concept of time led to sophisticated visual experiments with light, space, and motion, the major components of his aesthetic. In *Abstract Composition* he utilized his characteristic vocabulary of geometric shapes, including circular forms, trapezoidal planes, triangles and perpendicular lines, asymmetrically arranged. By varying the translucence and opacity of these elements, adding semi-circles in black ink and collage and suspending them in an irregularly spotted "atmosphere," Moholy created a universe of considerable spatial complexity.

SR

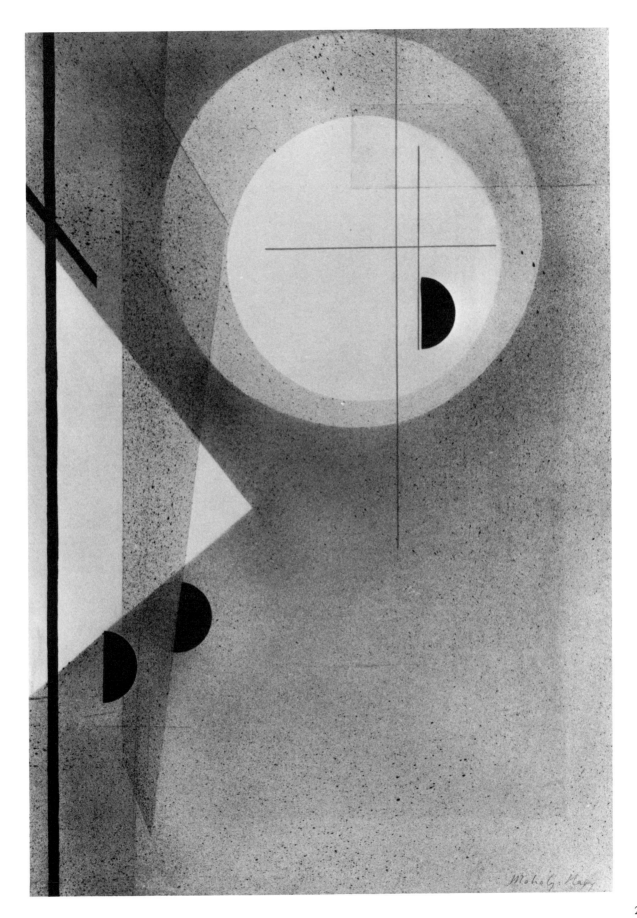

ANDRÉ MASSON

French
1896-1983

DRAWING

1926

Pen and ink on off-white laid paper

Watermark: INGRES

16⅞ x 12½ in. (427 x 317 mm)

Signed l.l.: *André Masson*

Exhibitions: AFA 1957-58, no. 40; East Lansing 1959-60; Ann Arbor 1966; MSCA 1967-68; Ann Arbor, The University of Michigan Museum of Art, "The Influence of Surrealism on American Art: Loans from the Solomon R. Guggenheim Museum," 1984-85

References: Helen B. Hall, "Contemporary Drawings," *UMMA Bulletin*, 1950, 14-15

Provenance: Galerie Louise Leiris, Paris

1949/2.40

André Masson was one of the first visual artists associated with the writers and poets who, under the leadership of André Breton, formed the Surrealist movement in Paris. Masson adhered to an aesthetic that drew heavily on Freudian dream psychology, and on Bergsonian concepts of intuition, mythology, and ethnographic studies of "primitive" societies that had profound effects on the surrealists' works.

This bold, sure, pen and ink drawing is a prime example of Masson's unique style of automatic drawing, one of the earliest attempts by surrealists to bring the concept of "pure psychic automatism" into the realm of the visual arts. In the early 1920s writers such as Breton and René Crevel began to develop a process that yielded freely flowing "stream of consciousness" prose that came as directly or automatically as possible from the unconscious, without the intervening editorial process of intellectual thought. Masson's drawings were the visual equivalent of this literary process of automatic writing. His earliest examples date to around 1924 and feature a tangled web of curving lines, which suggested forms and images that the artist would then reinforce with a minimum of added detail (New York, Museum of Modern Art, *André Masson*, 1976, p. 19).

The Michigan drawing is far less busy and interwoven than his earlier works. Its spare use of heavy pen strokes creates the essential elements of a muscular male torso rising from the sea, a generalized theme of the mythology of nature that Masson developed in drawings and paintings from 1924 through 1927 (*ibid.*, *Man*, 1924-25, p. 110 repr.; *Bestiary*, 1925, p. 114 repr.; *Lancelot*, 1926-27, p. 123 repr.). The man's head is a curving series of triangles filled with stars and a diamond-shaped eye. The broad chest is indicated by the right pectoral, balanced by a heart pierced by an arrow on the proper left, and just above this Masson includes a profile face with streaming hair. The entire figure tapers to a narrow waist with an umbilicus and genitalia. A series of waving lines, two fish-like forms in the lower right corner, and the signature within a summarily indicated fish, are references to the sea, which Masson frequently used in the development of his mythical universe of surrealist images.
EMM

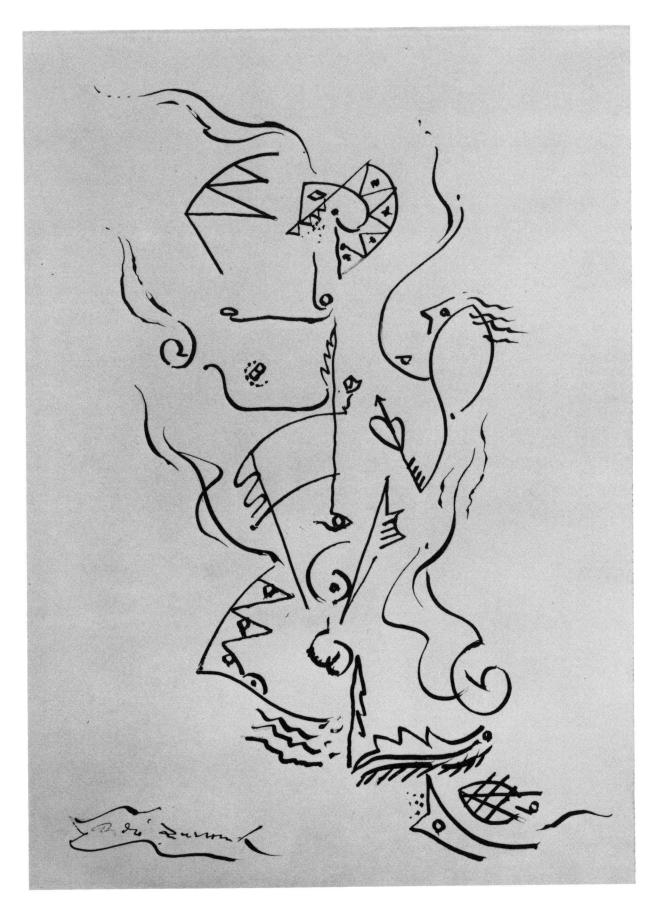

ALEXANDER CALDER

**American
1898-1976**

LION AND TWO ACROBATS

Ca. 1931-32

Colored crayons on tan paper

Watermark: INGRES

19⅛ x 24½ in. (485 x 622 mm)

Signed l.r.: *Calder*

Exhibitions: AFA 1957-58, no. 4; East Lansing 1959-60; MSCA 1967-68; Cincinnati, The Taft Museum, "Early Works: Alexander Calder," 1972, 5, 7 repr.; The Detroit Institute of Arts, "Alexander Calder," 1973; Flint Institute of Arts, "A Tribute to Calder," 1977; Flint Institute of Arts, "Alexander Calder: Mobiles, Stabiles, Gouaches, and Drawings from Michigan Collections," 1983, 33, no. 65; Ann Arbor 1984

References: "The University Art Museum," *The Ann Arbor News*, 26 May 1957, 6 repr.; *Handbook 1962*, no. 50 repr.

Provenance: John Becker

1948/1.260

The circus became a pivotal theme for Alexander Calder while he was in Paris during the late 1920s. Calder became so enthralled with the motif that he built an elaborate miniature circus out of wire and bits of cloth, giving live performances with it to ticket-buying members of the Paris avant-garde, frequently with artist Isamu Noguchi running the gramophone for him. As Jean Lipman observed, Calder's *Circus* "was the point of departure for all of his future productions. His *Circus* performances attracted the Paris art world; it was through the *Circus* that he met the most advanced artists of the time and was exposed to them" (*Calder's Universe*, New York, 1976, p. 20). Calder's *Circus*, with its multitude of tiny wire performers, is now on permanent display at the Whitney Museum of American Art, New York.

This deceptively simple drawing of circus performers is done in the same additive manner that Calder used when he was constructing his *Circus* out of wire. Calder's sequence of line is easily seen. He began with a red crayon and outlined the nude male figure on the right, adding the head after the body was drawn. He then balanced the composition by sketching in blue crayon the figure on the left, a woman acrobat wearing a ruffled tutu. Both figures appear to be moving, with their arms upraised or akimbo. As a central focus Calder added the wonderful surprise of a roaring yellow lion perched atop a black platform. (The black crayon of the platform, with its colorful zigzag decoration, overlaps the two human figures slightly). Even without his characteristic signature, the composition would be unmistakably by Calder: it is balanced, yet dynamic, rapidly drawn with a sureness of line. With Calder's special appreciation for the impact that primary colors have on the eye and mind, the work subliminally transports the beholder back to the visual joys of childhood and to the intense excitement of the circus.

A number of other drawings by Calder are in the Museum of Art's collection, including a related drawing, *Tightrope Walker* (Fig. 77a).
LA

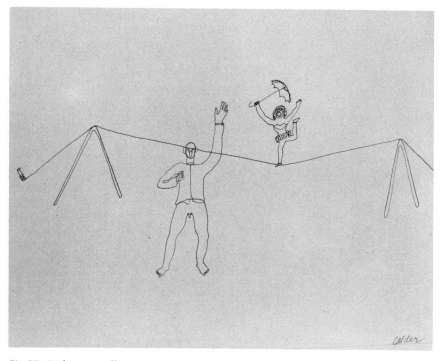

Fig. 77a *Tightrope Walker*, 1930-31, pen and ink on white paper (484 x 636 mm), The University of Michigan Museum of Art (1948/1.262).

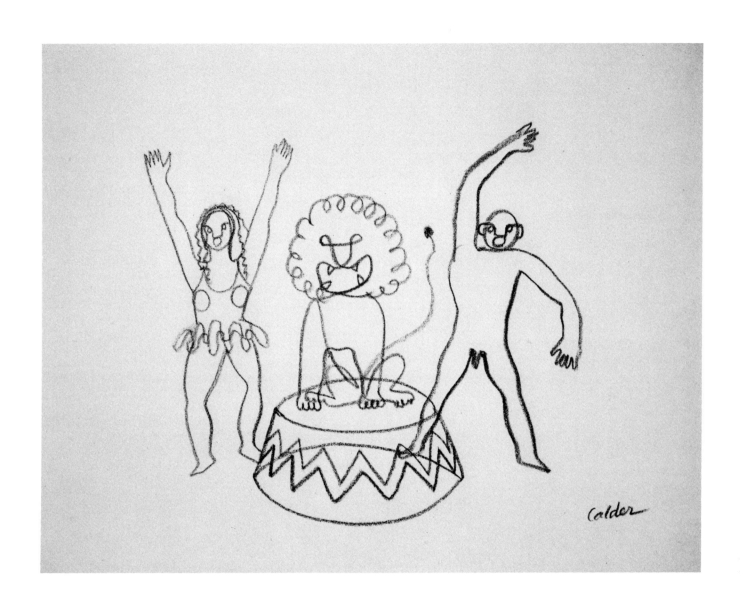

78

HENRY MOORE

English
born 1898

SEATED FIGURES

1944

Pencil, white wax crayon,
watercolor, colored crayons, pen
and black ink on white wove paper

10⁹⁄₁₆ x 7 in. (258 x 178 mm)

Signed, dated, and inscribed, recto,
l.r.: *Moore / 44 / 19.*

Exhibitions: Oberlin 1956; Flint
1962, no. 34; Ann Arbor 1966

Provenance: Ernest Brown & Phillips, Ltd., The Leicester Galleries,
London

1954/2.58

This previously unpublished drawing originated as folio 19 in a sketchbook also entitled *Seated Figures* (Henry Moore Foundation 2241). Fortunately, Moore frequently numbered the leaves of his sketchbooks, thus facilitating their reconstruction once the individual sheets were dispersed. Other pages from the *Seated Figures* sketchbook are located in private collections in the United States.

By the mid-1940s Moore began to express an increasingly naturalistic approach to the human figure and to explore groups and draped sculpture rather than solitary beings. Among his recurrent postwar themes was that of the family, especially the relationship between mother and child. Moore's interest in sculptural groups, particularly the latter subject, is apparent in the Michigan drawing. The roughly sketched, seated group at the left of the lower tier bears some similarity to a page entitled "Ideas for a Two-Figure Sculpture," from a sketchbook of 1944, the sheet now in the Museum of Modern Art (see Toronto, Art Gallery of Ontario, "The Drawings of Henry Moore," 1977-78, no. 203 repr.). Furthermore, Alan Wilkinson (letter in object file, 26 March 1985) has suggested that the figures on the bench at the left in the upper tier of the Michigan drawing anticipate Moore's bronze sculpture, *Mother and Child Against an Open Wall*, 1956 (Lund Humphries 418). Thus, Moore's sketchbook sheets such as *Seated Figures* functioned not only as studies for his ideas at the time, but as sourcebooks, records of the beginnings of pieces realized plastically only years later.

The University of Michigan Museum of Art has several other works by Henry Moore, including an early drawing, *Study of a Seated Nude*, 1928 (1951/2.27), and three sculptures, *Reclining Bird*, 1927 (1981/2.85), *Figure*, 1932 (1953/1.27), and *Stringed Reclining Figure*, 1939 (1968/1.98).
HF

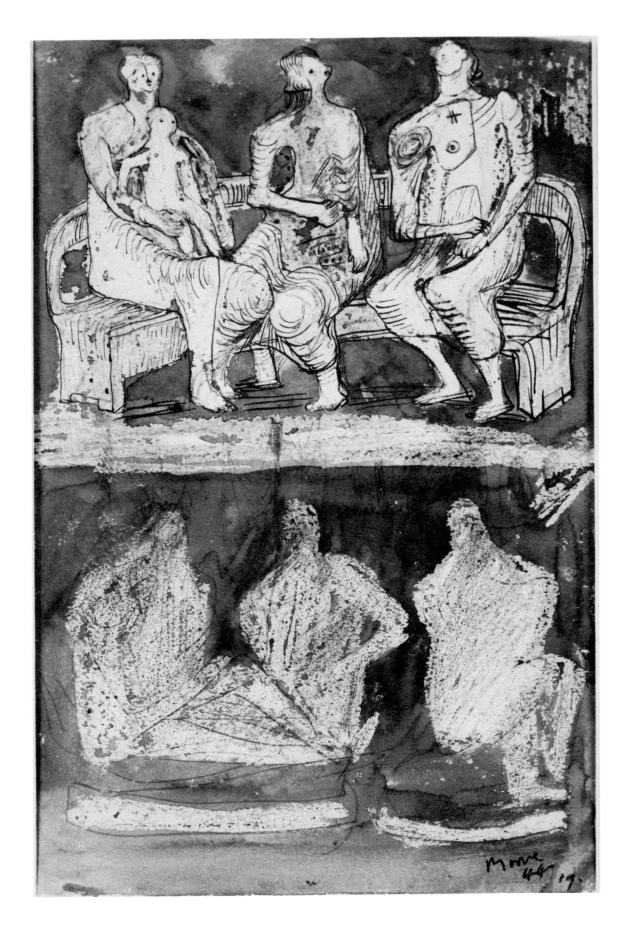

JOHN TUNNARD

English
1900-1971

SOUTH POLAR QUADRILLE

1947

Ink, colored crayons, watercolor,
and gouache on white wove paper

15 x 22 in. (381 x 558 mm)

Signed, dated, and inscribed l.r.:
John Tunnard 47 / W.33.

Inscribed on label, verso: *W33 /
S.Polar Guadrille.* [sic] */ John
Tunnard 1947*

Exhibitions: London, The Lefevre
Gallery, Alex Reid and Lefevre
Ltd., "John Tunnard: New Paint-
ings," 1947, no. 25; Bradford City
Art Gallery, Cartwright Memorial
Hall, "Fifty-Ninth Spring Exibi-
tion," 1952, no. 113; Flint 1962,
no. 41

Provenance: from the artist to Alex
Reid & Lefevre Ltd., London

1954/2.49

The individualistic art of the English surrealist John Tunnard is not well known in America. Yet in *South Polar Quadrille* Tunnard masterfully exploits the subtleties of watercolor, this most stubborn medium, proving that he deserves greater recognition for his powers of creativity and for his technical achievements.

South Polar Quadrille depicts an imaginary, hoary landscape on the frozen bottom of the earth's crust. Veils of multi-toned azure water-color wash across the antarctic sky. The benumbed atmosphere is warmed by the dazzling lights of the aurora australis. Rainbows, the prismatic admixture of water and light, enliven the polar ambiance. Their pastel hues are as much a tribute to Tunnard's skill in the manipulation of the watercolor medium while still wet, as they are the suggestions of a divine pres-ence. Two constellations in the configuration of the Southern Cross brighten the celestial sky, the larger one ablaze in the heav-ens. Across this glistening stage glide Tunnard's coupled protago-nists. We are not aware that they seem to have emerged from the bone-chilling sea-depths; rather, they move with balletic grace across a polar dance floor. The watercolor is a blast of icy *joie-de-vivre*, played out by anthropomor-phized creatures from an extraterrestrial realm.

Tunnard's watercolor is typi-cally English in its implied narra-tive. The artist creates a dialogue and tension in his representations of matter – solid, liquid, and gas – on his polar cap. For example, simi-lar forms and colors are employed to delineate the three states of mat-ter (the blues of the sky, sea ice, and mountain; the white of the atmosphere, light, shadow, ice and bones), and are differentiated only by their texture, transparency and brushstroke. These mutable forms of matter are situated in an equally volatile space where, for example, solid, massive polygons rest atop much more delicate, transparent rectangles, and the sky, instead of lightening towards the horizon, in fact grows darker in tone. It is a world of topsy-turveydom, suit-able for the antipodes. The water-color's imaginary aquatic envi-ronment must have been stimu-lated by Tunnard's relocation in 1947 to West Cornwall, to a home overlooking the Atlantic. His pen-insular setting, surrounded by craggy coastline and all forms of marine life, surely imprinted itself on his art.

South Polar Quadrille brings to mind the textural qualities of Max Ernst's frottage and decalcomania, and the ambiguity of Yves Tan-guy's fantastic landscapes. Its complex space of transparent and opaque planes, simultaneously asserting both flatness and depth, recalls the work of the constructiv-ists Moholy-Nagy, Gabo, and El Lissitzky. Furthermore, these care-free, but bizarre dancers remind us of Picasso's mediterranean bathing belles of the early 1930s. Yet *South Polar Quadrille* is more than just the skillful assimilation of modern-ist trends and imagery. It is a visual metaphor for the contradictory aspects of nature herself – ever-changing, playful, yet dangerous.
HF

80

JEAN DUBUFFET

French
1901-1985

NIGHT LANDSCAPE

1952

Ink, gouache, and colored crayon
on white paper, mounted on
cardboard

18¹¹⁄₁₆ x 23¹⁵⁄₁₆ in. (475 x 608 mm)

Signed, dated, and inscribed u.r.: *J.
Dubuffet oct. 52 / à Sidney Janis*

Exhibitions: Saginaw 1954; Ober-
lin 1956; AFA 1957-58; East Lan-
sing 1959-60; Ann Arbor 1966;
MSCA 1967-68

References: *Handbook* 1962, no.
57 repr.

Provenance: Sidney Janis Gallery,
New York

1953/2.8

Although it is not clear when the Museum of Art's Dubuffet drawing received the title *Night Landscape*, it is part of a group of about forty works in ink from 1951 and 1952, which the artist termed his "terres radieuses" ('radiant lands'). (See Max Loreau, *Catalogue des travaux Jean Dubuffet*, VII, Paris, 1967, nos. 154-85). All of these images were executed in pen or calamus (a sharpened reed) and ink. Michigan's drawing, according to Dubuffet scholar Andreas Franzke, is unique in its inclusion of gouache and color (in conversation with the curator, 8 December 1985). The "terres radieuses" evolved from another series, the "sols et terrains," where the painter used a plastic medium that he applied like paste to simulate the relief of the earth itself. The "terres radieuses" signal a somewhat different approach and effect than the paintings, for the drawing technique suggests the more ethereal aspects of nature, such as frost, rather than the texture of the soil. As the series evolved, Dubuffet noted a shift in his concerns away from a focus on the corporeal and the terrestrial, towards the recreations of more immaterial and psychic or mental realms, which would preoccupy him in the future (see "Mémoire sur le développement de mes travaux à partir de 1952," in Paris, Musée des Arts Decoratifs, *Jean Dubuffet 1942-1960*, 1960, pp. 131-33).

Night Landscape is particularly rich in its associations and readings. The spectator is propelled directly into an environment which is inhabited by living beings who thrive amidst an intricate, reticulated colony composed of nervous lines and amorphous shapes. By avoiding scale and viewpoint, and counterbalancing positive and negative space, Dubuffet's image offers multiple, even contradictory interpretations. On the one hand, the landscape is not unlike our perceptions in flying over an illuminated city at night. Or, one might alternately think that the landscape is composed of microorganisms. It is questionable if the image is viewed from above, or is a mountainous solid of agglomerated and interlocking forms, or is really a cross-section. *Night Landscape* is simultaneously a topographic analysis of a place, and a locale that defies description. Like its contradictory readings, the drawing's wit and sophisticated charm emanate from its simplistic, almost naive means – hallmarks of Dubuffet's style.

HF

ALBERTO GIACOMETTI

Swiss
1901-1966

SEATED MAN

1951

Pencil on off-white wove paper

Watermark: BFK RIVES

19⅝ x 12⅞ in. (499 x 328 mm)

Signed and dated, l.r.: *Alberto Giacometti 1951*

Exhibitions: Chicago 1952, no. 104; Saginaw 1954; Oberlin 1956; Lincoln 1957; AFA 1957-58, no. 49; East Lansing 1959-60; East Lansing 1963; Ann Arbor 1965-66, no. XIa; Ann Arbor 1966

References: Jean Paul Slusser, "Three Contemporary European Drawings," *UMMA Bulletin*, 1954, 22, fig. 12

Provenance: Pierre Matisse Gallery, New York, purchased at exhibition in Chicago in 1952

1952/2.19

The figure in the atelier was a recurring motif in Giacometti's repertory in the later 1940s and 1950s, and the Museum of Art's *Seated Man*, possibly a portrait of his brother Diego, typifies his themes, techniques, and methods as a draughtsman. From a circumscribed sphere of subjects, selected almost exclusively from his family, his environment, and the domestic objects around him, Giacometti constructed a personal cosmos built of his own observations and experience. "I'm trying to show how I see things," Giacometti wrote (quoted in James Lord, *Alberto Giacometti Drawings*, New York, 1971, p. 20). In fact, Giacometti's statement that "reality remains exactly as untouched and unknown as the first time any one tried to depict it," (*ibid.*, p. 20) paraphrases Cézanne's goal to "realize his sensations" – the endless probing and and concentration required to understand and to record vision. Erasures in Giacometti's drawings are not intended to correct errors, but are deliberate strokes (like those of the pencil), means of creating structure, ways to model and to re-constitute form. The thin border around Giacometti's figure separates it from the outer edge of the paper, endowing it with its own territory, independent of the page and the spectator. The interplay between figure and void, concrete image and intangible environment, and art work and viewer were constantly explored by Giacometti in his paintings, sculptures, and drawings.

From his earliest work as a draughtsman, Giacometti expressed the primacy of the medium for his creative process: "What I believe is that whether it be a question of sculpture or of painting, it is in fact only drawing that counts. One must cling solely, exclusively to drawing. If one could master drawing, all the rest would be possible" (quoted in *ibid.*, p. 26). *Seated Man* and another work, *Woman in the Atelier (Femme dans l'atelier)*, also dated 1951, in the Museum of Art (1985/1.154), are two fine examples of Giacometti's graphic art. A sculpture by the artist, *Standing Figure*, 1957 (1958/1.137) is also in the collection.

HF

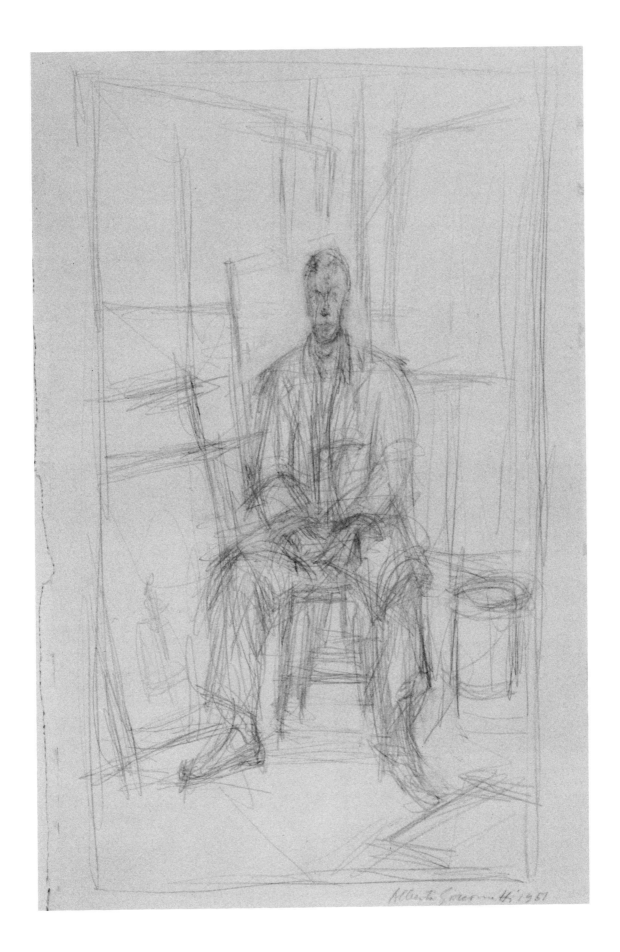

STANLEY WILLIAM HAYTER

English
born 1901

SEATED FEMALE FIGURE

1929

Pen and ink on white paper,
mounted on cardboard

17⅝ x 14³⁄₁₆ in. (447 x 360 mm)

Signed and dated in pencil, l.r.:
SWHayter / 1929.

Exhibitions: MSCA 1967-68

Provenance: John Becker

1948/1.267

Fig. 82a *Standing Male Figure*, 1929, brush,
pen and wash on white paper (413 x 318
mm), The University of Michigan Museum
of Art (1948/1.268).

*I*n 1926, when the British-born Hayter moved to Paris, printmaking as an art was at a lull. Hayter consequently founded a studio known as Atelier 17 to encourage innovative graphic techniques. He is best-known today as an educator and printmaker, although he has also produced many drawings and paintings during his career.

Seated Female Figure simultaneously merges profile and frontal views of a single figure, the motif expressed solely through contour in ink, without recourse to texture or shadow. Depth is suggested only through overlapping lines, which are abstracted and simplified to suggest shoulders, arms, breasts, hands, legs, and lap. The dynamism of the two views is enhanced by the tension between the horizontal lines at the lower left and upper right, and the vertical waves of hair at the center right. Hayter utilizes this vocabulary of rhythmic, undulating lines in his prints, developing a sense of movement through ambiguities of form and space. In addition to its group of prints by Hayter, the Museum of Art has a related drawing, *Standing Male Figure*, 1929 (Fig. 82a).
VJ

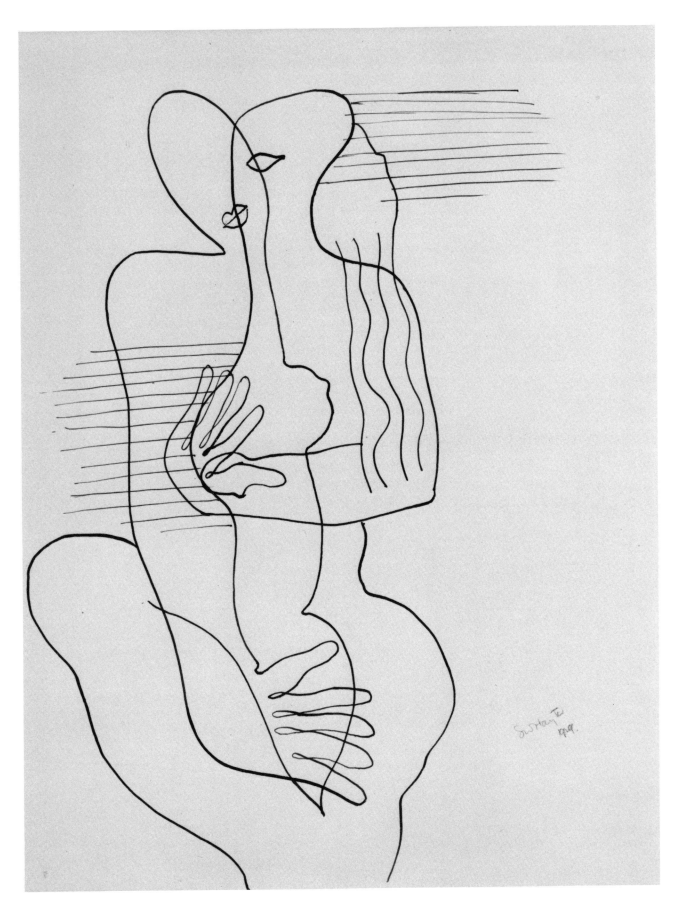

83

MARINO MARINI

Italian
1901-1980

MAN AND HORSE

1949

Ink and gouache on beige wove paper

15⅛ x 11⁹⁄₁₆ in. (384 x 288 mm)

Signed l.r.: *MARINO*

Provenance: purchased by Jean Paul Slusser in 1950 from the Buchholz Gallery (Curt Valentin), New York

Bequest of Jean Paul Slusser

1983/2.12

The motif of man and horse, explored in Marini's sculpture, paintings, prints and drawings, by no means constituted his only theme, yet the subject is synonymous with his name. Long a symbol of power and nobility in Western and Asian art, the horse also signifies the turbulent, irrational aspects of man (as in Fuseli's painting, *The Nightmare*). The theme of the horse with and without rider appealed to many twentieth-century artists, including Jacques Villon, Kandinsky, and Picasso (57), and today serves as the iconographic staple of the paintings and prints of Susan Rothenberg, for example.

Marini's *Man and Horse* expresses the darker side of the emotions found in the passionate drawings of steeds by Gericault (5), Delacroix (8), and Picasso in the collection. The angular, almost jagged pen line, summarily applied washes, and the asymmetrical placement of horse and man, suggest an agitated atmosphere, an aura reinforced by the shifting forelegs of the horse and the man's moving arms and torso.

HF

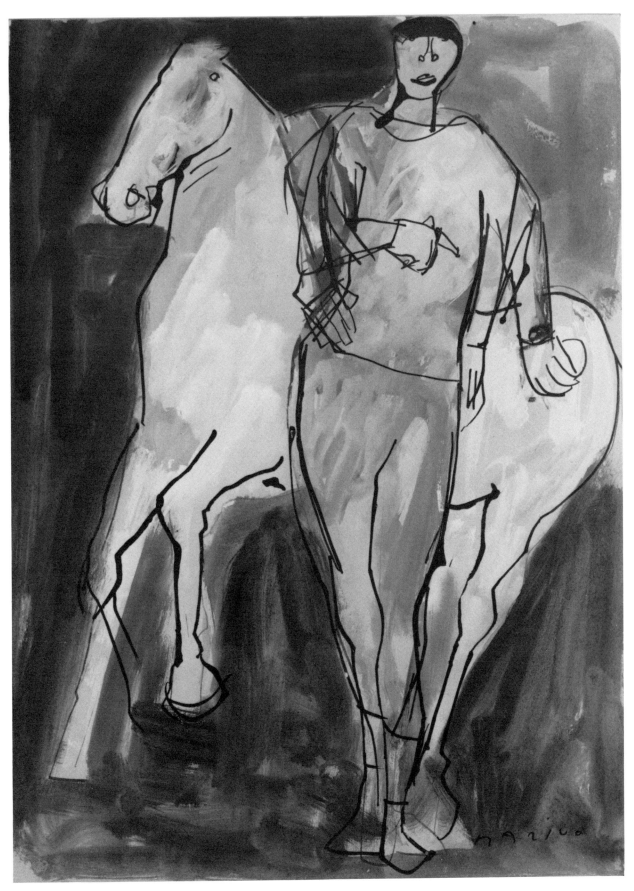

ADOLPH GOTTLIEB

American
1903-1974

BEASTS AT NIGHT

1949

Gouache on off-white wove paper

18 x 23¾ in. (457 x 603 mm)

Signed in pencil, recto, l.r.: *Adolph Gottlieb*

Inscribed in pencil, verso, c.: *18 x 24 / "BEASTS AT NIGHT" / ADOLPH GOTTLIEB / 1949*

Inscribed and circled in red pencil, verso, u.l.: *C1813*

Exhibitions: Ann Arbor 1968; Birmingham, Susanne Hilberry Gallery, "Adolph Gottlieb Pictographs," 1977; Ann Arbor, The University of Michigan Museum of Art, "The Influence of Surrealism on American Art: Loans from the Solomon R. Guggenheim Museum," 1984-85, brochure cover repr.

References: "Acquisitions July 1, 1964–June 30, 1968," *UMMA Bulletin*, 1969, 35; Jean Paul Slusser, "Art in Review: Museum of Art Shows Stol Collection," *The Ann Arbor News*, 23 February 1968, 11

Provenance: from the artist in 1949 to the Kootz Gallery, New York, sold in 1952 to Florence L. Stol

Gift of Mrs. Florence L. Stol

1964/2.28

Around 1941, in response to his dissatisfaction with the prevailing currents of American regionalism, realism, abstraction, cubism, and surrealism, Gottlieb formulated the pictograph. During the next decade he was to experiment repeatedly in over 500 oils, tempera paintings, and watercolors with his invention, in which Gottlieb wedded the seemingly opposite concepts of the subjective and the rational. He conjoined the rich, multi-layered, and emotionally charged world of images from the Jungian "collective unconscious" to the calculated and assertive two-dimensional field of the grid. Like a number of his contemporaries, Gottlieb derived his compartmentalized symbols from universal themes found in myth and primitive art. He juxtaposed his biomorphic fragments automatically, allowing their associations to fuse in the beholder's mind. This method recalled for Gottlieb the practice of the painters of early Italian panel pictures, who placed their representations on the gold grounds of rectangular compartments; but unlike them, Gottlieb's pictographs demand no sequential reading. Furthermore, while the cryptic language of the synecdotal pictographs recalls ancient hieroglyphs or cuneiform, their decoding ultimately reveals far more complex, multivalent meanings, crossing several cultures and levels of human consciousness (see The Edmonton Art Gallery, "Adolph Gottlieb: Pictographs," 1977 reprinted in *Art International*, XXI, 6, December 1977, pp. 27-33; and Washington, D.C., Corcoran Gallery of Art, "Adolph Gottlieb: A Retrospective," 1981).

Gottlieb's pictographic vocabulary became increasingly enriched throughout the 1940s, as he reused old forms and invented new ones. *Beasts at Night* belongs to a group of works treating the themes of impending evil and nocturnal life. The grid lines enclosing the compartmentalized cells of the beasts are not absolute, and the creatures spill over into each others' spaces, in the same manner that darkness obfuscates the delineation of form. The repeated motifs of the single circle or of circles within circles which Gottlieb uses to represent eyes, and even nostrils and ears, allude not only to the spectator's seeing, sensing and hearing the night life, but to his being watched and heard. If the drawing is viewed upside down, a new jungle of creatures appears, ears now serving as eyes, eyes as nostrils, and so forth. Bold, striated parallel accents on some of the beasts mimic the phenomenon of phosphorescence. Several of the beasts have a dual nature: the monsters' gaping mouths function as female genitals, especially when they are contrasted to the pointed, phallic beaks of the birds. Although these ominous beings are delineated in black, portions of their softer pink and violet underskins break through the surface. These nightstalkers are mutable beasts, and while they are threatening, it is our largely unconscious fear of them that exceeds their actual ferocity.
HF

GRAHAM SUTHERLAND

**English
1903-1980**

STUDY FOR "THREE
STANDING FORMS IN A
GARDEN"

1951

Black crayon and brush with wash,
heightened with white, on white
wove paper

21½ x 17 in. (546 x 432 mm)

Signed and dated u.l.: *Sutherland
1951*

Inscribed, dated, and signed verso,
top: *Study for Standing Forms in a
Garden 1951. / Graham
Sutherland.*

Exhibitions: Chicago 1952, no.
273; Saginaw 1954; Oberlin 1956;
Lincoln 1957; AFA 1957-58, no.
31; East Lansing 1959-60; Ann
Arbor 1966

References: Jean Paul Slusser,
"Three Contemporary European
Drawings," *UMMA Bulletin*,
1954, 17-20, fig. 10; Jean Paul Slus-
ser, "Art in Review: Display at
Rackham Building Features 20th-
Century Drawings," *The Ann
Arbor News*, 7 December 1966, 27
repr.

Provenance: purchased in 1952 at
exhibition in Chicago

1952/2.21

*T*he subject of the totemic
"Standing Forms" preoc-
cupied Sutherland in the
early 1950s. When asked
about their meaning, he replied:

They do not...*mean* anything.
The forms are based on the
principles of organic growth....
To me they are monuments and
presences.... They themselves
are emotionally modified
from their natural prototype.
They give me a sense of the
shock of surprise which direct
evocation [of the human figure]
could not possibly do.
("Thoughts on Painting," *The
Listener*, 6 September 1951,
p. 377)

According to John Hayes, these
menacing, fetishistic icons are
based on the decomposition of
plants; for example, bamboo roots,
stooked corn, maize, and gourds
(*The Art of Graham Sutherland*,
Oxford, 1980, p. 30). To these veg-
etable forms can be added their
resemblance to sea shells and ossi-
fied or fossilized animal remains.
Sutherland intended that these
sculptural beings, in their tortured
monumentality, would create a
powerful response in the viewer:
"I am trying to return these forms,
after drastic rearrangement and
emotional and formal modifica-
tion, to the field of purely visual
response – to throw them back, as
it were, into the original cradle of
impact" ("Thoughts on Painting,"
p. 377). A painter, Sutherland
believed, can paint tragic pictures,
without representing a tragic sub-
ject; however [he] "cannot...avoid
soaking up the implications of the
outer chaos of twentieth-century
civilization" ("Thoughts on Paint-
ing," p. 378).

This gouache is particularly
interesting in light of the genesis of
a group of oils and lithographs
entitled *Three Standing Forms*.
The earliest oil, *Three Standing
Forms in a Garden I*, 1951, in the
Minneapolis Institute of Arts (Fig.
85a), was shown at the Venice
Biennale in 1952. Since it was
committed for an exhibition at the
Curt Valentin Gallery in 1953, it
was unavailable for the tour which
followed. Therefore, Sutherland
painted *Three Standing Forms in a
Garden II*, 1952, as a replacement
(Fig. 85b), a work nearly identical
in size and design to Version I.
Michigan's drawing may be situ-
ated after the Minneapolis picture,
but before Version II, since the
drawing introduces the speckled
middle "head" of the later oil,
which is absent in the picture
dated 1951. (A third, smaller, more
colorful version of the composi-
tion with the same title is also in a
private collection.) The Michigan
gouache is closely related to a lith-
ograph, *Three Standing Forms* (Fig.
85c), which is perhaps misdated
1950 (Sutherland usually produced
prints *after* his oils). In the final
adaptation of the original design,
the tree-like botanical forms are
transmogrified into pterodactylian
walkers-on-stilts. A work repro-
duced on the cover of the catalogue
of the Sutherland exhibition at the
Curt Valentin Gallery in 1953 is
another example of this metamor-
phosis. In turn, a nearly identical
design, in reverse, is repeated in
another lithograph, *Three Stand-
ing Forms in Black*, 1953, in the
collection of The University of
Michigan Museum of Art (Fig. 85d).
HF

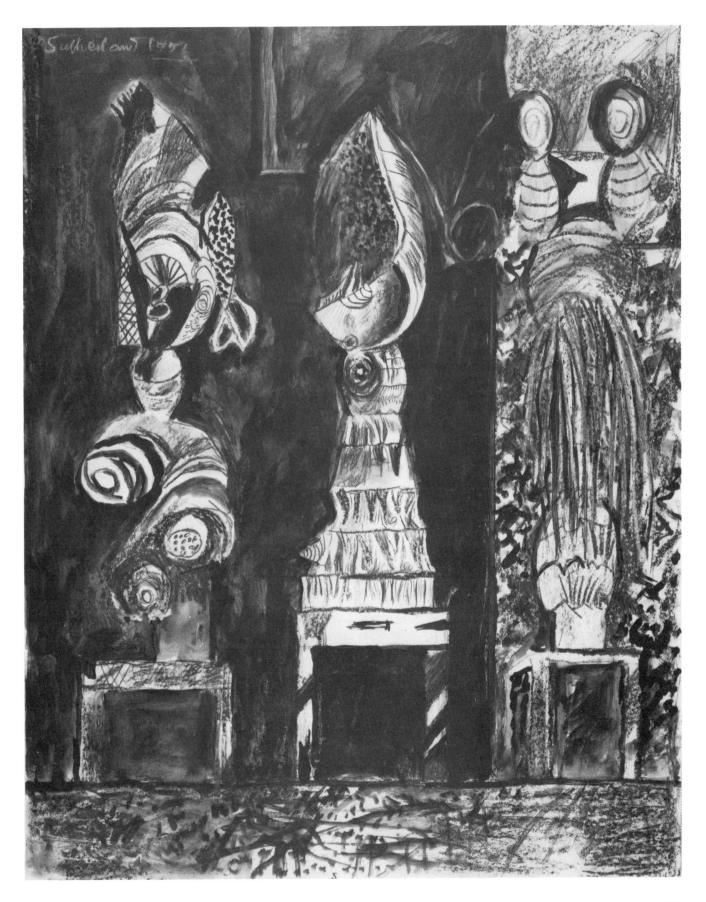

Fig. 85a *Three Standing Forms in a Garden*, 1951, oil on canvas (134.4 x 116.5 cm), The Minneapolis Institute of Art, gift of Mr. and Mrs. John Rood (63.75).

Fig. 85b *Three Standing Forms in a Garden II*, 1952, oil on canvas (133 x 116 cm), private collection, Milan.

Fig. 85c *Three Standing Forms*, 1950 [?], lithograph
(454 x 445 mm).

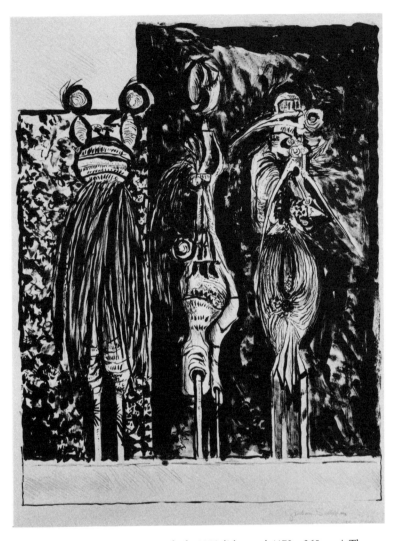

Fig. 85d *Three Standing Forms in Black*, 1953, lithograph (472 x 365 mm), The
University of Michigan Museum of Art (1968/2.30).

ARSHILE GORKY

American (born Armenia)
1904-1948

STUDY FOR "IMAGE IN
XHORKOM"

Ca. 1932-36

Pencil and tempera on off-white
laid paper

Watermark: MICHALLET / FRANCE

19³⁄₁₆ x 24¹¹⁄₁₆ in. (487 x 627 mm)

Signed, l.r.: *Gorky*

Exhibitions: Ann Arbor 1968;
Omaha, Joslyn Art Museum, "The
Thirties Decade: American Artists
and their European Contemporar-
ies," 1971, no.72; Austin, The
University of Texas, University
Art Museum, "Arshile Gorky:
Drawings to Paintings," (traveled
to: San Francisco Museum of Art;
Purchase, State University of New
York, Neuberger Museum; Utica,
Munson-Williams-Proctor Insti-
tute), 1975-76, 105, 37 repr.; Ann
Arbor, The University of Michigan
Museum of Art, "The Influence of
Surrealism on American Art: Loans
from the Solomon R. Guggenheim
Museum," 1984-85

References: Jean Paul Slusser, "Art
in Review: Museum of Art Shows
Stol Collection," *The Ann Arbor
News*, 23 February 1968, 11 repr.;
"Acquisitions July 1, 1964–June
30, 1968," *UMMA Bulletin*, 1969,
39; *Eighty Works...A Handbook*
1979, no. 73

Provenance: collection of Mrs.
Florence L. Stol

Gift of Mrs. Florence L. Stol

1964/2.41

Arshile Gorky (Vosdanik Manuk Adoian) was one of a group of young art-ists in New York City during the 1930s and 1940s who brought a new vitality to European surrealism, that eventually resulted in the New York school of abstract expressionism. *Study for "Image in Xhorkom"* is a strong example of Gorky's ability to cre-ate a bold and convincing style recalling aspects of surrealist imagery, without the dullness of an imitation or a derivative work.

Gorky studied drawing in his native Armenia, before he and his family were forced to flee during the Turkish interventions of World War I. In 1920, after several years of hardship, he and his sister Vartoosh secured passage to the United States. By 1924 Gorky was established in New York, pursuing his career as a painter and poet. His enrollment in the Grand Central School of Art led to his appoint-ment to the faculty in 1926, where he served as an inspiring teacher for five years.

During the 1930s Gorky devel-oped the personal vocabulary of curvilinear, biomorphic forms that, like many of his other themes, were related to his deep personal attachment to the country and culture of his birth. Michigan's sheet is one of three drawings and three paintings that specifically refer to the small village of Khor-kom (Xhorkom) on the shore of Lake Van, Armenia, the place of Gorky's birth. Evocations of the people and natural environment of his earliest years had powerful associations for the artist, and were a source of constant creative imagery. In 1942 he wrote to his sister: "Sweet Vartoosh, loving memories of our garden in Armen-ia's Khorkom haunt me fre-quently....Within our garden could be found the glorious living pano-ply of Armenian nature, so unknown to all yet so in need of being known...in my art I often draw our garden and recreate its precious greenery and life" (quoted in New York, The Solomon R. Guggenheim Museum, "Arshile Gorky: A Retrospective," 1981, p. 44).

Michigan's *Study for "Image in Xhorkom"* is the most defined and solid of the three drawings in the series, using larger areas of dense black and fewer design variations in the central section (see *ibid.*, nos. 52, 53 reprs.). This visual simplifi-cation puts Michigan's drawing in direct sequential relationship with the oil painting *Image in Xhor-kom*, which utilizes the formal elements developed in the draw-ings in a bold, yet reworked and unresolved manner. The culmina-tion of the series is *Xhorkom*, the larger oil painting of 1936 (*ibid.*, nos. 99, 100 reprs.). The reworking of the composition that is clearly reflected in the Michigan drawing is also seen in the painting *Xhor-kom*, where sections of the pre-vious painting have been erad-icated to give the artist a fresh, contrasting surface for the princi-pal images.
EMM

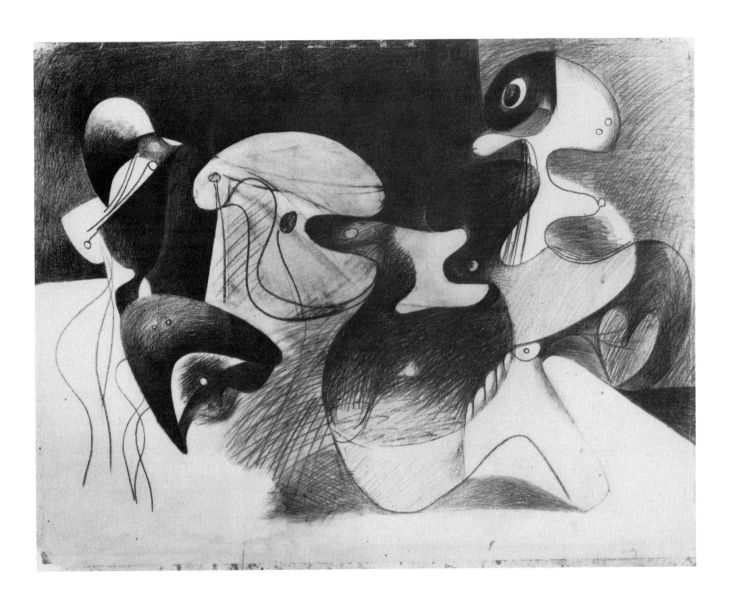

87

ISAMU NOGUCHI

**American
born 1904**

RECLINING MALE NUDE

1930

Brush and ink over pencil on off-white laid paper mounted on board

Watermark: two arms with hatchets; INGRES

17½ x 23⅛ in. (444 x 588 mm)

Signed and dated in pencil, l.r.:
Isamu Noguchi. 30.

Provenance: sold by the artist to John Becker

1948/1.302

*I*n the early 1920s Noguchi received academic training as a sculptor. He was later apprenticed to Brancusi in 1927, but experienced difficulty in selling his avant-garde works. He subsequently returned to representational sculpture during the early years of the Depression, attracting clients through portraiture.

Noguchi was most prolific as a draughtsman during the early 1930s. In his autobiography he writes: "I incessantly made drawings, mostly from the human figure" (*Isamu Noguchi: A Sculptor's World*, Tokyo, 1967, p. 18). The proceeds from his portraiture enabled him to resume his travels abroad, first to France to continue his training in the European tradition, then to mainland China and Japan to study his Oriental heritage. While in Paris he wrote, "I continued to make drawings at the Grande Chaumière, a stock of which I sold to a stranger named John Becker" (*ibid.*, p. 19). The Museum of Art purchased over forty of these drawings in 1948 from Becker; some, if not all of them, came undoubtedly from this cache. Becker also exhibited Noguchi's drawings from the nude at his gallery in New York in 1931.

In *Reclining Male Nude* Noguchi deftly indicates contour and volume through variations in line and texture. Strongly modulated outlines (almost calligraphic in passages), over fine pencil rendering, define the form, while rows of bold parallel hatchings along the face, torso, arms, and legs denote shadow. Areas of ink on the torso and legs, applied with a dry brush, further enhance the suggestion of mass. Although the sitter assumes a studio pose, the work lacks any vestige of academic dryness, for Noguchi infused the drawing with great vitality, the expression of an innovative artist whose reductivist, abstract style reflects the characteristics of twentieth-century art.
VJ

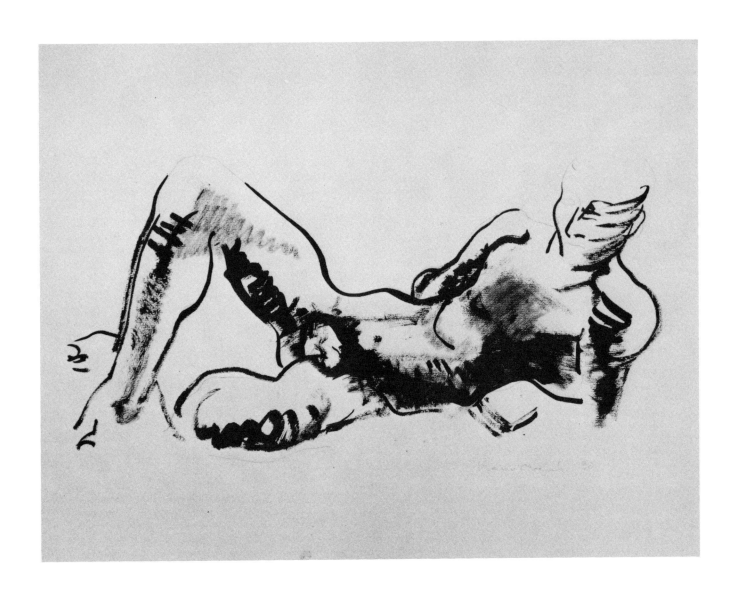

DAVID SMITH

**American
1906-1965**

UNTITLED

1952

**Ink and brush, and watercolor on
white paper**

18 x 23⅛ in. (457 x 588 mm)

**Signed and dated, in pencil, u.l.: ΔΣ
2/26/52**

Exhibitions: AFA 1957-58, no. 22;
East Lansing 1959-60; East Lansing
1963; Ann Arbor, The University
of Michigan Museum of Art, "One
Hundred Contemporary Draw-
ings," 1965, no. 84 repr.; Ann
Arbor 1966

Provenance: collection of the artist

Gift of David Smith

1952/1.79

David Smith's drawings
were an integral part of
his artistic activities, as
important to him in the
creative process as the monumen-
tal sculptures for which he is
famous. Smith was an amazingly
prolific draughtsman: he worked
in a variety of techniques, includ-
ing the medium of egg yolk, and
Chinese ink and brush, and pro-
duced about 300 to 400 drawings
per year. Few of his drawings
served as preparatory studies for
sculpture, nor were they intended
to do so. Smith wrote:

Sometimes [the drawings] are
atmospheres from which sculp-
tural form is unconsciously
selected during the labor process
of producing form. Then again
they may be amorphous floating
direct statements in which
I am the subject, and the draw-
ing is the act. They are all state-
ments of my identity and come
from the constant work stream. I
title these with the numerical
noting of month day and year. I
never intend a day to pass with-
out asserting my identity; my
work records my existence.
(*David Smith by David Smith*,
text and photographs by the
author, Cleve Gray, ed., New
York, Chicago, and San Fran-
cisco, 1968, p. 104).

Drawing for Smith immediately
fulfilled the passion for creativity,
and balanced the slow, laborious
process of physically making
sculpture with the joy of sponta-
neous invention (*ibid.*, pp. 84, 86).

In *Untitled*, 1952, like other
drawings and sculptures of the
early 1950s, Smith explored the
concept of the skeletal structure
placed in a horizontal, landscape-
like field. Angular animal forms –
part insect, perhaps part fish, fowl
or humanoid – struggle in a battle
for survival. The ferocity of the
fight and the strength of the image
reside in the reciprocity of the
forms and in the springiness and
tension of the combatants' bodies.
It has been pointed out that draw-
ings such as *Untitled* share with
the sculpture *Australia*, 1951
(New York, Museum of Modern
Art) the sense of transparency,
points of connection and suspen-
sion of form (see Washington,
D.C., Hirshhorn Museum and
Sculpture Garden, "David Smith:
Painter Sculptor Draughtsman,"
1983, p. 138, no. 92).

The Museum's collection
includes two sculptures by Smith,
Growing Forms, 1939 (1980/1.213),
and *Tahtsvaat*, 1946 (1950/1.164).
HF

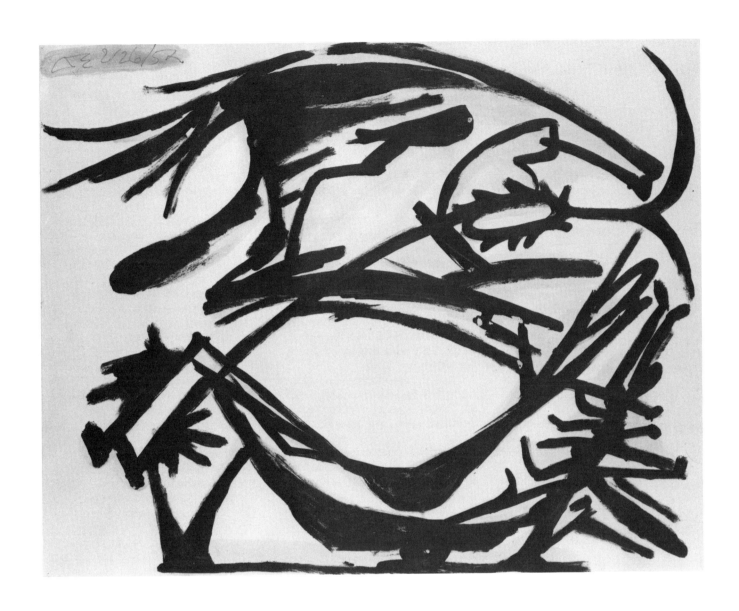

THEODORE J. ROSZAK

American (born Poland)
1907-1981

STUDY FOR SCULPTURE: SEA SENTINEL

1953

Pen and wash on white paper

10⅞ x 13⅞ in. (276 x 352 mm)

Signed recto, l.r.: *T. Roszak*

Inscribed recto, l.l.: *SEA-SENTINEL*

Inscribed verso, u.l.: ⑨
THEODORE ROSZAK / *ONE ST. LUKES PLACE, N.Y.C.* [stamped]
N° 18- (Eighteen)

Inscribed in pencil, verso, u.r.:
Study for Sculpture / *SEA-SENTINEL* / *1953-N.Y.C.* / *10 x 12*

Exhibitions: Flint 1961; East Lansing 1963; Ann Arbor 1966

References: *Handbook* 1962, no. 58 repr.; "Acquisitions June 1, 1957–June 30, 1961," *UMMA Bulletin*, 1965-66, 43

Provenance: collection of Jean Paul Slusser

Gift of Jean Paul Slusser

1957/1.37

The abstract rendering of the fatalistic combat between nature and the primordial creatures of the air, earth, and seas preoccupied Roszak after the mid-1940s. His sculptures suggest the imagery of birds, insects, plants, and aquatic animals, fragile and vulnerable in their airborne and underwater splendor, yet aggressive, tenacious and self-protective. The sculptures are thus metaphors for the forces of life – mutable, transient, and illusory.

Study for Sculpture: Sea Sentinel, 1953, was a preparatory work for Roszak's nine-foot project *Sea Sentinel*, 1956, in steel brazed with bronze (New York, Whitney Museum of American Art; Fig. 89a). As was his usual practice, the sculptor executed small preliminary studies in metal, and also drew innumerable designs, ranging in size, technique, and function, such as Michigan's study for the sculpture, and another also in the Whitney Museum, (Fig. 89b). The various smooth and scored textures ultimately realized in the metal are rendered in Michigan's drawing through vigorous cross-hatchings. The three-dimensional mass of the creature is articulated by the use of washes to establish the ground plane, and to accentuate the volumes of its "head" and arachnoid "body." The crescent-shaped head, juxtaposed in dynamic tension to the spiky projections of the torso, was a motif repeated by Roszak in a number of his zoomorphic sculptures (see New York, Whitney Museum of American Art, "Theodore Roszak," 1956-57, p. 33). The form of the sea sentinel, with its curved and barbed shapes, reflects its behavior and function – to remain on the *qui vivre*, to be self-protective, and to emit life-sustaining messages.

HF

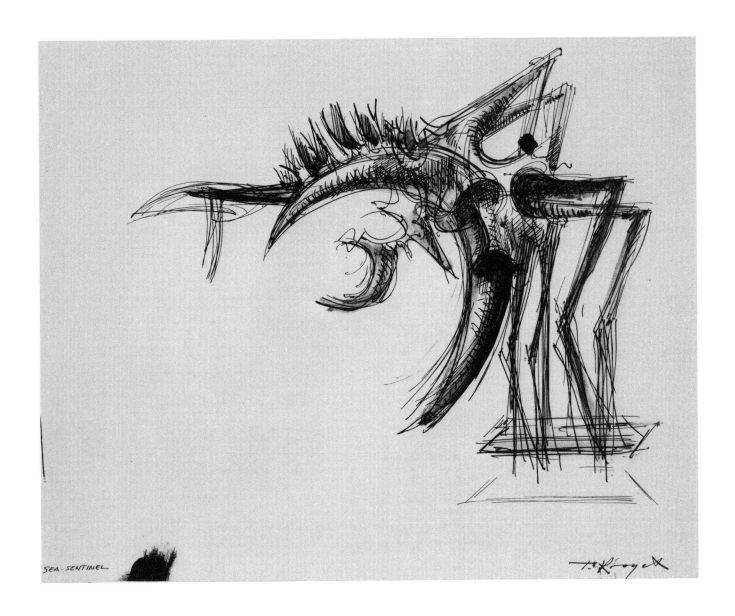

SEA-SENTINEL

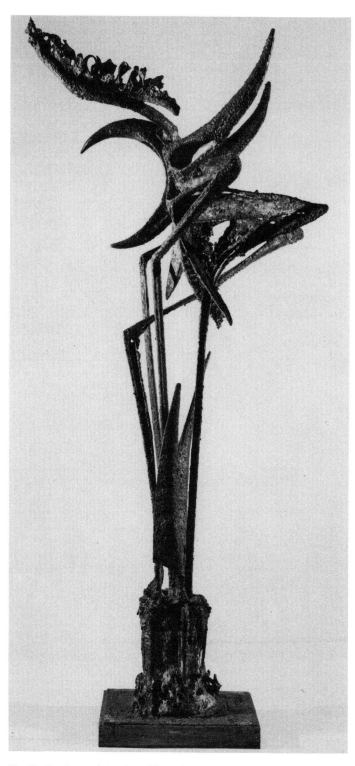

Fig. 89a *Sea Sentinel*, 1956, steel brazed with bronze
(266.7 x 106.7 x 114.3 cm), Whitney Museum of American Art (56.28).

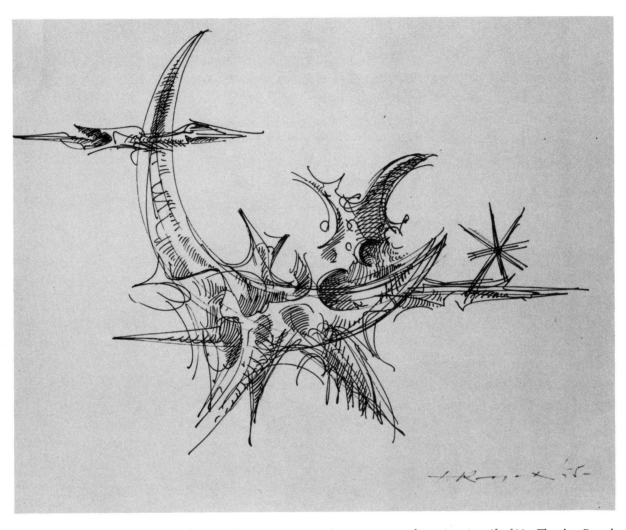

Fig. 89b *Study – Sculpture: Sea Sentinel*, 1955, ink (216 x 279 mm), Whitney Museum of American Art, gift of Mrs. Theodore Roszak (79.12).

GIACOMO MANZÙ

**Italian
born 1908**

RECLINING WOMAN

1959

**Charcoal, gouache, and ink wash
on white wove paper**

19 x 27⅜ in. (483 x 695 mm)

Signed l.l.: *Manzù*

References: John Rewald, *Giacomo Manzù*, Greenwich, 1966, 94 repr.

Provenance: from the artist to John Rewald

Gift of John Rewald

1984/2.77

Manzù's oeuvre is comprised almost exclusively of two very different motifs – religious themes and depictions of young men and women in casual poses. For a poor Catholic raised in Bergamo, John Rewald explains (see above), these themes are natural choices, reflecting Manzù's heritage and environment.

Throughout Manzù's career he has serendipitously found extremely sympathetic models, whom he represents repeatedly in his drawings and sculpture. In the mid-1950s, a young dancer named Inge began to sit for him, serving consistently as his model during that decade and into the 1960s. Inge posed for Michigan's *Reclining Woman*; her thin, lithe figure, oval face, almond-shaped eyes, and full lips are familiar from many of Manzù's works.

The drawing was given to the Museum of Art by John Rewald, Manzù scholar and friend of the artist.

HF

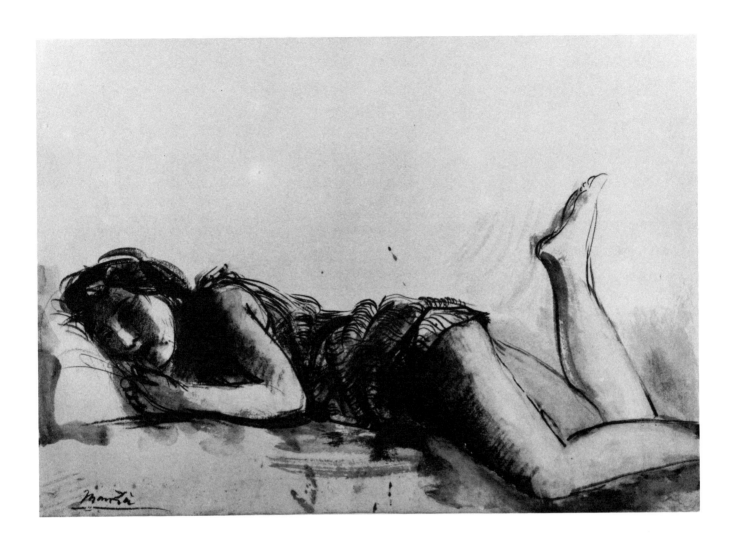

SAUL STEINBERG

**American (born Rumania)
born 1914**

THE HIGHWAY AT NIGHT

1954

**Pen and wash, watercolor, and
colored crayons on off-white paper**

14¼ x 22¾ in. (362 x 578 mm)

Signed and dated, u.l.: *Steinberg 54*

References: "Acquisitions June
1976–July 1977," *UMMA Bulletin*, 1978, 79

Provenance: collection of the artist,
sold in 1968 to Carl Solway Gallery, Cincinnati, sold in 1971 to
private collection; London Arts,
(London and Detroit); private
collection, New York, sold to
James Goodman Gallery, Inc.,
New York, sold in 1977 to Alice
Simsar Gallery, Ann Arbor

1977/1.181

Saul Steinberg is one of the
most profound and lucid
of contemporary artists,
and certainly one of the
most eloquent visual spokesmen of
urban American life. His illustrations have appeared in *The New
Yorker* for decades, and the cartoonist has been honored with
countless national and international awards and exhibitions. He
is a master of graphics who prefers
working with the fine line of ink
and the pen nib; and the superb
quality of his draughtsmanship
and the nature of his artistic statements have bridged the so-called
gap between "mere illustration"
and "fine art." While his art is
small in scale, his intelligence and
wit are of the highest order. Visual
and verbal puns abound in Steinberg's drawings, which are simultaneously epic and epigrammatic.

The watercolor *The Highway at
Night* originally appeared as a
black and white drawing in Steinberg's book, *The Passport*, 1954,
later reissued in a revised edition
in 1979 (Fig. 91a). It treated a
number of themes especially
meaningful to the artist, including
identity, illusion, and mask. After
the first printing of *The Highway
at Night* in black and white, Steinberg reworked the drawing in ink,
watercolor, and colored crayons,
"in order to explain the sinister
side of a small town main street at
night deserted but illuminated by
billboards and neon lights" (letter
from the artist in object file, 28
August 1985).

HF

Fig. 91a *The Highway at Night*, from *The Passport*, revised edition, New York, 1979.

BERNARD MEADOWS

**English
born 1915**

FRIGHTENED FIGURE

1960

Pencil and gray wash heightened with white on off-white paper

10¾ x 8⅝ in. (273 x 218 mm)

Signed and dated, l.l.: **'60**

Exhibitions: London, Gimpel Fils, "Bernard Meadows: Recent Sculpture," 1963 no. 34; Ann Arbor 1966

References: "Acquisitions July 1, 1961–June 30, 1964," *UMMA Bulletin*, 1966-67, 47; Diane Kirkpatrick, "Modern British Sculpture at The University of Michigan Museum of Art, part two," *UMMA Bulletin*, 1981, 60, fig. 9

Provenance: From the artist to Gimpel Fils, London

1963/2.31

During the Cold War years of the 1950s, a group of young British sculptors emerged in the vanguard of the English art scene. Each had been born around the time of World War I, and had been nourished on the innovative work of Henry Moore. Some, including Bernard Meadows, had served as Moore's studio assistants (1936-40), absorbing from the older master his vocabulary of half-figurative, half-abstract forms. Yet, unlike Moore's figures in repose, the representations of these young, rising sculptors, as Herbert Read wrote in 1952, "belong to the iconography of despair, or of defiance.... Here are images of flight, of ragged claws 'scuttling across the floor of silent seas,' of excoriated flesh, frustrated sex, the geometry of fear" (quoted in Diane Kirkpatrick, "Modern British Sculpture at The University of Michigan Museum of Art, part one," *UMMA Bulletin*, 1980, p.65).

The Museum of Art is fortunate to have three works by Meadows which form an ensemble, the graphic and plastic expressions of the same idea. This drawing of *Frightened Figure*, and another watercolor of nearly identical size with the same title, dated 1961 (Fig. 92a), are related to a third piece in the collection, a bronze entitled *Seated Armed Figure (Opus 58)*, 1962 (Fig. 92b). Kirkpatrick (see above), in her discussion of the group, points out that these solid forms on spindly legs with their tough, armored exteriors, protecting softer, more vulnerable inner cores, are metaphors for modern man. At the time he did these pieces, Meadows was interested in the concept of the figure endangered, struggling in spite of its handicaps. In the Museum's watercolors of *Frightened Figures* are two differing reactions to fear: this drawing and the sculpture feature a spiky being, armed for self-defense; the figure in the other watercolor shrinks from confrontation.

The ensemble, as Kirkpatrick states in her 1981 article, is a reminder of the fact that we live in a complex society in which we are never very far from the primitive battle for survival.

HF

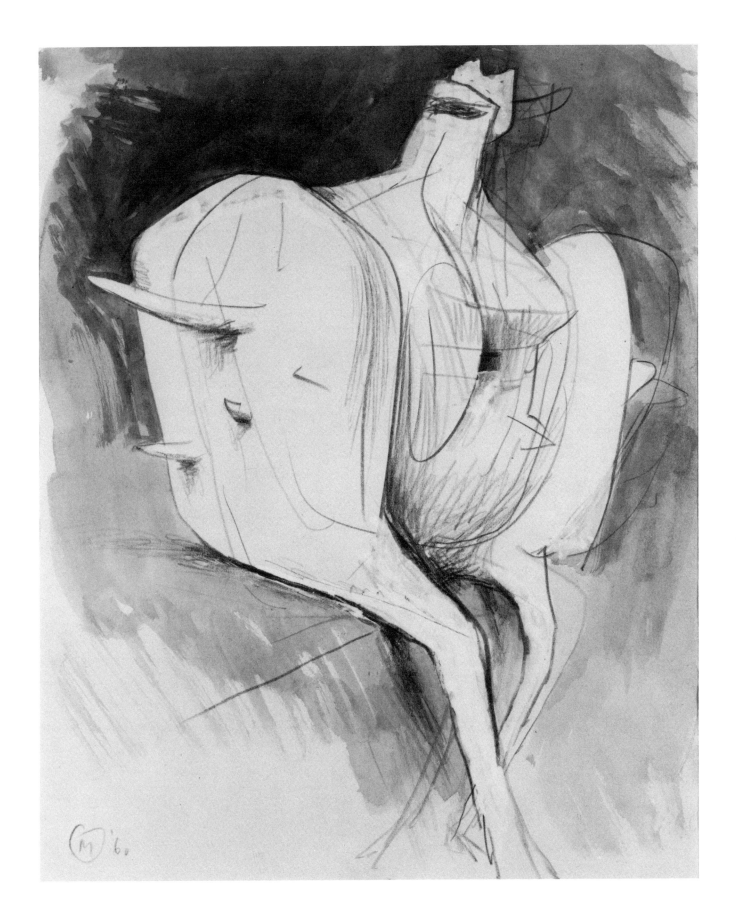

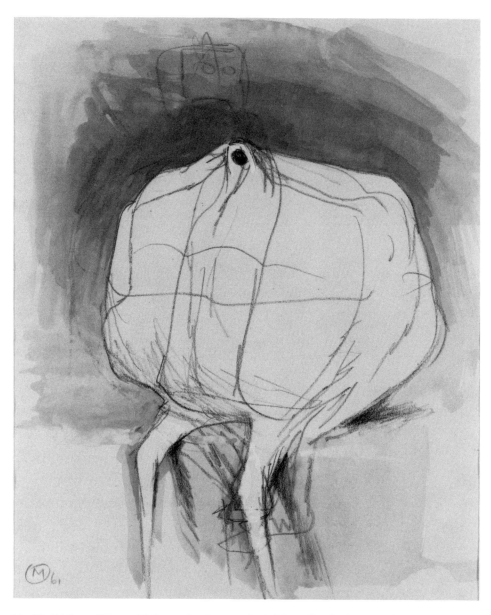

Fig. 92a *Frightened Figure*, 1961, pencil and watercolor heightened with white on white paper (271 x 220 mm), The University of Michigan Museum of Art (1963/2.32).

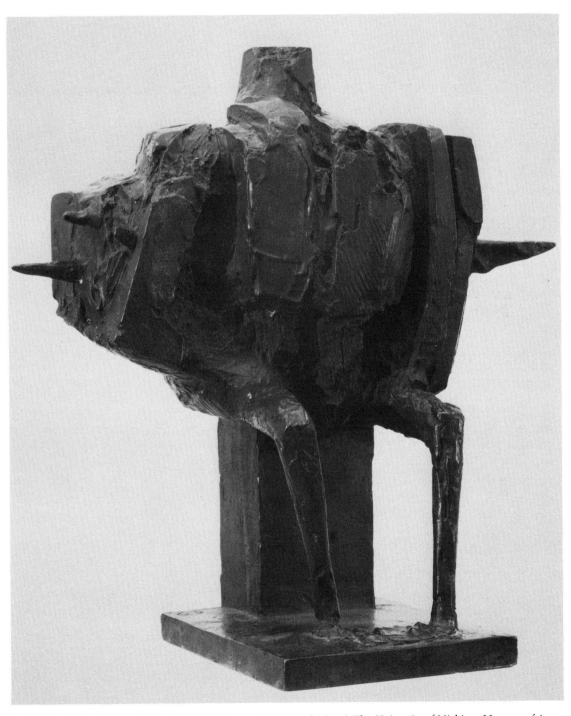

Fig. 92b *Seated Armed Figure (Opus 58)*, 1962, bronze (40 x 37.5 x 24.1 cm), The University of Michigan Museum of Art (1963/2.30).

KAREL APPEL

**Dutch
born 1921**

FALLEN HEAD

1960

**Gouache and crayon on white wove
paper**

22⅜ x 30⅞ in. (566 x 783 mm)

Signed and dated, l.r.: *Appel '60*

**Inscribed verso, in pencil, u.l.:
#5369 / *STARVING HEAD***

Exhibitions: Ann Arbor, The University of Michigan Museum of
Art, "Contemporary Watercolors
for Purchase Consideration,"
1963, no. 1

References: "Acquisitions July 1,
1961–June 30, 1964," *UMMA
Bulletin*, 1966-67, 41

Provenance: Martha Jackson Gallery, New York

1963/1.74

Karel Appel first
achieved fame in the
early 1940s as one of
the founding members
of COBRA, an international group
of avant-garde artists and writers.
Appel's style and subject matter
evolved during the COBRA years
and after World War II toward
activated, expressionistic images.
His abstract depictions of heads,
such as the Museum's gouache,
were developed during 1959-61 as
a catharsis for memories of the
war; his turbulent, isolated subjects reflect both man's destructive
action and the resulting anguish.

The gouache is dominated by a
highly abstracted single head,
defined by large, rough features
recalling children's art: a simple
oval suggests the outer boundary
of the face; the smaller circles, the
eyes; the black vertical hooked
stroke, the nose. Hair is suggested
by the zigzagging line at the forehead, while the curved lines radiating from the bottom suggest
appendages. The motif is built up
of thickly brushed strokes of black,
gray, and cobalt blue, while additional crayon lines in bright
orange, green, and yellow provide
sharp color contrast. The irregular
bands of color and splatters of
paint indicate the speed of execution and the energy of creation.
The brush was wielded with great
pressure, the edge bristles separating from the center, resulting in
secondary strokes accompanying
the primary outlines. *Fallen Head*
expresses an almost chaotic, primal
energy, the circle whirling in a
counter-clockwise fashion. The
inscription on the verso is a gallery
error, amended on a label removed
from the backing, and correctly retitled as "*Fallen Head*," no. 5377.
VJ

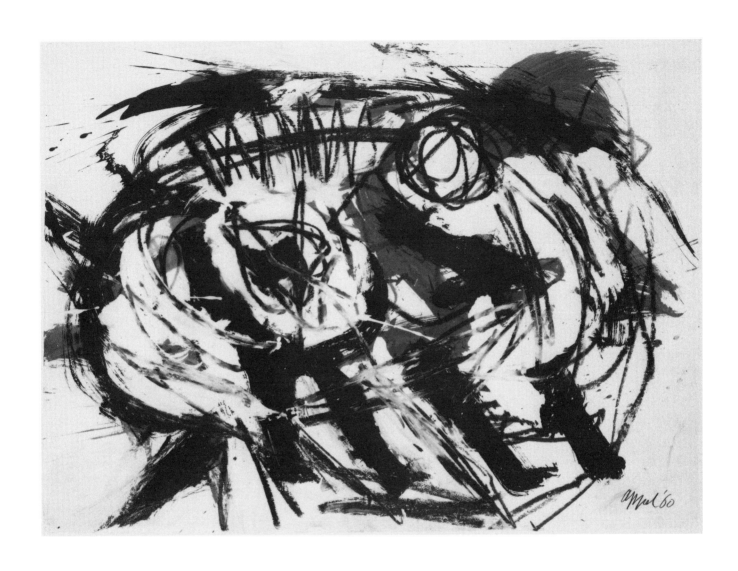

LEONARD BASKIN

**America
born 1922**

CROW

1964

Ink and wash on heavy white paper

**Embossed watermark: a thistle in a
circle [surrounded by]:**
STRATHMORE USE EITHER SIDE

29 x 23⅛ in. (736 x 586 mm)

Signed and dated l.r.: *Baskin. 1964.*

References: "Acquisitions July 1,
1971–June 30, 1976," *UMMA
Bulletin*, 1976-77, 32

Provenance: purchased in 1964
from the Boris Mirski Gallery,
Boston, by Mr. and Mrs. Stephen
A. Stone

Fig. 94a *Bird Man, 1969*, etching (602 x 452
mm), The University of Michigan Museum
of Art, gift of Mr. Nick S. Nicolas (1975/
2.101).

Gift of The Stephen and Sybil
Stone Foundation

1971/2.121

Leonard Baskin considers
himself a moral realist
whose representations of
humanity and of birds of
prey, such as the *Crow*, serve as
metaphors for the current, degen-
erated state of the world wrought
by man. As Baskin wrote:

Man has always created the
human form in his own image,
and in our time that image is
despoiled and debauched....He
[man] has not molded a life of
abundance and peace and has
charred the earth and befouled
the heavens more wantonly than
ever before. He has made of
Arden a landscape of death. In
this garden I dwell, and in limn-
ing the horror, the degradation
and filth, I hold the cracked mir-
ror up to man (*Baskin: Sculpture
Drawings & Prints*, New York,
1970, p. 15).

The crow is a particularly potent
and paradoxical image for Baskin,
who often sees the bird as a menac-
ing creature, which is nonetheless
noble and beautiful. This duality is
apparent in the Michigan drawing.
The black, stealthy crow preys on
carrion and is traditionally sym-
bolic of thievery and death. Yet
this alert crow, head erect, fills the
space like an iconic image, empha-
sizing its intellect and cunning.
Baskin depicts the extraordinary
richness of the animal in crisp pro-
file. The bird's body and the back-
ground are created by thick, visible
brush strokes, in which portions of
the white paper are left untouched,
defining form and suggesting the
texture of feathers. The clarity of
individual brushstrokes, and the
whisps of black left by the stray
hairs of the brush, give the crow a
powerful sense of vitality.

The Museum of Art has numer-
ous works by Baskin, including the
print *Bird Man*, 1969 (Fig. 94a),
which is linked thematically to
this drawing.

VJ

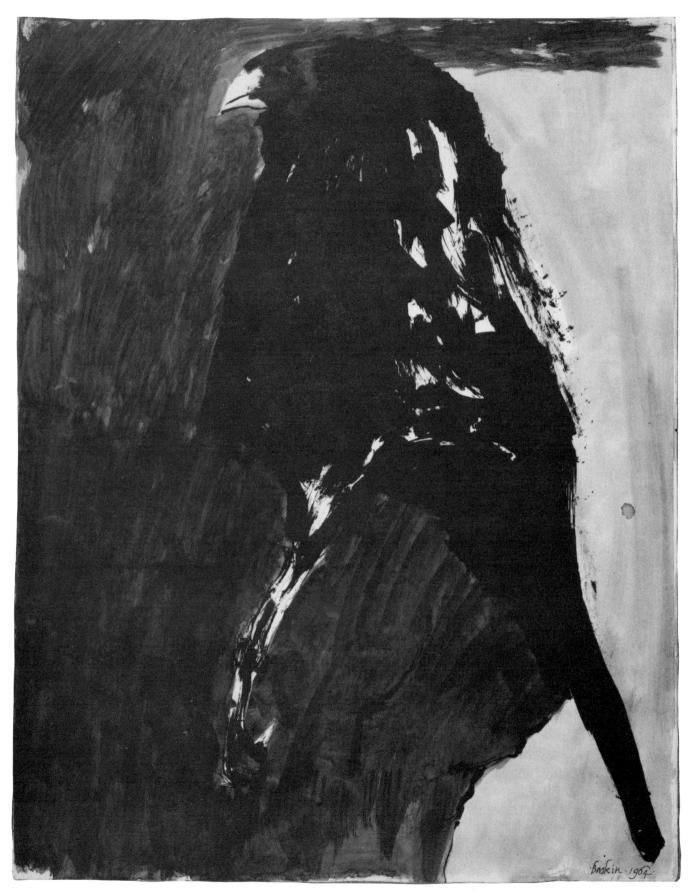

baskin. 1964.

PHILIP GRAUSMAN

**American
born 1935**

NUDE

1973

Pencil on white paper

Watermark: C.M. FABRIANO 100/100 COTONE

15⅛ x 22⅜ in. (382 x 566 mm)

Signed and dated l.r.: *Grausman / 1973*

Exhibitions: Ann Arbor 1982-83

References: "Acquisitions July 1, 1971–June 30, 1976," *UMMA Bulletin*, 1976-77, 32, 31 repr.

Provenance: purchased from the artist

1974/1.247

Grausman is a minimalist who defines mass primarily by contour. The artist frequently represents the nude, exploring it from a variety of atypical and sometimes awkward vantage points. In the Museum of Art's drawing, the rear view of a seated female, the buttocks and line of the backbone create a stable triangular form. The line of the spine retains its essential definition as part of the human body, yet the high arc raised above the curve of the hips is exaggerated beyond naturalistic form. The figure dissolves into abstraction at the upper thighs, where rows of parallel vertical lines imply the model's legs. The manipulation of form is further accentuated by the size and fullness of the hips and buttocks in contrast to the much smaller shoulder area and slender arms. This unusual point of view, which excludes the model's head, heightens the abstract nature of the work. Grausman's interest in full, swelling contour is also apparent in the artist's sculptures, which emphasize elements of growth and fertility.

The artist utilized a similarly unorthodox pose in *Untitled Nude Drawing* in the Museum's collection (Fig. 95a), positioning the model to accentuate the volume of the thighs and hips and concealing the head behind folded arms.
VJ

Fig. 95a *Untitled Nude Drawing*, 1973, pencil on white paper (385 x 575 mm), The University of Michigan Museum of Art, Marvin Felheim Collection (1985/1.161).

THEO WUJCIK

**American
born 1936**

**TRIBUTE TO THE
GRAPHICSTUDIO: PORTRAIT
OF PHILIP PEARLSTEIN**

1976

**Silverpoint on prepared, clay-coated
Morilla paper**

18¾ x 24 in. (476 x 610 mm)

Signed and dated, l.r.: *Theo Wujcik
1976*

References: "Acquisitions June
1976–July 1977," *UMMA Bulletin*, 1978, 79

Provenance: Donald Morris Gallery, Inc., Birmingham, Michigan

1976/2.135

Fig. 96a Philip Pearlstein, photograph taken
at the Donald Morris Gallery, Birmingham,
Michigan, 18 April 1976.

Theo Wujcik, the Detroit-born contemporary artist, is a master print-maker and draughtsman who excels in the demanding medium of metalpoint. This technique has been used for fine drawings since the early Renaissance, and entails making a fine line with a metal-tipped stylus on a prepared ground, leaving particles on the surface which tarnish with age. The process permits no erasures, and requires the greatest coordination of visual, mental, and mechanical skills.

To create his silverpoint portrait of Philip Pearlstein, Wujcik requested a photograph from the Donald Morris Gallery, which was taken in 1976 (Fig. 96a). With typical economy, Wujcik reinterpreted the photographic image, suggesting mass and shadow, material and texture, by his masterful manipulation of linear tone and breadth. Although the profile forms a stable triangle, the portrait emerges from the delicately-colored paper as if from a haze: the representation of Pearlstein is subtle, quiet, evocative.

Both Wujcik and Pearlstein were involved in the printmaking activities of the Graphicstudio at the University of South Florida, (where Wujcik is presently professor of art), but they never actually worked together there. The process of collaboration was the subject and content of the ten drawings comprising the entire series "Tribute to the Graphicstudio," of which Michigan's drawing is a part. Wujcik had also paid homage to Pearlstein by including him in his suite of five etchings entitled "Mentors" (along with portraits of Albers, Dine, Rauschenberg, and Rosenquist). He has subsequently drawn four more silverpoint portraits of Pearlstein, including one dated 1979 in the Brooklyn Museum (letter from the artist in object file, 5 September 1985).
HF

BRICE MARDEN

**American
born 1938**

HYDRA STUDY

1975

Graphite and wax on heavy white paper

Embossed watermark:
VERITABLE PAPIER D'ARCHES / FIN ARCHES / FRANCE

30½ x 22⅜ in. (775 x 568 mm)

Inscribed verso, center bottom: *B. Marden 75 / HYDRA STUDY*

References: "Acquisitions July 1, 1971–June 30, 1976," *UMMA Bulletin*, 1976-77, 33

Provenance: from the artist to Sperone Westwater Fischer Inc., New York

1976/1.231

Brice Marden's minimalist drawings explore the pictorial elements of space and color common to non-representational and figurative two-dimensional works of art. *Hydra Study* focuses on an ensemble of three overlapping rectangles alternating in color, two black and one white, which have been divided width-wise. Three new geometric motifs emerge – a smaller black rectangle in the center, surrounded by a white rectangular arch (not unlike the form of a post and lintel), in turn surrounded by a larger rectangular arch in black. In reducing his compositional components, Marden strips the artistic problem of all artifice and associations and squarely confronts formal issues of color, texture, and space. Black, normally considered the absence of color, is the applied pigment in *Hydra Study*. The white rectangular arch is untouched paper. To create his black Marden used a thick graphite and wax mixture applied like paint with a brush but worked almost sculpturally with a spatula and knife (see New York, Solomon R. Guggenheim Museum, "Brice Marden," 1975, p. 13). The waxy "patina" gives the dark sections of the image a dull shine which contrasts with the flat, matte finish of the paper. The glossy texture calls into question the spatial relationships suggested by the juxtaposition of light and dark. The black areas are clearly on the surface of the paper and are closer to the viewer, yet the shape of the bright white arch seems to advance spatially. The usually clear separation between figure and ground, and advancing and receding elements, is thus obfuscated.

Like Herakles's repeated attempts to slay the nine-headed mythical beast Hydra, who grew two heads for each one lopped off by the hero, the compositional conundrum of repeated rectangles is endlessly enigmatic. Marden revels in such fascinating problems. A related group of six drawings from about the same time called the "Thira Series" poses similar problems (reproduced in Jeff Perrone, "Brice Marden, Sperone Westwater Fischer," *Artforum*, XIV, 10, June 1976, p. 66). Moreover, like the word "Hydra," the etymology of "Thira" signifies the eager pursuit of something, or a fabulous monster. Marden's labyrinthine ambiguities create pictorial hydras that resist firm conclusions and question traditional expectations.

VJ with HF

GLADYS NILSSON

American
born 1940

MALE VENUS

1974

Watercolor on white handmade paper

Embossed watermark: VERITABLE PAPIER D'ARCHES / FIN ARCHES / FRANCE

22¾ x 30½ in. (577 x 774 mm)

Signed, dated, and inscribed, in pencil, verso, center: *gladys Nilsson / w/c May/June 1974 / "Bottacellee series: Male Venus"*

Exhibitions: Washington, D.C., National Collection of Fine Arts, Smithsonian Institution, "Made in Chicago" (traveled to Chicago, Museum of Contemporary Art), 1974-75, no. 36, 47 repr.; Greensboro, The University of North Carolina, Weatherspoon Art Gallery, "1975 Art on Paper," 1975, no. 84 repr.; Ann Arbor, The University of Michigan Museum of Art, "Chicago: The City and Its Artists 1945-1978," 1978, no. 14, 71 repr.; The Detroit Institute of Arts, "Detroit and Chicago: The Art of the 70s," 1978

Provenance: from the artist to the Phyllis Kind Gallery, Chicago

1977/1.199

*I*n *Male Venus*, a work from the "Bottacellee Series," Chicago "Hairy Who" artist Gladys Nilsson creates a fantastic landscape populated by bizarre creatures with tongue-like torsos, tubular heads, and long, languid appendages. The work is a parody, based loosely on Botticelli's painting *The Birth of Venus* in the Uffizi. Nilsson has increased the number of protagonists from two to four figures, spacing them horizontally across the central register in a manner that recalls many of Botticelli's allegorical works. Smaller figures appear in groups along all four edges, giving the watercolor the sense of *horror vaccui*. Many of these creatures stand on half-circle mounds reminiscent of Venus's seashell. In the original *Birth of Venus*, an attendant offers the goddess a cloak; in Nilsson's version many figures (particularly the large ones to the far right and the extreme left edges), proffer, wear, and play in lengths of fuchsia and purple cloth.

Nilsson amplifies the sexuality of the love goddess in an explicit fashion. In Botticelli's painting, Venus raises and lowers her hands to discretely mask her nakedness. The figures in the Michigan watercolor, however, do not cover themselves but instead lower their hands to cradle and fondle their phalli. Moreover, the bodies of Nilsson's creatures allude to both male and female sexual organs: the "torsos" are suggestive of tongues and uteri (the fallopian tubes indicated by the long, thin arms), while phallic imagery is directly expressed through the penises included on the male figures at the bottom, as well as implicitly through the forms of their heads. The participants are segregated sexually, the male creatures dominating the lower half of the composition while the the female figures, also depicted with explicit anatomy, fly into the composition at the top. The predominance of heightened flesh tones further suggests the states of sexual arousal in the *dramatis personae*.

Nevertheless, *Male Venus* is more than a sophisticated satire, for its complex art-historical, literary, and sexual connotations are both visual and verbal. Spatially, the work defies Western perspective; subsidiary groups (such as the female figures walking into the pictorial field at the upper left corner, and swooping in at the top) are perhaps "playing around" the circular composition. Wavy lines emanating only from the mouths of the female participants in the watercolor's upper register enhance the idea that the male members are verbally (and visually) "tongue-tied." Fully-clothed figures of no specific gender at the upper right wield enormous spoons and knives, which are traditionally symbols of the female and male sex. These tiny figures seem to parade to a dinner party where "Venus on the Half-Shell" is the main dish.

Nilsson engages the viewer in repartee with the history of art and with social customs. Her *Male Venus* is a rebus; the verbal articulation of its visual components aids in understanding the work, which is not a puzzle easily or completely deciphered. The unexpected juxtapositions of male and female, and the manipulation of image and word create a comic and thoughtful exploration into issues of psychology and identity.

VJ with HF

EDDA RENOUF

**American (born Mexico)
born 1943**

SOUNDS OF DAWN

1976

**Incised lines over gray pastel on
white Arches paper**

12½ x 12¾ in. (318 x 323 mm)

Signed and dated, verso, l.r.: *Edda
Renouf 9.9.1976*

Inscribed verso, l.l.: *SOUNDS OF
DAWN / Open parallelogram of
lines incised after pastel chalk*

References: "Acquisitions July
1976–June 1977," *UMMA Bulletin,* 1978, 79

Provenance: purchased from the
artist

1977/1.183

*I*n Edda Renouf's works, such as *Sounds of Dawn,* the process of creation is the paramount concern. For her drawings, a thick layer of pastel chalk is applied to a sheet of white paper. The chalk ground is then worked with a sharp needle or eraser, which removes areas of color revealing the paper below. In *Sounds of Dawn,* the finely incised lines are confined to the center of the work, constructing a central, rhythmic focus against the subtler variations of the gray ground. The artist's method is revealed by the surface quality; the depressions produced by the needle, the irregular thickness of the incised lines, and traces of gray left in the white gridwork are tactile features that emphasize the nature of the materials and the tools used by the artist.

The title of the work draws the viewer to sensorial associations with music. The quiet rhythms of the parallelogram and the subtle variations in the presentation of the lines produce a melodic, serene impression, harmonious with the essence of morning. The lines of the grid vary in thickness, imparting a quality of pulsing life. The center motif, which emerges from an indistinct background, further emphasizes the awakening dawn. In presenting an abstract image that exposes the act of creation, Renouf encourages the viewer to confront the work on a sensual level, bringing to it a tactile and aural quality in addition to its visual presence. Although their language and syntax vary, Renouf's drawings share a bond with those of Whistler, whose soothing works suggest visually the harmonies intrinsic to the structure of music. In an oil, *Frequency Piece III* (Fig. 99a), and a drawing, *Night Sounds* (Fig. 99b), in the Museum of Art's collection, Renouf also explores a range of visual-aural associations. *VJ*

Fig. 99a *Frequency Piece III*, 1976, acrylic on linen (40 x 150 cm), The University of Michigan Museum of Art, purchase made possible through an anonymous gift and a grant from the National Endowment for the Arts (1978/1.173).

Fig. 99b *Night Sounds*, 1977, incised points and pastel (318 x 318 cm), The University of Michigan Museum of Art (1977/1.198).

PHOTOGRAPHY CREDITS

Fig. 4a, from *Illustrations of the Bible*, by Westall and Martin, I, London, 1835, n.p.; Fig. 5a, New York, Pierpont Morgan Library, "Master Drawings by Gericault," 1985-86, no. 29a; Fig. 5b, Musée des Beaux Arts et d'Archéologie de Besançon, "Autour de David et Delacroix: Dessins français du dix-neuvième siècle," 1982-83, no. 86; Figs. 8a, 9a, 9b, Musée du Louvre, Cabinet des dessins, *Inventaire générale des dessins ecole française: Dessins d'Eugène Delacroix, 1798-1863*, I, Paris, 1984, nos. 1129, 293, 295; Fig. 10a, *L'Artiste*, 2nd series, III, 1839, 156 opp.; Fig. 10b, Musée du Louvre, Cabinet des dessins; Figs. 10c, 10d, Spencer Museum of Art; Fig. 11a, The University of Michigan Museum of Art; Fig. 17a, from *Encyclopédie d'architecture: Revue mensuelle des travaux publics et particuliers*, II, Paris, 1873, pl. 163; Fig. 21a, Sterling and Francine Clark Art Institute, Williamstown, Massachusetts; Fig. 21b, The University of Michigan Museum of Art; Figs. 22a, 22b, Leighton House, London; Fig. 25a, Victoria and Albert Museum, London; Fig. 26a, Staatsgalerie Stuttgart; Fig. 26b, Fitzwilliam Museum, Cambridge; Fig. 26c, The Tate Gallery, London; Fig. 26d, reproduced by courtesy of the Trustees of the British Museum, London; Fig. 30a, courtesy, Museum of Fine Arts, Boston; Fig. 30b, from *Gazette des Beaux-Arts*, XXIX, 1884, p. 481; Figs. 30c, 33a, The Cleveland Museum of Art; Fig. 34a, Victoria and Albert Museum, London, photo from The Paul Mellon Centre for Studies in British Art, London; Figs. 36a, 36b, The University of Michigan Museum of Art; Fig. 37a, from *The Century Magazine*, XLII, 4 August 1891, p. 549; Fig. 37b, from Joseph Pennell, *The Adventures of an Illustrator*, Boston, 1925, p. 209; Fig. 43a, *The New York Call*, January 1910, photo from the John Sloan Collection, Delaware Art Museum; Fig. 44a, *The New York Call*, 1 May 1912, p. 9., photo from the John Sloan Collection, Delaware Art Museum; Figs. 46a, 48a, 49a, The University of Michigan Museum of Art; Fig. 49b, Fitzwilliam Museum, Cambridge; Fig. 49c, Art Gallery of Ontario, Toronto; Fig. 49d, Fitzwilliam Museum, Cambridge; Fig. 53a, © The Art Institute of Chicago; Fig. 54a, Städtisches Museum Abteiberg, Mönchengladbach; Fig. 55a, The University of Michigan Museum of Art; Fig. 58a, The Tate Gallery, London; Figs. 64a, 64b, 64c, 64d, from *Le Corbusier Sketchbooks 1914-1948*, I, Cambridge, Massachusetts, 1981, nos. 403, 404, 520, 521; Fig. 64e, The University of Michigan Museum of Art; Fig. 72a, from New York, Museum of Modern Art, "Joan Miró," n.d., p. 18; Fig. 74a, The Cleveland Museum of Art; Figs. 77a, 82a, The University of Michigan Museum of Art; Fig. 85a, The Minneapolis Institute of Art; Fig. 85b, Private collection, Milan; Fig. 85c, from Roberto Tassi, *Graham Sutherland: Complete Graphic Works*, New York, 1978, no. 51; Fig. 85d, The University of Michigan Museum of Art; Figs. 89a, 89b, Whitney Museum of American Art; Fig. 91a, from *The Passport*, rev. ed., New York, 1979; Figs. 92a, 92b 94a, 95a, The University of Michigan Museum of Art; Fig. 96a, photograph taken at the Donald Morris Gallery, Birmingham, Michigan, 18 April 1976; Figs. 99a, 99b, The University of Michigan Museum of Art.

INDEX OF ARTISTS

Printed by Dearborn Lithograph, Inc., Livonia, Michigan. Stocks are 10 point C1S Frankote cover and 80# Mohawk Superfine text. Designed by Jennifer Spoon, editorial and production assistance, Suzanne Williams and John Hamilton, The University of Michigan Office of Development and Marketing Communication.